PROJECT QUARKXPRESS 5®

NAT GERTLER

DEDICATION

To George Washington Carver, who brought us peanut butter, the fuel of the gods.

—*Nat*

PROJECT QUARKXPRESS 5®

..

NAT GERTLER

THOMSON

DELMAR LEARNING™ Australia Canada Mexico Singapore Spain United Kingdom United States

THOMSON™
DELMAR LEARNING

Project QuarkXPress 5 ®

by Nat Gertler

Business Unit Director:
Alar Elken

Executive Editor:
Sandy Clark

Acquisitions Editor:
James Gish

Editorial Assistant:
Jaimie Wetzel

Executive Marketing Manager:
Maura Theriault

Marketing Coordinator:
Serena Douglass

Channel Manager:
Fair Huntoon

Executive Production Manager:
Mary Ellen Black

Production Manager:
Larry Main

Production Editor:
Tom Stover

Cover Design:
May Mantell

Library of Congress Cataloging-in-Publication Data:

Gertler, Nat.
 Project QuarkXPress / Nat Gertler.
 p. cm.
 Includes index.
 ISBN 1-40181-475-1
 1. QuarkXPress (Computer file) 2. Desktop pub-
lishing. I. Title.

Z253.532.Q37 G47 2003
686.2'25445369—dc21

 2002009174

CONTENTS

PROJECT 4 A STORY BOOKLET31

Importing text • Flowing text • Master pages • Style sheets • Page
numbering

PROJECT 5 BUILD A BOOK .41

Templates • Books • Ordering chapters • Checking spelling • Lists

PROJECT 6 BOOKENDS FOR YOUR BOOK51

Indices • Sections

PROJECT 7 BOOK JACKET .59

Points • Segments • Stacking • Runaround • Resizing

PROJECT 8 A CAR CARD .71

Spot colors • Building shapes • Layers • Measurement palette

PROJECT 9 THE TRICKY 4-10 SPLIT83

Creating groups • Spacing and alignment • Line design • Arrows •
Moving items between layers

PROJECT 19 LET US RHYME ONE MORE TIME 181

Links and anchors • Pictures for the Web

PROJECT 20 FORMING A FORM191

Web form design

INDEX .201

PREFACE

Welcome to *Project: QuarkXPress*. This book will take you step by step through 20 interesting and fun projects you can do with QuarkXPress. By the time you've completed these projects, you'll know from experience how to use the program. This book can be used as a stand-alone tutorial, or it can be used as part of a classroom experience.

QuarkXPress is a vast and complex graphics tool, with an unspeakably huge number of features and options. This book doesn't explain every single detail of every possible feature. There are books that do try to do that—they're usually the size of a city phonebook (and almost as exciting). Instead, *Project: QuarkXPress* shows you the features you'll probably need, give you tips about useful and interesting options, and build in you a larger understanding of how QuarkXPress works. With that understanding, you will be well equipped to grasp QuarkXPress's on-disk manual's explanation of any additional features you need.

You don't need a lot of computer experience to use this book. If you know how to use a mouse, and you've used a word processor, a spreadsheet program, or even a music program to create, save, and reopen files, you should be able to follow everything in this book without a problem.

QUARK**X**PRESS VERSION

This book was written around QuarkXPress version 5. Because new versions of the program rarely eliminate old features, you can expect the techniques you learn here to work with later versions of the program, although the interface may change somewhat. Many of the techniques here will also work with earlier versions of the program.

The projects in this book were designed to work with both the Windows and Macintosh versions of QuarkXPress. The program is extremely similar on the two platforms. The screen shots in this book were taken from the Macintosh version. Occasionally, the Windows version may look different, but the difference should be small and not confusing.

HOW THIS BOOK IS ORGANIZED

There are 20 QuarkXPress projects in this book. Each project is broken down into one-page procedures that advance the project in some visible way toward completion. If this book were *Project: Lunch*, for example, the first project might be making a peanut butter and jelly sandwich. "Spreading the peanut butter" would be one of the procedures in that project, and that procedure would be broken down into steps ("Open peanut butter jar," "Scoop some peanut butter out of the jar with a knife," "Drag knife across the bread," and so on).

I designed the projects to be performed in order, with earlier projects showing you the most basic features of the program, and later projects demonstrating more complex and subtle uses. Sometimes the later projects reuse things you created in earlier projects (the second project in *Project: Lunch* might be "Packing Your Lunchbox," and one of the steps might be "Take the sandwich you made in Project 1 and stick it in the lunchbox"). Did you skip over that project? Don't worry; just use a similar item that you get from somewhere else. In this book, we're basically recycling computer graphic files, and you can use any similar computer graphic file instead.

Later projects also presume that you've learned from the earlier ones. If the fourth project is "Make a Peanut Butter, Tuna, and Mustard Hoagie," I'm not going to spend an entire procedure telling you how to spread peanut butter again. Instead, it'll just be a single step: "Spread peanut butter on the roll (as shown in Project 1, Procedure 3)."

THE PROJECTS

Each project begins with a page listing the things you'll need for that project (bread, peanut butter, jelly, knife, plate) and a list of concepts that are taught in that project (spreading, slicing, and so on). In the color section of the book, you'll see pictures of the complete projects in full, glorious color, as well as a handy guide to QuarkXPress's screen and toolbox and a guide to how colors mix together.

THE PROCEDURES

Each procedure has a series of steps. Many of those steps are illustrated with pictures of parts of the program's interface. If you're asked to click a button you haven't used before, I'll show you a picture of the button. If you're asked to select some options on a dialog

box, I'll show you a picture of that dialog box (and if it's a complex one, I'll circle the options you need to pay attention to). If a step requires some special mouse movement, you'll see a picture with a highlighted arrow showing you the path for the mouse.

Many of the steps have additional notes.

 Read the *tip* notes that look like this! They show you faster and better ways of doing things.

 Why are there *why* notes such as this one? To explain why a step is needed, and why it works as it does.

A DEEPER UNDERSTANDING: THESE SECTIONS

When you encounter an *a deeper understanding* section, you find a more in-depth explanation of some QuarkXPress concept. You don't have to read these notes to complete the project at hand, but you probably should read them for educational value.

At the bottom of each page of each procedure is a picture of what the project looks like at the end of that procedure, so you can see how you're building to the end result. Please realize that what you see at the bottom of the page is what your image would look like if you printed it after that procedure, or in the case of Web-oriented projects, if you viewed it in your Web browser. It may not match what you see in your image window. For example, if the procedure is about how to zoom in on a portion of your image so you can work on small details, the picture at the bottom will still have the entire image rather than the enlarged portion.

Most of the projects include color. Check the color section of the book to see the end results in full color!

ABOUT THE AUTHOR

Astronaut, juggler, the missing member of Ozzy Osbourne's family—none of these descriptions truly captures the real Nat Gertler. In fact, all are laughably inaccurate, having absolutely nothing to do with Nat.

No, Nat's a writer. He has credits on over a dozen computer books, including *Easy PCs, Multimedia Illustrated,* and *Complete Idiot's Guides* on such topics as MP3s, PowerPoint, and Paint Shop Pro. His non-computer writing credits encompass a wide range of

media, spanning from slogan buttons to animated TV. He's most at home working in comics, where he has written everything from serious drama to adventures of the Flintstones. His self-published miniseries *The Factor* brought him a nomination for comicdoms coveted Eisner award. He is the founder and publisher of the About Comics, LLC line of comics-related books, including the popular *Panel One: Comic Book Scripts by Top Writers*. This year he is also writing the third, fourth, and fifth books in his *Project* series, writing columns and crossword puzzles for *Hogan's Alley* magazine, programming for the e-Badge.com Web site, running AAUGH.com (a site for fans of books of the Peanuts comic strip), and occasionally sleeping.

For more about Nat, check out www.Gertler.com.

THANKS

Thanks to the Delmar Hollywood-in-the-East super crew who conspired on this book and the entire series of books to date: executive producer Jim Gish, director Tom Stover, production designer Juanita Brown, best boy Melissa Cogswell, center fielder Jaimie Wetzel, and all the unforgettable crew members who I have managed to forget.

Project 1
Happy Happy Day

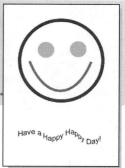

Have a Happy Happy Day!

CONCEPTS COVERED

❑ Starting a document
❑ Using tools
❑ Creating a text box
❑ Basic drawing
❑ Saving a document

REQUIREMENTS

❑ None

RESULT

❑ A greeting card for International Happy Day

PROCEDURES

1. Set your preferences
2. Open a new document
3. Get the text box tool
4. Write your greeting
5. Frame your words
6. Add more pages
7. Put on a happy face
8. Finish the face
9. Flow some text
10. Save the file

PROCEDURE 1: SET YOUR PREFERENCES

1. Start the QuarkXPress program.
2. From the **Edit** menu choose **Preferences**. A submenu opens up. Choose **Preferences** from the submenu as well, and a dialog box appears.

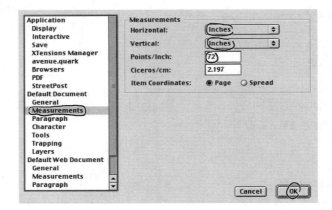

 From now on, this book will string submenu names and commands together with commas, so this would just be *choose* **Preferences, Preferences.**

3. Go to the left of the dialog box and in the **Default Documents** area click on **Measurements**. Settings related to the measurements of documents appear at the right.
4. Set both the **Horizontal** and **Vertical** drop menus to **Inches**.

 This sets the units used in designing the documents you create. You only have to do this once. All your documents will use inches as their unit until you change this again.

5. Click on the **Points/Inch** field and type **72**.

 Text size is measured in *points*. A point is one seventy-second of an inch, but some people adjust this value for tricky effects.

6. Click **OK.** The dialog box closes.

PROCEDURE 2: OPEN A NEW DOCUMENT

1. From the **File** menu choose **New, Document**. A dialog box opens.

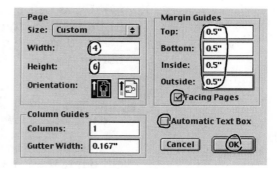

 Next to *Document* on the submenu you'll see a *keyboard shortcut* for starting a new image: ⌘N on the Macintosh, Ctrl+N on Windows. If you hold down the ⌘ key or **Ctrl** key and press **n**, a new image is opened. Many menu commands have such shortcuts.

2. Set **Width** to **4** inches and **Height** to **6** inches.

3. Set all four **Margin Guides** values to **0.5** inch.

 This sets the amount of blank space around the edges of each page of the document.

4. Put a check in the **Facing Pages** check box.

 This is the option for bound documents. It changes how the margins are interpreted.

5. Clear the **Automatic Text Box** check box.

 This option puts an area for text on each page. That's fine if you're putting together a book or a newsletter, but a greeting card doesn't need a standard text item on every page.

6. Click **OK**. The document is created.

· ·

A DEEPER UNDERSTANDING: FACING PAGES

The *facing pages* option changes how the margins are interpreted. With the option off, you set the top, bottom, left, and right margins. Turn the option on and you'll find you're still setting the top and bottom margins, but the other two settings are for *inside* and *outside* margins. The inside margin is the left side of any right-hand pages and the right side of any left-hand pages. With this option on, you can set a larger margin for the inside to make up for the space that is lost in the binding.

RESULT

PROCEDURE 3: GET THE TEXT BOX TOOL

1. Go to the tool palette, point to the fifth button from the top, and press your mouse button down.

 If you don't see the tool palette, go to the **View** menu and choose **Show Tools.**

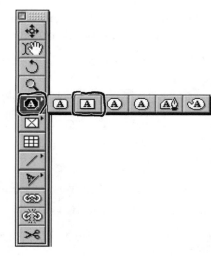

2. A row of buttons appears, although they may be in a different order than you see here. Each of these buttons has the letter A to indicate that they are text tools. What varies is the shape around the A, indicating the shape of text box the tool creates. Point to the button with a rectangle around the A. This is the **Rectangle Text Box** tool.

 If the button with the text tools isn't the fifth button from the top, then you're probably using a system where someone has rearranged the buttons or removed some. You can reset the buttons to their default setup by going to the **Edit** menu and choosing **Preferences, Preferences.** Click **Tools** on the left, then click the **Default Tool Palette** button that appears. Click **OK** to finish it up. Of course, if you're just a guest on someone else's computer, you may want to avoid resetting their defaults.

3. Release the mouse button. The tool is selected.

. .

A DEEPER UNDERSTANDING: USING THE TOOL PALETTE

QuarkXPress has too many tools to show buttons for all of them. Some buttons are used for several tools. If a button has an arrowhead in the upper-right, it has a menu. A quick click of the button gets you the tool currently pictured on the button, but pressing down gets you the button bar of tools associated with that button.

If the tool you want is already on the tools palette, you don't have to click and drag. You can just click the button to get the tool.

Procedure 4: Write your greeting

1. On the document should be four colored lines indicating the four margins. If you don't see these lines, go to the **View** menu and choose **Show Guides**.

2. Point to where the top margin meets the left margin.

 The pointer jumps to the corner because it assumes that you want to line up what you're doing with the margin.

3. *Drag* (hold the mouse button down while moving the mouse) down and to the right. As you do this a rectangle appears, with the upper-left corner where you started the drag and the lower-right corner where the pointer currently is. Drag to the right margin, about halfway down the page, and then release the mouse button. The text box is now in place.

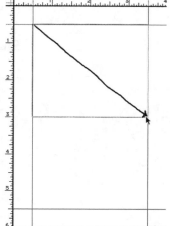

4. Go to the tool palette and click the **Content** tool button. When you do this, a blinking vertical line called a *cursor* appears in the text box.

 You can skip this step if the content button becomes automatically selected after you place this text.

5. From the **Style** menu choose **Font, Arial Black**.

6. Go to the **Style** menu again and choose **Size, 12 pt.**

 Pt. is short for *point*, the measurement of text height. Because there are 72 points per inch, this means that capital letters will be one-sixth inch high.

7. Return to the **Style** menu yet again and choose **Type Style, Bold** to make thicker letters.

8. Head back to that now-all-too-familiar **Style** menu and choose **Alignment, Centered** to center the type horizontally in the text box.

9. Type **International Happy Day** then press the **Return** or **Enter** key to start a new line.

10. Enter three more lines: **has come again this year,** followed by **You mustn't sob or sulk or pout** and, finally, **But just grin ear to ear.**

RESULT

PROCEDURE 5: FRAME YOUR WORDS

1. Go to the **Item** menu and choose **Frame**. A dialog box opens up.

2. Set **Style** to **Deco Shadow**, **Width** to **8 pt.**, **Color** to **Black**, and **Shade** to **30%**.

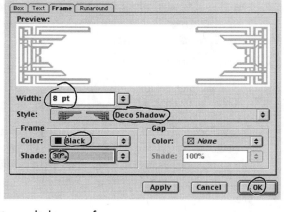

 Shade sets how dense the black ink is when this item is printed. By setting it to 30%, you're creating a light gray frame.

3. Click **OK**. The decorative border appears on the inside edge of your text box.

 Click **Apply** and the frame is applied without closing the dialog box. Now you can make adjustments to the settings without having to reopen the dialog box. If the dialog box is covering up part of the image, you can move it out of the way by dragging the top bar of the box.

4. Around the edges of the text box are eight *sizing handles,* little black squares that you'll find at the corners and the middle of each side. Point to the bottom handle and drag it upwards until the gap between the bottom of the text and the bottom edge of the box is the same size as the gap between the top edge and the top of the text.

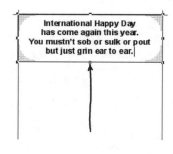

 If the last line of text disappears when you release the mouse button, you've made the text box too small. Drag the bottom sizing handle down a little.

PROCEDURE 6: ADD MORE PAGES

1. Find the document layout palette. If you don't see it, go to the **View** menu and choose **Show Document Layout.**

2. Point to the **Blank Facing Page** icon and drag it so that the pointer is just above the top of the page that's displayed in the layout. You can tell you're at the right place when the pointer becomes a down arrow. When you release the mouse button, a new page is added to the layout.

3. Drag the **Blank Facing Page** icon again, placing it to the left of the lower of the two pages. When you're pointing to the right place, a dotted rectangle that appears around the pointer will seem to stick to the line down the center of the layout area.

4. Drag one more page into place, putting it below the page on the left. Your document now has all four pages of a greeting card: the front cover, the two pages of the inside, and the back cover.

5. Point to page 1 in the layout area and *double-click* it (click twice quickly) to make it the current page.

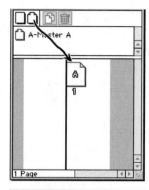

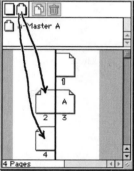

 The page number is under the image of the page on the layout.

- -

A DEEPER UNDERSTANDING: FACING PAGES LAYOUT

The document layout display for documents created with the *facing pages* option is actually well organized. Any page you place to the left of the center divider line is a left-hand page. Any page you place to the right of the line is a right-hand page. When you have pages right next to each other, that's a *spread*, like the two pages of this book that you're staring at right now. (Unless you're a *cover roller*, bending one page all the way back behind the book. Be careful, you'll crack the spine!) The spreads are in order from top to bottom.

The first page of a new document is always a right-hand page, because the first page of any standard English language book, booklet, or magazine is a right-hand page.

RESULT

PROCEDURE 7: PUT ON A HAPPY FACE

1. Go to the tool palette and get the **Oval Picture Box** tool.

 To make sure you have the right tool, point your pointer to the button and take your hand off the mouse so that the pointer stays perfectly still. After a second, a small *hint* appears, displaying the name of the button.

2. Point to the upper left margin corner. Hold down the **Shift** key while dragging down and to the right, ending at the right margin. A circle with a big X in it appears.

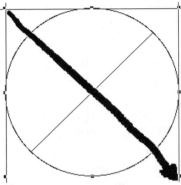

 Holding down the shift key tells the program that you want an object with the same width as the height.

3. From the **Item** menu choose **Content, None**. The X disappears.

 The X indicates that the program expects you to put a picture in the circle. You just want a circle.

4. Set a frame for this circle using the same technique you used in Procedure 5. Set the **Style** to **Solid**, the **Color** to **Black**, the **Width** to **8 pt.**, and **Shade** to **100%**.

5. Get the **Bézier Line** tool from the tool palette.

6. Click a point about one-eighth of the way across from the left sizing handle on the circle to start the smile.

7. Point a little above the bottom of the circle and drag 1 inch to the right. As you drag, the line connecting the first and second points becomes increasingly curvy.

8. Double-click a point on the right side to finish the smile.

PROCEDURE 8: FINISH THE FACE

1. From the **Style** menu choose **Width, 6 pt.** The smile becomes thicker.

2. Return to the **Style** menu and choose **Color, Red.**

3. Using the same technique as in Procedure 7, draw a circle as an eye.

4. If the colors palette is not visible, go to the **View** menu and choose **Colors.**

5. Click the **Background Color** button at the top of the palette.

6. Click the **Cyan** entry on the palette list. The circle fills with this color.

7. Set the **Shade** field on the top of the palette list to **50%.**

8. Select the **Item** tool.

 If you have the content tool selected the program doesn't know that your're copying the item.

9. From the **Edit** menu choose **Copy.** A copy of the eye is stored in an area of memory called the *clipboard.*

10. From the **Edit** menu choose **Paste.** A copy of the clipboard contents is placed on your page, so now there's a second eye.

11. Drag the second eye from where it appears to where a second eye should be.

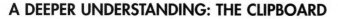

A DEEPER UNDERSTANDING: THE CLIPBOARD

The clipboard is an area of your computer's memory that can store a piece of your image. When you use the *cut* or *copy* commands on the edit menu, the currently selected objects are stored on the clipboard. When you use the *command* paste, whatever's on the clipboard is copied onto your image.

The clipboard can only hold the result of one cut or copy command. The next time you cut or copy, whatever was on the clipboard disappears, even if you cut or copy in your word processor! All programs use the same clipboard, so you can copy something from one program and paste it into another.

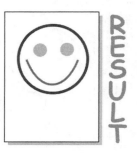

PROCEDURE 9: FLOW SOME TEXT

1. Get the **Freehand Text-Path** tool.

2. Drag a slightly wavy line across the lower part of the page going from the left margin to the right margin.

3. Select the **Content** tool and type **Have a Happy Happy Day!**

4. Go to the **Item** menu and choose **Modify**. A dialog box appears.

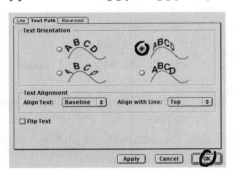

 This dialog box looks different from earlier dialog boxes for this same command. The modify command is smart enough to know what you're trying to modify and displays the appropriate modifiable attributes for that item.

5. Click the **Text Path** tab. Choose the upper-right **Text Orientation** option then click **OK** to change how the text follows the line.

6. From the **Edit** menu choose **Select All** to select the line's text.

 You're about to do text-changing commands. If you don't *select* text, the changes would only alter any further typing you do. With text selected, the changes affect the selected text.

7. Go to the **Style** menu and choose **Size, Other.** A dialog box opens up.

8. Set **Font** to **Arial** then set a value in the **Size** field and click **Apply** to see how it looks. Keep trying different size val-

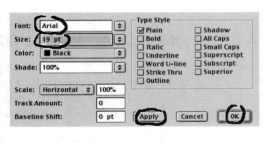

ues until you find the one that brings the *Day!* in the phrase as close as possible to the right margin without going past it.

 While you can select sizes from the drop menu at the end of the field, that only allows you certain specific size values. By typing a value into the field, you can pick a size that's not on the list.

9. Click **OK** to close the dialog box.

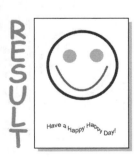

RESULT

Have a Happy Happy Day!

Procedure 10: Save the file

1. Go to the **File** menu and choose **Save**. A file browser opens up.

2. In the **Save Current Document As** field type **greeting card.**

3. Make sure that **Type** is set to **Document** and **Version** is set to **5.0.**

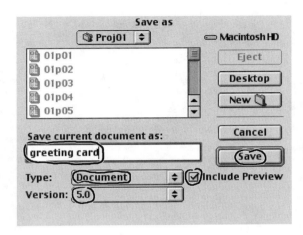

 If you're using a Macintosh put a check in the **Include Preview** check box. This generates a small image of your project which can be seen when opening files. This makes it easier to recognize a selected file.

4. Click **Save** and the file is saved to disk.

 Notice that the name *greeting card* now appears on the document window. Whenever you deal with a saved document, the name will appear here.

5. From the **File** menu choose **Close** to show that you're finished working with the document. The document window disappears.

6. From the **File** menu choose **Quit** to end the program.

PROJECT 2
YOUR OWN BASEBALL CARD

CONCEPTS COVERED

❏ Creating a blend
❏ Choosing colors
❏ Placing pictures
❏ Rulers and guides
❏ Saving a document

REQUIREMENTS

❏ A digitized photo, preferably of yourself. If you don't have one, you can download one from:

http://www.delmarlearning.com/companions/projectseries

RESULT

❏ The front of a baseball card

PROCEDURES

1. Set up your card
2. Mix some colors
3. Fade in a background
4. Put your picture on
5. Resize your picture
6. Name your team
7. Polish your text

PROCEDURE 1: SET UP YOUR CARD

1. Start the QuarkXPress program.

2. Using the technique from Project 1, Procedure 2, start a new document. It should have a **Width** of **2.5** inches, and a **Height** of **3.5** inches. The **Facing Pages** and **Automatic Text Box** check boxes should be clear, and all of the margins should be **0**.

3. Go to the **View** menu and choose **Fit in Window.** The document area enlarges to fill the available space. You haven't actually changed the size of your final document. Think of this as looking at your document through a magnifying glass, making it easier to see the detail of what you're doing.

4. Look at the rulers above and to the left of your document area. If you don't see rulers there, go to the **View** menu and choose **Show Rulers.**

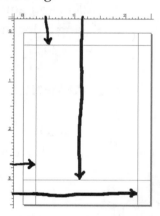

5. Point to the top ruler then start dragging downwards. You'll discover that you're dragging a line. The line goes all the way across to the left ruler. Drag the line to the one-quarter inch mark on the ruler. When you release the mouse button, the line turns color.

 This line is a *guide*, it is there to make it easy for you to place items in a precise location.

6. Point to the top ruler again and drag another guide down, placing this one at the 3-inch mark.

 You can change the color of the guides by going to the **Edit** menu and choosing **Preferences, Preferences.** Click **Display** on the left, then click the colored box next to **Ruler** to get a color picker.

7. Point to the ruler on the left and drag toward the right to create a vertical guide. Place one vertical guide at the one-quarter inch mark, and another at the two-and-one-quarter inch mark.

 These guides are a lot like the margin guides that you used in Project 1. The margin guides are handy because they can automatically set the edges of text boxes. These ruler guides are useful because you can have as many or as few of them as you want, independent of the text boxes.

PROCEDURE 2: MIX SOME COLORS

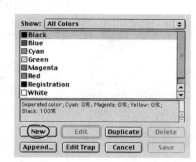

1. From the **Edit** menu choose **Colors**. A dialog box opens.

2. Click **New**.

3. Another dialog box opens. In the **Name** field type **Metallic Blue**. Set **Model** to **CMYK** and clear the **Spot Color** check box.

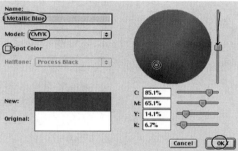

There are two methods of printing colors. *Spot color* is when you have a separate ink for each color, which can be used when you're only using a few colors. Printing in full color, however, requires *process color,* which mixes together four color inks to make any color you need. The CMYK method of specifying colors actually specifies the amount of each of the four colors needed to make the specific color.

4. Drag the **brightness** slider on the upper-right about halfway down. The color wheel darkens.

5. Click the color wheel in an area down and to the left to select a shade of blue.

6. Click **OK**. The second dialog box closes and Metallic Blue is added to the list of colors.

7. Repeat steps 2 through 7 to create another color named **Steel Gray**. Instead of a blue color, you want to pick a gray color of similar darkness.

You can set a gray by clicking the color wheel in the middle and varying the brightness slider, or try setting the **C**, **M**, and **Y** values to **15%** and the **K** value to **25%**.

8. Click **Save** to close the first dialog box.

A DEEPER UNDERSTANDING: CMYK COLORS

Each CMYK color is a mixture of *cyan* (a shade of blue, abbreviated *C*), *magenta* (a vibrant red, abbreviated *M*), *yellow* (abbreviated *Y*), and *black* (unexpectedly abbreviated *K*, because B is used for Blue). Because paper is white, if you don't add any color, it will be as bright as possible. The more ink you add, the darker the color becomes. The amount of each component color is measured on a percent scale from 0 (no ink) to 100 (as much ink as possible). Near the end of the color section of this book is a diagram that shows how these colors mix together.

PROCEDURE 3: FADE IN A BACKGROUND

1. Get the **Rectangular Picture Box** tool from the tool palette.
2. Drag from the upper-left corner of the document to the lower-right corner to create a picture box that covers the entire document.
3. Go to the **Item** menu and choose **Content, None** to convert this from a picture box to a simple box.
4. Go to the **Colors** palette and click the **Background Color** button, the third button from the left on the top.

 If you don't see this palette, go to the **View** menu and choose **Show Colors.**

5. Click the **Metallic Blue** entry on the palette. The rectangle turns blue.
6. There's a drop menu below the top row of buttons on this palette. Click the drop menu and choose **Mid-Linear Blend.**
7. Click the **#2** option button, then click **Steel Gray** on the color list. The color in the box now fades from the #1 color (metallic blue) to the #2 color (steel gray) and back again.

 The colors you see here aren't exactly what you'll see in print. Your computer screen doesn't use the CMYK system to create colors. It uses another system, called RGB, and not all CMYK colors can be re-created in RGB.

8. Type **90** into the field to the right of the #1 and #2 options. The colors now change from top to bottom, rather than changing from side to side.

 This value rotates the direction of the fade. The value is a degree measurement.

PROCEDURE 4: PUT YOUR PICTURE ON

1. If you don't have a digital picture of yourself, either scan one in or set your Web browser to:

 http://www.delmarlearning.com/companions/projectseries

 and follow the directions there for downloading a photo. It won't be a photo of you, alas, unless you happen to be a member of my family (and if you are, why don't you ever call?).

2. Get the **Rounded-corner Picture Box** tool from the tool palette.

 The difference between the images on the picture box buttons are subtle. After you select what you think is the right button, point to the button again and hold the pointer still for a moment to see the name of the button.

3. Drag, starting where the top guide meets the left guide and ending where the bottom guide meets the right guide. A rounded rectangle appears, touching all four guides.

 You can change the size of the curves at the corners by going to the **Item** menu and choosing **Modify**.

4. From the **File** menu choose **Get Picture**. A file browser appears.

5. Using the file browser, locate the picture file, click the file name, then click **Open**. The picture appears in the rounded rectangle. Depending on the resolution of the picture, you may just see the upper-left of the picture, or you may see the whole picture and some extra blank space.

RESULT

PROCEDURE 5: RESIZE YOUR PICTURE

1. From the **Style** menu choose **Fit Picture to Box (Proportionately).** The picture changes size so that it is either just as wide or just as tall as the picture box. Unless your picture just happens to have the same width-to-height ratio as the picture box, however, you will have some blank areas on two edges of the picture.

 There's a version of this command without the *(Proportionately)* part that adjusts both the width and height of your picture to fit. However, it distorts your image to make it fit.

2. Take a look at the picture and decide what portion of it you want framed on your card. Hold down the Macintosh **shift, option,** and ⌘ keys or the Windows **Shift, Ctrl,** and **Alt** keys and press > to enlarge the picture, < to shrink it.

3. Drag the **Content** tool across the image. The tool grabs hold of your picture and slides it, changing what part is displayed in the frame. You may need to bounce back and forth between steps 2 and 3 a few times to get the framed portion of the picture to be close to what you want.

 After you use any other tool QuarkXPress automatically switches to either the content tool or the item tool, whichever you used more recently.

4. From the **Item** menu choose **Modify.** A dialog box opens up. Click the **Picture** tab to display settings about the picture's appearance.

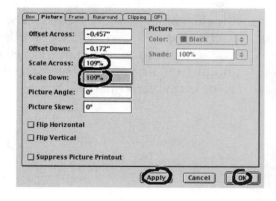

5. Here's where you fine-tune the magnification of your picture. In the **Scale Across** and **Scale Down** fields are the current amount of magnification of your original image, displayed as percentages. Increase these values to enlarge the picture, or decrease them to shrink the picture, but be sure to keep the same number in both fields or you'll warp the image. Click **Apply** to see how the magnification looks, and click **OK** when you're happy with it. You'll probably need to move the picture again slightly.

R
E
S
U
L
T

PROCEDURE 6: NAME YOUR TEAM

1. Create a text box as you did in Project 1, Procedures 3 and 4. The upper-left corner should be on the left ruler guide, two and three-quarter inches from the top of the card. The lower-right corner should be where the right ruler guide meets the bottom of the card. The type font should be **Impact**, the size should be **7 pt.,** and the alignment should be **Right**. The contents of the box should be three lines of text. For the first line, make up the name of a baseball team for the person pictured. The second line should be the person's name. The third line should be the position that the person plays.

2. *Triple-click* (click three times quickly) on the name of the team. The name becomes *selected* (highlighted to indicate that whatever commands you give will alter just this text).

 Clicking once on text places the editing bar where you click, so whatever you type appears where you clicked. Double-clicking selects just the word you click on. Three clicks select a line of text and four clicks select a paragraph.

3. From the **Style** menu choose **Character**. A dialog box opens.

4. Set **Size** to **12 pt., Color** to **Red,** and **Scale** to **Vertical** with a value of **250%**.

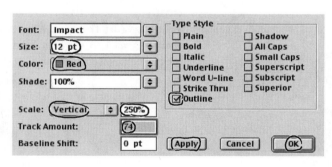

 This makes text that's as wide as 12 point type, but two and one-half times as tall.

5. In the **Type Style** area choose the **Outline** option.

6. In the **Track Amount** field enter **50,** then click **Apply.**

 The track amount sets the spacing between letters.

7. Look at your image. If there are letters missing from the end of the team name, set **Track Amount** to **40.** If no letters are missing, set the value to **60.**

8. Click **Apply** and see how the team name looks now. Keep adjusting the **Track Amount** value and clicking **Apply** until you find the highest valuethat doesn't make letters disappear.

9. Click **OK.**

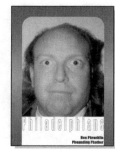

PROCEDURE 7: POLISH YOUR TEXT

1. Drag from the start of your player name to the end of your position. The text you dragged over becomes selected.

2. From the **Style** menu choose **Type Style, Small Caps.** The lowercase selected letters become small uppercase letters.

3. On the **Colors** palette, click the **Background Color** button then click **None.** The background of the text box disappears, so now the text appears on the photograph and border that you drew before.

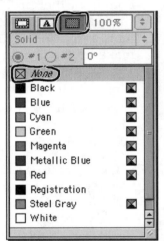

4. Triple-click the player name to select it.

5. Go to the **Style** menu and choose **Type Style, Shadow.** The text now casts a little shadow.

6. Save the file with the name **card** using the technique from Project 1, Procedure 10. Now you've managed to avoid the years of athletic training and have gone straight to the good part—your own card!

PROJECT 3

BACK OF YOUR BASEBALL CARD

Ben Phranklin

YEAR	Donuts	Cats	Mellow
2000	17	1	7
2001	13	1	3
2002	2	0	5

CONCEPTS COVERED

❏ Reloading
❏ Resizing
❏ Rotating
❏ Creating and formatting tables
❏ Text box shapes

REQUIREMENTS

❏ The baseball card file you created in Project 2

RESULT

❏ The back of the baseball card

PROCEDURES

1. Reload your card file
2. Rotate your card
3. Rotate your page
4. Set your table
5. Enter your stats
6. Format the table
7. Make yourself fancy
8. Print your card

PROCEDURE I: RELOAD YOUR CARD FILE

1. Start QuarkXPress.
2. From the **File** menu choose **Open**. A file browser appears.
3. If the directory listed on the folder drop menu is the one where you saved the file with your baseball card, skip to step 6.
4. Click the drop menu. A list of directories in the path to the current folder appears. Select the folder furthest along the path to the folder with the card.

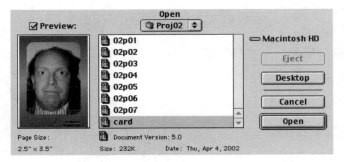

In order to make your files easier to manage, they are organized in folders. Each folder can hold both files and other folders. The folder drop menu shows all the folders within folders within folders that it takes to reach the folder you're in.

5. On the file list, find the next folder on the path to your file and double-click it. The folder opens and its contents are displayed. Repeat this until you actually open the folder that has the card file in it.
6. Click the **card** file.

If you're using a Macintosh put a check in the **Preview** check box. A black-and-white image of the contents of the selected file appears, so you can verify that you have selected the right file.

7. Click **Open**. The file opens and your card is displayed.

PROCEDURE 2: ROTATE YOUR CARD

1. From the **View** menu choose **Actual Size** to display the card smaller in the window.

2. Point above and to the left of the card, and drag down and to the right. As you drag, a dotted *selection box* appears, making a rectangle with the upper-left corner where you started dragging and a lower-right corner at your pointer's current location. When the entire card is inside the box, release the mouse button. Sizing handles appear around each of the elements of the card, indicating that they're selected and will be affected by commands.

 You can drag a selection box with either the item tool or the content tool, so it doesn't matter what tool you've ended up with.

3. Get the **Rotation** tool from the tool palette.

4. Point somewhere near the center of the card, hold down the **Shift** key, and drag to the right and then down. An outline appears and rotates as you drag. When the outline has rotated 90 degrees (one-quarter turn) clockwise, release the mouse button.

A DEEPER UNDERSTANDING: ROTATING

If you use the rotation tool without holding down the shift key, you can rotate to any angle you want. This is a very powerful tool, and it's fine if you don't need to rotate to an exact angle. Reaching an exact angle is difficult.

Hold down the shift key and the rotation only takes place in 45 degree leaps. This makes it easier to rotate the most commonly needed amounts.

PROCEDURE 3: ROTATE YOUR PAGE

1. Get the **Item** tool from the tool palette.
2. Use this tool to drag the card, placing it so that what is now its upper-left corner is in the upper left corner of the page. You'll find that it sticks there easily.

 The edges of the page are not naturally sticky. However, the margin guides are, and because the margin widths were set to zero, the margin guides are right on the edge of the page.

3. From the **File** menu choose **Document Setup**. A dialog box opens.
4. If you're using Windows choose the **Landscape** option. If you're using a Macintosh click the second of the two **Orientation** buttons. The height value becomes the width value and vice versa.

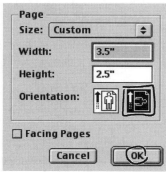

 The first orientation button is for *portrait* orientation, where the page is turned so that it is taller than it is wide. The second button is for *landscape* orientation, turning the paper so that it's wider than it is tall.

5. Click **OK**. The page has rotated, matching the placement of the card image.

 This may seem like a lot of work. Why are you rotating the card? The backs of baseball cards are often in landscape format, and that's how your card will be. Because you've learned the rotation tool, you might think that you could just create the elements of the back of the card and rotate them into place. That's a good thought, and you're very smart. Alas, the rotation tool works on every QuarkXPress element *except* for something called *tables*, and a table is exactly what you'll want to have on the back of your card.

RESULT

PROCEDURE 4: SET YOUR TABLE

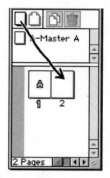

1. Go to the document layout palette and drag the **Blank Single Page** icon down to the right of page 1 to create page 2.

2. A new page appears to the right of page with the front of the card. Make that page fully visible by using the scroll bar on the bottom of the editing window.

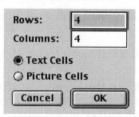 You can scroll by either clicking the right arrow button near the bottom right of the window, or dragging the draggable button across the scroll bar. You can also enlarge the entire window by dragging the lower-right corner of the window down and to the right.

3. Get the **Tables** tool from the tool palette.

4. Drag a rectangle that covers all but one-half inch from the edges on the second card.

5. A dialog box appears. Set both **Rows** and **Columns** to **4** and choose the **Text Cells** option. Click **OK**. A *table* (grid) appears on the document.

Rows:	4
Columns:	4

● Text Cells
○ Picture Cells

[Cancel] [OK]

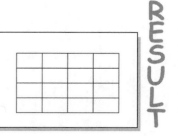

RESULT

PROCEDURE 5: ENTER YOUR STATS

1. Get the **Content** tool from the tool palette.

2. Type **YEAR**. It appears in the upper-left cell.

3. Press the **Cursor Down** key (the one with an arrow pointing down) and the *cursor* (the blinking line that shows where what you type goes) moves down to the next cell.

4. Type the year date from three years ago. Pressing the cursor down key again, enter the year from two years ago into the cell below that one, and last year in the bottom cell of the column.

5. Press the **Cursor Right** button to move to the bottom cell in the next column. Press **Cursor Down** again, and the cursor wraps around to the top cell of the column.

6. In the first cell of the second column, enter the word **Donuts**. In the cells below that, type the number of donuts you ate in each year listed in the first column. Similarly, the top cell of the third column should say **Cats** and underneath will be listed the number of cats you owned each year. Finally, in the fourth column enter **Mellow**, and list how mellow you were each year on a scale from 1 to 10.

7. Point to just above the upper-left cell and drag to the right. As you drag, the columns change color to show they're selected. When all the columns are selected, release the mouse button.

 If this doesn't work the first time, you'll have to click on the table again to select the table, then try this step again to select all the content.

8. Using the **Style** menu, set the **Font** to **Arial** and the **Alignment** to **Centered**. This changes the text in all the selected cells.

9. From the **Item** menu choose **Modify**. A dialog box opens.

10. Click the **Text** tab. In the **Type** area, set **Vertical Alignment** to **Centered**. Click **OK**. Now all the text is centered in the cell, rather than clinging to the top of the cell.

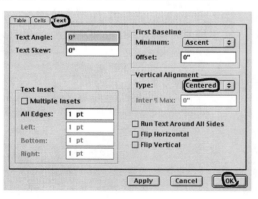

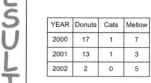

YEAR	Donuts	Cats	Mellow
2000	17	1	7
2001	13	1	3
2002	2	0	5

PROCEDURE 6: FORMAT THE TABLE

1. With all the cells still selected, use the technique from Project 2, Procedure 3 to set the **Background Color** to **Black** with the drop menu set to **Solid**.

 Don't worry if it looks like your text disappears and the cells become deselected. You turned the background black, which means you now have black text on black, making it invisible. Selected cells are indicated by reversing their real color, so when you changed the color to black, the selected cells look white. They are still selected.

2. On the colors palette, click the **Text Color** button then click **White**.

3. Cursor to the second cell in the second row. When you do this, the cells become deselected.

4. While holding down the **Shift** key, cursor down to the last cell in the last row. As you do this, the cursor doesn't move, but a rectangle of cells become selected.

5. Set the **Background Color** for these cells to **White** and the **Text Color** to **Black**.

6. Get the **Item** tool from the tool palette. When you do this, the cells stop being selected, but the table as a whole is still selected.

7. From the **Item** menu choose **Modify**.

8. A dialog box opens up. Click the **Grid** tab, click the **Select Vertical** button, and set the **Width** to **Hairline** (that's the smallest possible line) and the **Color** to **Steel Gray**.

 The dialog box you have now is different from the one you got in Procedure 5 because now you have the item tool, so the program thinks you want to modify the structure of the table. You had the content tool before so you were given the dialog box to modify the content.

9. Click the **Select Horizontal** button (the one below the select vertical button). Set **Width** to **4 pt.**, **Style** to **Double**, and click **OK**. The lines of the grid change to match the design you've set.

PROCEDURE 7: MAKE YOURSELF FANCY

1. Using the techniques from Project 1, Procedures 3 and 4, create a text box covering the area above the table, the same width as the table. Put your name in it.

2. From the **Edit** menu choose **Select All** to select all the text in the box.

3. From the **Style** menu choose **Character**. A dialog box opens.

4. Set **Font** to **Impact**, **Size** to **18 pt.**, and **Scale** to **Horizontal**.

5. By setting the **Scale** value to different values then clicking **Apply** to test the value out, find the largest value that will keep the text within the text box then click **OK.**

6. From the **Style** menu choose **Text to Box.** A second copy of your name appears, although it may be hard to read because it will be an outline with a number of sizing handles around it.

To the program this second copy isn't actually text. Instead, it's a picture box that happens to have the shape of text.

7. Click the **Item** tool button on the tool palette.

The item tool is the one you want selected when you want to move an item. This is true even if you're not dragging the item with the tool itself.

8. Use the cursor keys to move the second copy of your name, placing it so it overlaps the first copy as closely as possible.

9. From the **Item** menu choose **Content, None.** The X in the box disappears.

10. Use the technique from Project 2, Procedure 3 to fill the background of the name-shaped box. Set the color palette drop menu to **Full Circular Blend,** color #1 to **Black,** and #2 to **Steel Gray.**

11. Click on some part of the rectangular text box that's not covered by the name-shaped picture box. Delete this text box by going to the **Item** menu and choosing **Delete.**

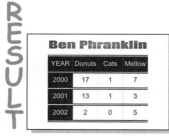

YEAR	Donuts	Cats	Mellow
2000	17	1	7
2001	13	1	3
2002	2	0	5

PROCEDURE 8: PRINT YOUR CARD

1. From the **File** menu choose **Save**. The new file with both sides of the card replaces the one with just the front.

2. Return to the **File** menu and choose **Print**. A dialog box appears.

3. On the **Document** tab set the **Spreads** option.

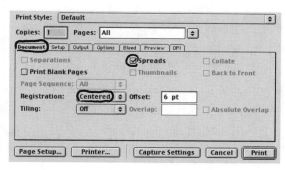

 This prints two adjacent pages of your document on each page of paper. Of course, this only works if your document pages are no more than half the size of your paper!

4. Set the **Registration** drop menu to **Centered**.

 This prints tick marks around the corners of your pages to help you see where the corners are, which is important when dealing with blank-edged items like the card back.

5. Click the **Setup** tab, set the **Page Positioning** drop menu to **Centered**, and click the **Landscape Orientation** button.

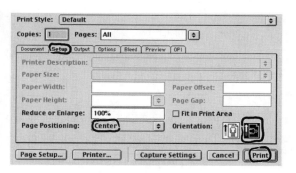

This will put the image in the center of a standard piece of paper turned sideways. This way, you don't have to worry about losing any of your image in the margins where your printer can't reach.

6. Click **Print**. A page with both sides of your card will come spilling out of your printer. If you have a color printer, the front will be in full color.

 The back of the card is all in black and white because the author of this book is an old fogey who remembers the days when baseball card companies were too cheap to print the backs in full color.

7. Use scissors to trim the page, using the registration marks to judge the corners of the back. Fold the front behind the back, and you have a paper baseball card!

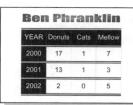

| **Ben Phranklin** | | | |
YEAR	Donuts	Cats	Mellow
2000	17	1	7
2001	13	1	3
2002	2	0	5

R E S U L T

PROJECT 4
A STORY BOOKLET

CONCEPTS COVERED

- ❏ Importing text
- ❏ Flowing text
- ❏ Master pages
- ❏ Style sheets
- ❏ Page numbering

REQUIREMENTS

- ❏ A Microsoft Word file with a story at least five pages long. If you don't have your own, go to:

 http://www.delmarlearning.com/companions/projectseries

 to find files to download.

RESULT

- ❏ The story laid out over several pages

PROCEDURES

1. Start the layout
2. Add a text highlight
3. Design a corner
4. Add another corner and page numbers
5. Get the story
6. Redesign the first page
7. Design some styles
8. Apply the styles
9. Quote the quotes

PROCEDURE 1: START THE LAYOUT

1. From the **File** menu choose **New, Document.**

2. Set **Height** to **10** inches and **Width** to **8** inches. Put a check in the **Facing Pages** check box, setting **Inside** to **1** inch and the other three margin values to **.5** inch.

3. Put a check in the **Automatic Text Box** field. Set **Columns** to **2** and **Gutter Width** to **.2**.

 These settings will create a page automatically broken into two text boxes, with one-fifth of an inch in between.

4. Click **OK**. Your document appears.

5. From the **View** menu choose **Fit in Window** so that the full page is displayed.

6. Go to the document layout palette. If you're using Macintosh, click the words **A-Master Page.** If you have Windows, you have to *double-click* (click twice rapidly). The words become selected.

If you don't see the document layout palette, go to the **View** menu and choose **Show Document Layout.**

7. Type **Standard page** then press the **Enter** or **Return** key. The words change to *A-Standard page.*

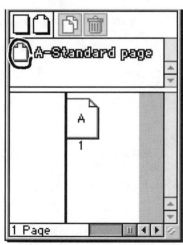

Each master page has a one-letter label (A) and a name (Standard page). What you just did changed the name but not the label. If you had typed *Z-Standard page,* the label would have changed to *Z* and the name would have changed as well.

8. Double-click the page icon to the left of **A-Standard page**. A pair of pages is displayed.

Master pages hold the basic design of a page. By putting standard elements such as page numbers and decorations on master pages, you don't have to put them separately on every page you design. When you create a document with the facing pages option turned on, each master page holds separate designs for left-hand and right-hand pages.

Procedure 2: Add a text highlight

1. Get the **Oval Text Box** tool from the tool palette.
2. While holding down the **Shift** key drag a circle into place on the upper half of the left-hand page. Make it about 3 inches across, with its center overlapping the margin between the two columns.

3. On the color palette click **Red**. The circle turns red.
4. From the **Item** menu choose **Modify**. A dialog box opens.
5. Click the **Text** tab, set **All Edges** to **10 pt.**, then click **OK**.

> This sets the distance between the edges of the circle and the edges of the text it holds inside. This way, the text won't come too close to the edge.

6. If the **Content** tool isn't selected, get it from the tool palette.
7. From the **Style** menu choose **Character**. A dialog box opens. Set **Font** to **Arial Black, Size** to **18 pt., Color** to **White,** and select the **Shadow** option then click **OK**.
8. From the **Style** menu choose **Alignment, Centered**.
9. From the **Item** menu choose **Duplicate**. A second copy of the circle appears overlapping the first.
10. Use the **Item** tool to drag the copied circle over to the right-hand page of the master page layout, placing it in the lower half of the page, centered between the two text columns.

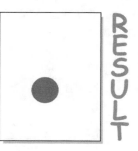

RESULT

PROCEDURE 3: DESIGN A CORNER

1. Use the **Rectangular Picture Box** tool with the **Shift** key held down to drag a small square in the lower-left of the left-hand page, below and to the left of the margins.
2. Set the background color of this box to yellow.
3. From the **Item** menu choose **Content, None.**
4. Return to the **Item** menu and choose **Step and Repeat.** A dialog box opens up.

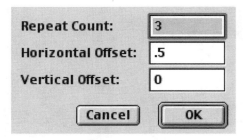

Repeat Count:	3
Horizontal Offset:	.5
Vertical Offset:	0
	Cancel OK

5. Set **Repeat Count** to **3, Horizontal Offset** to **.5** inch, and **Vertical Offset** to **0**, then click **OK**. There are now four squares (one original plus three copies) in a row, with the centers one-half inch apart.
6. Click on the original square to select it.
7. Do the **Step and Repeat** command again, only with **Horizontal Offset** set to **0** and **Vertical Offset** set to **–.5**. Three more squares appear trailing up from the first square.

 Measurements in QuarkXPress measure distance down and to the right. As such, a negative value moves the repetition up the page.

PROCEDURE 4: ADD ANOTHER CORNER
AND PAGE NUMBERS

1. The topmost square is selected. Hold down the **Shift** key and click on each of the other squares to select them as well.

 When selecting, the shift key tells QuarkXPress to select these items in addition to what's already selected. Clicking an already-selected item with the shift key held down deselects it.

2. From the **Item** menu choose **Group**. A rectangle appears around all the previously selected squares.

 This command took the selected items and turned them into a *group*, which you can treat as a single item.

3. Return to the **Item** menu and choose **Duplicate**. A second set of squares appears.

4. Use the **Rotation** tool as shown in Project 3, Procedure 2 to rotate the duplicated squares 180 degrees (one-half turn).

5. Drag the rotated group of squares into the upper-right corner of the right-hand page.

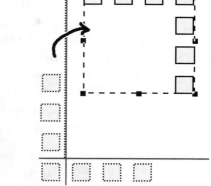

6. Get the **Orthogonal Text-Path** tool and drag a short horizontal line in the lower margin of the left-hand page, near the very bottom of the page, near the center.

 This tool makes text paths that are horizontal, vertical, or at a 45 degree angle.

7. Get the **Content** tool.

8. Using the **Style** menu, set the **Font** to **Helvetica** or **Arial**, the **Size** to **8 pt.**, **Type Style** to **Italic,** and **Alignment** to **Centered**.

9. If you're using Windows, hold down **Ctrl** and press **3**. If you're using a Macintosh, hold down the ⌘ key and press **3**. A small <#> appears on the line.

 This is the code for *page number.*

10. Repeat steps 6 through 9 for the other page of the master.

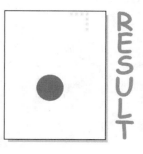

RESULT

PROCEDURE 5: GET THE STORY

1. If you have an Internet connection, bring up:

 http://www.delmarlearning.com/companions/projectseries

 on your Web browser and follow the directions there for downloading the story. If not, you'll have to use a WordPerfect or Microsoft Word file of your own.

 Any word processor you have can probably save in Word format.

2. Return to QuarkXPress.

 If you're using Windows, you can switch between programs using the buttons on the bottom of your screen. If you're using a Macintosh, click the symbol on the right end of your menu bar to get a menu of currently running programs.

3. Go to the document layout palette and double-click on the icon for page **1**. The page is displayed.

4. Click the **Content** tool on one of the two text columns.

5. From the **File** menu choose **Get Text**. A file browser opens up. Locate and select your story file.

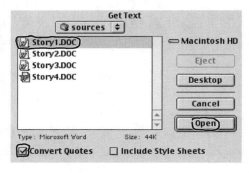

6. Select the **Convert Quotes** option.

 This replaces the "straight quotes" in some documents with "curly quotes."

7. Click **Open**. The text appears in your document. New pages appear in your document layout until there are enough pages to contain the entire story, because you selected the automatic text box option when you made the document. On screen the text may be too small to show clearly, so it may be *greeked* (shown as gray pattern bars without detail).

 If QuarkXPress has a problem reading your file, it's probably because your word processor saved the file using a *fast save* option, which creates muddled files. Open the file in your word processor, turn off the fast save option, save again, and close the file. Go back to step 5 and try again.

PROCEDURE 6: REDESIGN THE FIRST PAGE

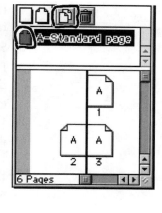

1. On the document layout palette, click the icon to the left of **A-Standard page.** The master page becomes selected.

2. Click the **Duplicate** button. An entry marked *B-Master Page* appears on the master page list.

3. Using the technique from Procedure 1, give this new master page the name **First page.**

4. Double-click the icon for this new master page. The master page is displayed. It should come as no surprise that it looks like the master you just duplicated.

5. Delete the circles by clicking the **Item** tool on one, going to the **Item** menu and choosing **Delete**, then repeating this maneuver for the second circle.

6. Use the **Rectangular Text Box** tool to create a single text box covering the top third of the two text columns on the left-hand page.

7. Set the **Font** for the text box to **Comic Sans MS**, the **Size** to **48 pt.**, and the **Alignment** to **Centered**.

8. Using the same technique that you used to copy the circle in Procedure 2, make a copy of this text box and put it in the same position on the right-hand page.

9. On the document layout palette, drag the **B-First page** icon onto page **1.** The first page appears, with no circle and no text in the top third.

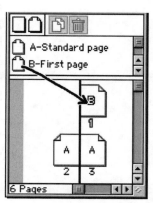

TIP You may need to use the scroll bar on the right of the palette to find page 1.

10. Click the **Content** tool on the top third of the page and type a title for your story.

Nat Gertler, Movie Star (well, Extra)

RESULT

PROCEDURE 7: DESIGN SOME STYLES

1. Using the **Content** tool, click four times quickly on the story's first paragraph. The paragraph becomes selected.

2. Set the **Font** to **Helvetica** or **Arial** and the **Size** to **13 pt.**

3. From the **Edit** menu choose **Style Sheets**. A dialog box opens.

4. Click the **New** button and choose **Character** from the menu that appears.

5. Another dialog box appears. Into the **Name** field type **Story text** then click **OK**.

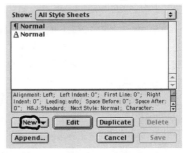

 This creates a *character style sheet*, which stores the font, size, style, and color settings under the name you selected so that you can recall them later.

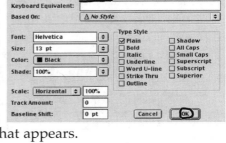

6. The second dialog box closes. Click the **New** button again, this time choosing **Paragraph** from the menu that appears.

7. A dialog box opens. Dialog boxes are your friends. In the **Name** field, type **Body** then click the **Formats** tab.

8. Set **First Line** to **.2** inch, **Space After** to **.1** inch, and **Alignment** to **Justified**.

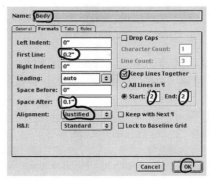

 First line sets the indent at the start of the paragraph, and *space after* puts space between paragraphs. **Justified** keeps both edges of the text straight.

9. Put a check in the **Keep Lines Together** check box, and set both **Start** and **End** to **2.**

 This makes sure that a column doesn't end with the first line of a new paragraph, or start with the last line of an old one.

10. Click **OK** to close this dialog box, and click **Save** to close the list of style sheets.

PROCEDURE 8: APPLY THE STYLES

1. From the **Edit** menu choose **Select All**. All the text in your story becomes selected.

 When working in a text box, the select all command selects all the linked text. If you're not working with a text box, the command selects all items on the current page.

2. Go to the **Style** menu and choose **Paragraph Style Sheet, Body.** All of the settings that you stored in Procedure 7 are applied to the text.

 The settings you stored in your character style sheet are applied as well as the ones in the paragraph style sheet. This is because the paragraph style sheet remembers what the current character style is and makes that part of the style.

3. Click four times quickly on the first paragraph to reselect it.

4. From the **Style** menu choose **Formats**. A dialog box opens.

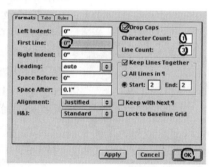

5. Set **First Line** to **0**. Put a check in the **Drop Caps** check box and set **Character Count** to **1** and **Line Count** to **3**.

6. Click **OK**. The first character of the paragraph turns large. That's your *drop cap.*

7. From the **Edit** menu choose **Style Sheets**. On the dialog box that appears, click **New** and choose **Paragraph** from the menu that appears. Another dialog box arises.

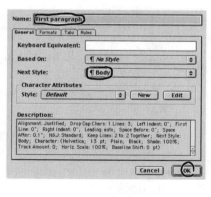

8. In the **Name** field type **First paragraph.**

9. From the **Next Style** drop menu choose **Body.**

 With this setting, if you set the first paragraph style and then add text, all of the following paragraphs will be in the body style. This way, only the first paragraph has the drop cap.

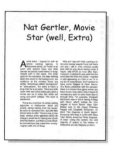

Nat Gertler, Movie Star (well, Extra)

R E S U L T

10. Click **OK** to close this dialog box, then click **Save** to close the style sheet list.

PROCEDURE 9: QUOTE THE QUOTES

1. Double-click page **2** on the document layout palette to go to that page.

2. Click the **Content** tool on the circle.

3. Using the same technique from Procedure 7, create a character style sheet named **Quote** for **18pt. Arial Black** with **White** color and a **Shadow** style.

 You're about to copy and paste some of your text into this circle. The text you'll be copying will have its own style. Because you've made this style sheet, you'll be able to restore the circle's style.

4. Find an interesting phrase or short sentence on this page, no more than 10 words. Point to the left of the first letter of the phrase and drag to the right of the last letter. The text becomes selected.

 luck of not being much of a type; there is no shortage of 30-something white guys and I'm not menacing, not.

5. From the **Edit** menu choose **Copy**. The selected text is copied onto the clipboard.

6. Click in the circle on this page.

7. Go to the **Edit** menu and choose **Paste**. The copied text appears in the circle.

8. Return to the **Edit** menu and choose **Select All**. The quoted text becomes selected.

9. Go to the **Style** menu and choose **Character Style Sheet, Quote**. The text style switches to the style you designed for the circle.

 Space is added to the text to make it fit the width of the circle. That's because the alignment is part of the paragraph style. Because you saved only the character style, the quote has the same alignment as the text you pasted.

10. Repeat steps 4 through 9 for the rest of the pages of the story, picking a good quote from each page.

11. Save the file under the name **Story,** then go to the **File** menu and choose **Close**.

PROJECT **5**

BUILD A BOOK

CONCEPTS COVERED

- ❑ Templates
- ❑ Books
- ❑ Ordering chapters
- ❑ Checking spelling
- ❑ Lists

REQUIREMENTS

- ❑ The story file you saved in Project 4, plus another Microsoft Word or WordPerfect file with a story at least five pages long. Go to:

 http://www.delmarlearning.com/companions/projectseries

 to find files to download.

RESULT

- ❑ A book made up of chapters in different files

PROCEDURES

1. Create a template
2. Story II: the sequel
3. Catch your "erorrs"
4. Be a bookmaker
5. Stop being listless
6. Make lists for all chapters
7. Build a contented page
8. Set your tabs

PROCEDURE 1: CREATE A TEMPLATE

1. Using the technique from Project 3, Procedure 1, reopen the **Story** file you created in Project 4.

2. On the document layout palette click on page **3**.

 Most of the pages in the layout have a little *A* on them, but the first page has a *B*. That indicates which master page layout is used on that page.

3. Scroll down to the bottom of the layout, hold down the **Shift** key, and click on the last page. All of the pages from 3 to the end become selected.

4. Click the **Delete** button,which has a picture of the trash can on a Macintosh or an X in Windows. A dialog box appears, just trying to make sure that you know what you're doing. Click **OK** and the pages are deleted. If any pages remain after page 2 re-select and delete them.

5. Click the **Content** tool five times quickly on the main text of one of the remaining pages. The entire text of the story becomes selected.

6. Press the **Delete** key. The story disappears.

7. Using this same technique, delete the text from the circle on page **2**.

8. From the **File** menu choose **Save As**. A file browser appears.

9. From the **Type** drop menu choose **Template**. In the **Save Document As** or **File Name** field type **myformat**. Click **OK** and the template is saved.

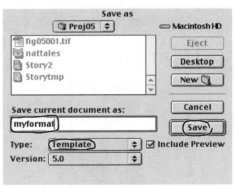

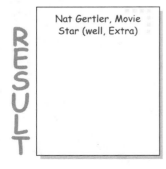

Nat Gertler, Movie Star (well, Extra)

R E S U L T

A DEEPER UNDERSTANDING: TEMPLATES

A template stores your design in a reusable file. That way, you can easily build new documents around the same layouts, style sheets, and colors.

PROCEDURE 2: STORY II: THE SEQUEL

1. Get another text file and flow it through your document as you did in Project 4, Procedure 5. Once again, new pages using the format of master A are automatically generated.

> New pages are automatically generated using the same master format as the last page that's already in place. That's why you kept two pages on the template. If you had only kept the first page, your entire document would have used master B, which is meant for first pages only.

2. Select the text of the story by clicking the **Content** tool on it five times quickly.

> Notice what gets selected with each click. The first click places the cursor where you click. The second click selects the word where you click. The third click selects the line of text, the fourth click selects the paragraph, and the fifth click selects the whole story.

3. From the **Style** menu choose **Paragraph Style Sheet, No Style.**

> This clears all the word processor style settings. If you try setting a new style without clearing those settings first, you'll likely end up with a mix of those two styles.

4. From the **Style** menu and choose **Paragraph Style Sheet, Body.**

5. Go to page **1** and select the first paragraph by quadruple-clicking on it.

6. Head back to your friendly neighborhood **Style** menu once again and choose **Paragraph Style Sheet, First Paragraph.**

7. Select the title on the first page, then type a title for this second story.

8. At the bottom of the window is an area marked Page 1. Click the right arrow button to the right of that and select page **2** from the list that appears. The second page is displayed.

> This is usually a quicker way of switching pages than going to the document layout.

9. Select a quote from each page and put it in the page's circle as you did in Project 4, Procedure 9.

PROCEDURE 3: CATCH YOUR "ERORRS"

1. From the **Utilities** menu choose **Check Spelling, Document**. After a brief pause, a dialog box opens up telling you how many words you've used.

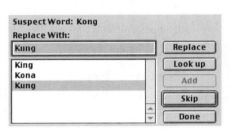

2. Click **OK** or **Close**.

3. The dialog box disappears and another may appear if the program thints it found spelling errors. The new dialog box shows a *suspect word*, a word in your document that QuarkXPress didn't find in its dictionary. If the word is actually spelled correctly, click **Skip** to move on to the next word, or . . .

4. If you have a word misspelled but the program suggests a correct spelling on the list below, click the right spelling on the list and then click **Replace**, or . . .

5. If you misspelled the word but the right word is not on the suggested list but you know the right spelling, type the correct version into the **Replace with** field, then click **Replace**, or . . .

6. If you misspelled the word and there are no right suggestions, type another guess at spelling into the **Replace With** field then click **Look up**. A list of words similar to what you entered will be listed. You can select one of those and click **Replace** or you can try another guess.

As the program displays each word, it advances the document to display that word in its context, making it easier to figure out what you meant to say.

7. Once you've corrected one word, the dialog box will display another. Repeat this process until you correct the final problematic word, at which point the dialog box disappears.

8. Save the file under the name **Story2**.

Nat Versus the
Invisible Giant
Monkey

PROCEDURE 4: BE A BOOKMAKER

1. From the **File** menu choose **New, Book**. A file browser opens up.

2. In the **Book Name** field type **mytales**. Select the folder for the book file then click **Create**. A new palette called the *book palette* opens up.

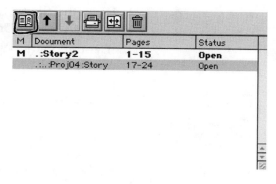

3. Click the **Add Chapter** button on the book palette. A file browser opens up.

4. Using the file browser, locate and select the **Story2** file you saved in Procedure 3.

5. Click **Add**. The Story2 file is now listed on your book palette, which means it's a chapter in the book.

6. Without closing any files, open up the **Story** file you created in Project 4.

 When you have more than one file open, you can easily bring the one you want to the front. If you're using a Macintosh go to the **View** menu, choose **Windows**, then select the document you want from the submenu that appears. If you're using Windows go to the **Windows** menu and choose the document.

7. Check the spelling of the story file as you did in Procedure 3.

8. From the **File** menu choose **Save** to save the spelling corrections.

9. Repeat steps 3 through 5 to add the story file as a chapter in your book.

 Adding a chapter to your book sometimes fails to work if the chapter is not currently open. It's better to open up the file and then add it.

10. On the book palette, click the entry for the **Story** chapter then click the **Move Chapter Up** button to make that the first chapter in the book.

Nat Gertler, Movie Star (well, Extra)

RESULT

PROCEDURE 5: STOP BEING LISTLESS

1. From the **View** menu choose **Show Lists**. A new palette opens up.

2. From the **Show List For** drop menu choose **Current Document**.

3. If you're using Windows, right-click on the blank area at the bottom of the palette. If you're using a Macintosh, hold down the **ctrl** key and click on that area. A menu appears.

4. Choose **New List** from the menu. A dialog box appears.

5. In the **Name** field type **Table of Contents**.

6. In the **Available Styles** list are two entries marked **Normal**. Click the one with the *A* symbol next to it.

 This is list of all your style sheets. The ones marked with an *A* are character style sheets, whereas the ones marked with the backwards *P* are paragraph style sheets. *Normal* is the default style for both characters and paragraphs. However, you have changed the character style for all the text in your documents except the titles, so building a list of the titles alone will make a table of contents.

7. Click the right arrow button between the two lists. The normal character entry moves from the *available styles* list to the *styles in list* list.

8. Some of the column titles on the *styles in list* list are actually menus. From the **Numbering** menu choose **Text....Page #** so that the table of contents lists the titles and page numbers. From the **Format As** menu choose the **Body** paragraph style sheet for the look of the table of contents.

9. Click **OK**. The title of the story of the currently selected document appears on the palette.

 When you originally create a list, it only applies to one document. When your document is a chapter, this gives you a rather small table of contents, but soon you'll see how to make a list that covers more documents.

RESULT

Nat Gertler, Movie Star (well, Extra)

PROCEDURE 6: MAKE LISTS FOR ALL CHAPTERS

1. Go to the book palette. While holding down the **Shift** key, click on the entries for both documents in the book. Both documents become selected.

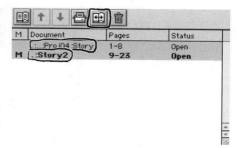

2. Click the **Synchronize** button.

 The *synchronize* feature helps you share style sheets, list designs, and other settings between the documents in your book.

3. A dialog box opens, as dialog boxes are wont to do. Click the **Lists** tab.

4. On the **Available** list, click **Table of Contents**.

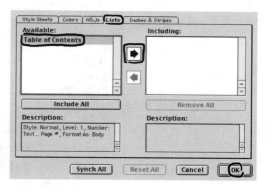

5. Click the right arrow button. The table of contents entry is transferred from the *available* list to the *including* list to show that this list design will be synchronized.

6. Click **OK**. The dialog box closes. If another dialog box opens asking you if it's okay to synchronize other things, click **OK** on that dialog box as well.

7. On the lists palette, set **Show List For** to **mytales** and **List Name** to **Table of Contents**.

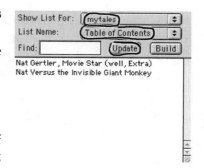

8. Click **Update**. A list of chapter titles appears on the palette.

A DEEPER UNDERSTANDING: LISTS

Lists can be used for more than just a basic table of contents. If your book has pictures of sandwiches with captions naming each sandwich, you can create a reference listing all the sandwiches pictured. You'd just have to make sure that the captions use a different paragraph style sheet than anything else in the book. This is part of why creating style sheets for each element is vital.

RESULT

PROCEDURE 7: BUILD A CONTENTED PAGE

1. From the **File** menu choose **New, Document**. In the dialog box that opens, set **Columns** to **1,** select the **Automatic Text Box** option and click **OK**. Now you have a new document with pages the same size as the previous document.

2. Click the **Content** tool on the text box.

3. Use the **Style** menu to set the **Alignment** to **Centered** and the **Size** to **18 pt.**

4. Type **Table of Contents**, then press the **Enter** or **Return** key twice to skip a line.

5. Go to the lists palette and click the **Build** button. The table of contents appears on the page.

6. Save this file, giving it the name **StoryTOC**.

7. Use the techniques from Procedure 4 to add this document to the book, making it the first chapter.

8. On the lists palette, click the **Build** button again. A dialog box opens.

9. Click **Replace**. The contents listing is updated with the page numbers that are two numbers higher.

You only added one page, but the program knows that you started each chapter on a right-hand page. It, therefore, assumes that there's a blank left-hand page between the table of contents and the first chapter.

A DEEPER UNDERSTANDING: TABLE OF CONTENTS

The book you're reading now is laid out using QuarkXPress. All the project names use one style sheet, and the procedure titles use another. The table of contents is just a list that includes both of those styles. The list design dialog box has a column marked *levels*. The level value for the project title is set to 1, and for the procedure titles it is set to 2. Look at the table of contents of this book and see the results that are achieved.

PROCEDURE 8: SET YOUR TABS

1. From the **Edit** menu choose **Select All** to select all the text on the table of contents page.

 When working in a text box, the select all command selects all the linked text. If you're not working with a text box, the command selects all items on the current page.

2. From the **View** menu choose **Fit In Window** to ensure that you can see the full page width.

3. Go to the **Style** menu and choose **Tabs**. A dialog box opens up, but that's not the only thing that happens. Look at the document and you'll see that a new ruler appears right above the text box, in addition to the one that's on the very top of the window.

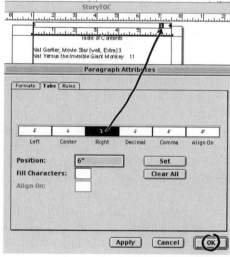

4. On the dialog box is a series of little down arrows, each with a name under it. Drag the **Right** arrow from the dialog box up to the **6"** mark on the ruler.

 As you drag the arrow, the *position* field in the dialog box shows you its current location, making it easier to hit the 6" mark exactly.

5. Click **OK**. The dialog box closes. The page numbers of the list move to the 6" mark.

 The list has an invisible tab character between the text and the page number. Those characters move the following text to the next tab location. Because you didn't have any tab settings, the program assumed there were several tabs per inch. Now that you've set a *right* tab stop, the program moves the right end of the tabbed text to the location.

6. Click the **Close** button on the book palette's title bar (the bar at the very top). If you're using Windows, it's a little button with an X on the right end. If you're using a Macintosh, it's a little square on the left end. A series of dialog boxes opens up, first warning you that this will close all your documents, and then asking if you want to save changed documents. Click **OK** or **Yes** on all the dialog boxes.

RESULT

PROJECT 6

BOOKENDS FOR YOUR BOOK

CONCEPTS COVERED

❑ Indices
❑ Sections

REQUIREMENTS

❑ The book you saved in Project 5

RESULT

❑ The book will have a title page and an index.

PROCEDURES

1. Add opening pages
2. Give the book a title
3. Enumerate, Roman style
4. Start being indexterous
5. Select your index items
6. Place your index
7. Update your contents

PROCEDURE 1: ADD OPENING PAGES

1. From the **File** menu choose **Open**. A file browser opens.

2. Locate and select the **mytales** book file that you created in Project 5. Click **Open**. The book palette opens, listing the files in your book.

3. On the book palette, double-click the entry for **StoryTOC**. The table of contents file opens.

4. From the **Page** menu choose **Insert**. A dialog box opens.

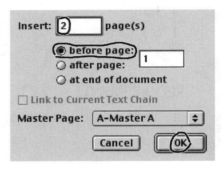

 If the page menu is grayed out just click anywhere on the page. The menu should now be available.

5. Set **Insert** to **2** pages and select the **Before page** option.

 You're only going to add one page of content, the title page, which is the first page of most books. However, the first page is always a right-hand page, and most books are designed so that the table of contents is on a right-hand page. By adding two pages, you're putting a blank left-hand page between the title page and the table of contents.

6. Click **OK**. Two pages are added to the start of the document.

. .

A DEEPER UNDERSTANDING: ADDING PAGES

You've now added pages using three different techniques. The simplest was when you got the text to your stories, and the pages to hold the story were generated automatically. When you want to add a single page, dragging in pages on the layout palette is both quick and easy. When you want to add a batch of pages all at once, however, using the page menu is the way to go. It can add as many pages as you want, anywhere in the document, although they will have to all follow the same master.

PROCEDURE 2: GIVE THE BOOK A TITLE

1. The blank first page is now facing you. It has a big text box running from margin to margin. Click the **Content** tool in this text box to place your cursor.

2. Using the **Style** menu, set the **Font** to **Impact**, **Size** to **60 pt.**, **Alignment** to **Centered**, and **Character Style Sheet** to **No Style**.

3. Type **EXTRA:** then press return and type **Read All About It.**

4. From the **Item** menu choose **Modify**. A dialog box opens.

5. Select the **Text** tab and set **Text Skew** to **–10** degrees.

 Text skew makes the text lean, somewhat like italicizing it. However, you can select the angle you want the text to lean. Setting a negative value causes it to lean to the left.

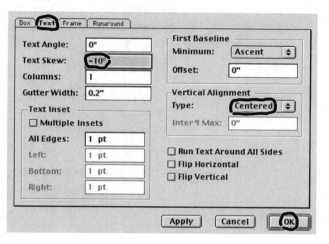

6. In the **Vertical Alignment** area, set **Type** to **Centered.**

 This moves the text down to the center of the text box.

7. Click **OK**.

EXTRA:
Read All About It

RESULT

PROCEDURE 3: ENUMERATE, ROMAN STYLE

1. On the book palette, double-click the **Story** entry. The first chapter document opens up.

2. From the **Page** menu choose **Section**. A dialog box opens up.

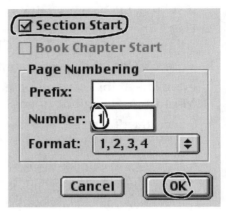

3. Put a check in the **Section Start** check box and set **Number** to **1**.

4. Click **OK**. If you look at the *pages* column on the book palette, you'll see that the page numbering now restarts at the start of the first chapter.

 On most books, the first page of the main text is page 1. If the pages before that are numbered, they are numbered using lowercase roman numerals.

5. On the book palette, double-click the entry for **StoryTOC**. The document with the title page and the table of contents comes forward.

6. From the **Page** menu choose **Section** again.

7. Put a check in the **Section Start** check box and set **Format** to **i, ii, iii, iv**.

8. Use the method from Project 4, Procedure 4 to add page numbers on the lower outside corners of this document.

Table of Contents

RESULT

PROCEDURE 4: START BEING INDEXTEROUS

1. On the book palette, double-click the **Story2** entry. The first chapter document opens up.

 Because Story2 was the first chapter placed in the book, it's considered the *master document* for the book. When you want to add style sheets or other attributes that you want to spread to other documents, you should add them to the master document and then synchronize them to the other documents from there.

2. From the **Edit** menu choose **Style Sheet**. A dialog box opens.

3. Click the **New** button and choose **Character** from the menu that appears. The character style sheet dialog box opens.

4. In the **Name** field type **Main index**. Set **Font** to **Helvetica** or **Arial, Size** to **10 pt.**, **Style** to **Plain**, and click **OK**.

5. On the style sheets dialog box, click the entry for **Main index** then click **Duplicate**. The settings dialog box opens.

6. Set **Name** to **Name index, Based On** to **Main index**, **Style** to **Bold**, and click **OK**,

7. Click **Save** to close the style sheet dialog box.

8. Start a new blank document with **3** columns, save it under the name **Index**, and add it to the end of your book using the technique from Project 5, Procedure 4.

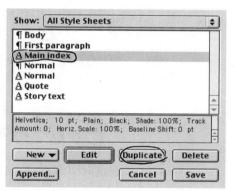

9. On the book palette select all four documents and open up the synchronization dialog as you did in Project 5, Procedure 6. A dialog box opens up.

10. Click **Include All** then click **OK**. If another dialog box opens up, click **OK** on that as well. All of the style sheets, including the two new index style sheets, are synchronized.

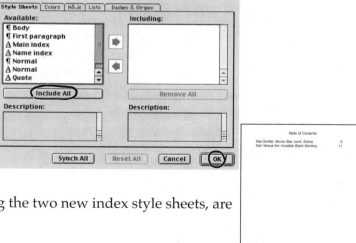

PROCEDURE 5: SELECT YOUR INDEX ITEMS

1. Use the **View** or **Windows** menu to bring the first story to the front.

2. In the story, locate a word that you want to include in your index. Select that word by double-clicking the **Content** tool on it.

3. From the **View** menu choose **Show Index**. The index palette opens up.

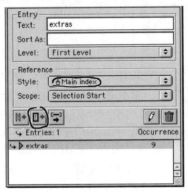

4. Set the **Style** drop menu to **Main Index**. This is the style that this entry will appear in on the index.

5. Click the **Add All** button. Every appearance of that word in the current document will be added to the index.

 The colored brackets that appear around the term in the document when you do this are just to show you that the term has been indexed. The brackets will not show up in your printed document.

6. In the document, locate a title or the name of a person or place. Select it by dragging the **Content** tool across it.

7. On the index palette set **Style** to **Name index.**

8. Click the **Add** button.

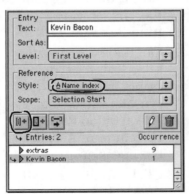

 This adds the currently selected appearance of the text to the index without adding all other appearances of the same term.

9. Use these techniques to index all the terms you want to include from this chapter.

10. From the **File** menu choose **Save** to save this chapter with its index information.

Procedure 6: Place your index

1. Bring the second story to the front.

2. Use the techniques from Procedure 5 to index this chapter then save it.

 Each document has its own index list.

3. Bring the index document to the front.

4. Go to the **Utilities** menu and choose **Build Index**. A dialog box opens.

5. Put a check in the **Entire Book** check box.

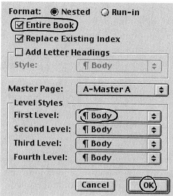

 Without this option, only the index from the current document would be placed. Because the current document is currently blank, that would be mighty pointless.

6. Set **First Level** to **Body**.

 This is the text that the index entries will appear in.

7. Click **OK**. The index appears. Notice that the page numbers for the proper nouns are in bold, because those are the ones you used for the name index character style. The other page numbers use the main index character style.

8. Drag a text box covering about the top quarter of the page, and put the word **Index** in it. Use the **Normal** character style, with the word right in the center of the text box using the technique from Procedure 2.

A DEEPER UNDERSTANDING: INDEX LEVELS

Your index can have subtopics. For example, you can have a section of your index for *buffalo*, with listings under that for *raising buffalo, running from buffalo,* and *buffalo wings.* To create a second level entry, use the index palette to add a **buffalo** entry to the index. Then select **buffalo wings** in your document, set the **Level** drop menu to **Second Level**, click **buffalo** on the list on the bottom of the index palette, and then click **Add**.

RESULT

PROCEDURE 7: UPDATE YOUR CONTENTS

1. Check the first page of the index document. If it's blank, go to the **Page** menu and choose **Delete**, then click **OK**. The blank page is deleted, so the document begins with the start of the index.

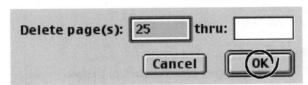

2. Using the techniques from Project 5, Procedure 6, select all of the documents in the book and synchronize the table of contents list into all of the documents.

3. Go to the lists palette and set **Show Lists For** to **mytales** and **List Name** to **Table of Contents.**

 > Remember, if the palette isn't open, go to the **View** menu and choose **Show Lists** to open it.

4. Click the **Update** button to update the list.

 > If one of your chapter titles is broken up into several parts on the list, this is because one of the title words was indexed. The program doesn't handle this well. There is a proper way to fix this and an easy way to fix this. The easy way is to go to the file with the problem chapter, select the indexed words in the title and retype them, then click the **Update** button again. And if you know the easy way, who needs the proper one?

5. Go to the **StoryTOC** document and drag the **Content** tool from the beginning to the end of the current table of contents.

6. On the lists palette click **Build**. In the dialog box that opens click **Replace**. The updated list replaces the old one. You'll probably need to reset the tab setting as you did in Project 5, Procedure 8.

7. Click the **Close** button on the title bar of the book palette. Click **OK, Yes,** or **Save** on all the dialog boxes that appear as all the documents are closed. You now have a short book with a disproportionately long and unnecessary table of contents and index!

PROJECT 7
BOOK JACKET

CONCEPTS COVERED

- ❏ Points
- ❏ Segments
- ❏ Stacking
- ❏ Runaround
- ❏ Resizing

REQUIREMENTS

- ❏ The photo you used in Project 1

RESULT

- ❏ A dust jacket for a hardcover edition of your book

PROCEDURES

1. Lay out the cover
2. A balloon of text
3. Tail of the balloon
4. A twist of the tail
5. Smooth curves
6. noollab is balloon backwards
7. A spray of balloons
8. Shuffle more balloons
9. Straighten up your spine
10. Flap the ends

PROCEDURE 1: LAY OUT THE COVER

1. Create a new document with **Width** set to **22** inches, **Height** set to **10.5** inches, and the **Facing Pages** option turned off. Set the top and bottom margins to **0**, and the **Left** and **Right** margins to **2** inches. Turn off the **Automatic Text Box** feature, set **Columns** to **2**, and the **Gutter Width** should be **1** inch.

 You're not actually going to use the columns for text on this cover design. By setting the values as you do here, you're actually creating one column for the front of the book and another column for the back of the book. The inch between the two columns is the spine, which is ridiculously thick for the booklet you've created, so I guess it's being printed on paper as thick as baloney slices. The space in the side margins is actually for the *end flaps*, the parts of the dust jacket that fold over and go inside the front and back covers of your book.

2. From the **View** menu choose **Fit in Window** so that the whole cover is visible.

3. Get the **Rectangular Picture Box** tool.

4. Drag from the upper-left of the left column to the lower-right of the right column. The picture box covers the back cover, the front cover, the spine, but not the end flaps.

5. On the **Color** palette, click **Red**. The box becomes red.

6. On the **Item** menu, set **Content** to **None**. The big X across the picture box disappears.

 That X indicated that you were expected to place a picture there.

7. Repeat steps 3 through 6, except start the drag from the upper-right of the left column and end at the lower-left of the right column, so the rectangle covers the spine. Color this rectangle black.

RESULT

PROCEDURE 2: A BALLOON OF TEXT

1. Get the **Rounded-corner Text Box** tool.

2. As you move your pointer, markers on the top and side rulers indicate where on the page you're pointing to. Point to the location **14** inches from the left and **5** inches from the top, then drag to the point **19.5** inches from the left and **9** inches from the top. The text box appears.

3. Set the **Font** to **Comic Sans**, the **Size** to **60 pt.**, the **Style** to **Italic,** and the **Alignment** to **Centered**.

4. Type **EXTRA! READ ALL ABOUT IT!**

5. From the **Item** menu choose **Modify**. A dialog box appears.

6. On the **Box** tab set the **Origin Across** to **14** inches, the **Origin Down** to **5** inches, the **Width** to **5.5** inches and the **Height** to **4** inches.

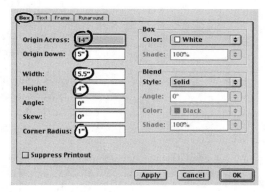

 These are the measurements and placement you were trying to create when you dragged. Typing the values in lets you adjust for any slight error in your drag.

7. Set **Corner Radius** to **1** inch for big rounded corners.

8. Click the **Text** tab and set **All Edges** to **20 pt.**

 This makes sure that the text stays at least 20 points away from the edges of the text box.

9. Click the **Frame** tab and set **Width** to **4 pt.**

10. Click **OK**. The changes are applied to the dialog box.

PROCEDURE 3: TAIL OF THE BALLOON

1. With the text box still selected, go to the **Item** menu and choose **Shape**. The submenu that appears shows a list of shapes. Click on the one that looks like a dented oval.

 Most of the selections on this menu would actually change the shape of your text box to match the pictured shape. This selection, however, merely says that you don't want to work with a predesigned shape. You'll start with the same rounded rectangle you had, but you'll now be able to edit that rectangle.

2. Return to the **Item** menu and open up the **Edit** submenu. If there is a check mark next to the command *Shape*, just move your pointer away from the menu and release it so that no command is selected. If there is no check mark, click on **Shape**.

 The check mark indicates that you are in shape editing mode. If you don't have that check mark there, you can resize the current box but not change the shape of the outline. Selecting the command turns the shape editing mode on or off.

3. A series of outlined dots appear around the text box. QuarkXPress defines shapes as a series of points and the angle at which the outline enters and leaves those points. While holding down the Windows **Alt** or Macintosh **Option** key, put your pointer over the bottom edge of the shape, about midway across. The pointer turns into a circle. Click, and a new point is added to the shape.

4. Using this technique, add two more points, one about one-quarter inch to the left of the point you just added, the other about one-quarter inch to the right.

5. Drag the first point you placed down about 1 inch and about one-half inch to the left. Now you have a comic strip-style word balloon.

PROCEDURE 4: A TWIST OF THE TAIL

1. Use the **Zoom** tool to drag a rectangle around the entire *word balloon*. The word balloon is magnified, making it easier to work on.

 The zoom tool is used by dragging as you did here, or by clicking on a spot to *zoom in* (get a close-up look) on that spot, or by holding down the Windows **Alt** or Macintosh **option** key while clicking to *zoom out* (get a more distant view).

2. Get the **Content** tool and click on the right-hand edge of the *tail* you just added to the word balloon. The points at both ends of that edge change color to show they are selected.

3. From the **Item** menu choose **Point/Segment Type, Curved Segment.** Two more dots appear, attached to the points by line. These are the *curve handles.*

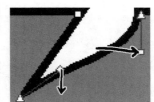

4. Drag the upper curve handle to the right, until it's directly under the point. The outline of the shape curves as if pulled magnetically toward the handle.

5. Drag the lower curve handle to adjust the bottom end of the curve to get it nice and smooth.

6. Using the same technique, curve the left edge toward the right to match the original curve.

A DEEPER UNDERSTANDING: THE TWO TYPES OF SEGMENT

A *segment* is the bit of line that connects one point of a box's outline to the next. A *straight segment* simply connects the two points with a straight line. A rectangular box, for example, is four straight segments connecting four points. A *curved segment* doesn't actually have to be curved. The moment you chose that curved segment command the program considered it curved, although a perfectly flat curve.

Points have types too. The difference between types is only significant when they have two curve handles. If a point connects two straight segments or one straight segment to a curved segment, it doesn't matter what kind of point it is.

RESULT

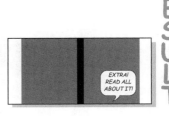

Procedure 5: Smooth curves

1. Click inside the word balloon.

 This deselects the selected segment of the edge. If you didn't do this, you couldn't select just one of the points on the edge; the other point would remain selected.

2. Click the point on the top of the tail's left edge to select it.

3. From the **Item** menu choose **Point/Segment Type, Symmetrical Point.** Two curve handles appear attached to the point, and the line takes a big, smooth path through the point.

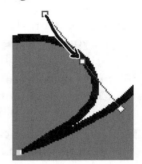

4. Drag one of the curve handles toward the point. As you do, the curve becomes tighter, and the other handle moves just as close to the point on the opposite side, maintaining the symmetry.

5. Using the same technique from Procedure 4, select the line segment to the right of the tail and convert it into a curved segment.

6. Select the point where the segment meets the tail.

7. From the **Item** menu choose **Point/Segment Type, Smooth Point.** Two curve handles appear.

8. Adjust the curve handles so that they're reasonably close to the point, making a smooth but tight curve into the tail.

A DEEPER UNDERSTANDING: THE THREE TYPES OF POINTS

If a point connects two straight segments, it doesn't matter what kind of point it is because there are no curves to adjust. If the point connects a straight segment to a curved segment, it still doesn't matter what type of point it is because you'll just have one curve handle, for the curved side. The type is only relevant for points connecting two curved segments. On a *symmetrical point* like the one on the left of the balloon tail, you adjust one curve handle and the other one mirrors its movement precisely, keeping an even, consistent curve. On a *smooth point* like the one on the right, the two curve handles are on the same line through the point but can be different distances from the point, so that the line passes smoothly through the point, however, the curve can get quickly tighter or looser as it passes through. On a *corner point* like the tip of the tail, the two curve handles can be moved completely independently, making sharp angles possible.

RESULT

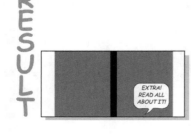

PROCEDURE 6: NOOLLAB IS BALLOON BACKWARDS

1. With the word balloon still selected, go to the **Item** menu and choose **Duplicate**. A second copy of the dialog box appears.

2. From the **Item** menu choose **Edit, Shape** to turn off the shape editing mode and go into the resizing mode. Sizing handles appear around the copied word balloon.

3. Point to the sizing handle on the center of the right edge and drag it until it's somewhere to the left of the left edge. The shape is reversed so that the tail points to the right rather than the left, but the text is still forward.

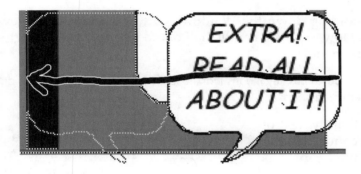

4. Go to the **Item** menu and choose **Modify**. A dialog box opens.

5. On the **Box** tab set the **Origin Across** to **2.5** inches, the **Origin Down** to **5 inches**, and the **Width** to **5.5** inches.

 This positions the balloon so it's on the back cover, in a mirror image position to the original position. You don't need to worry about the height, because you've done nothing to change it.

6. Click the **Text** tab and put a check mark in the **Flip Horizontal** box.

 This reverses the text mirror-backward.

7. Click **OK**.

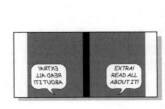

RESULT

PROCEDURE 7: A SPRAY OF BALLOONS

1. Using the technique from Project 4, Procedure 3, create four additional copies of the reverse balloon with a **Horizontal Offset** of **.5** inch and a **Vertical Offset** of **–1** inch.

2. With the top balloon selected, go to the **Item** menu and choose **Modify**. A dialog box opens.

3. On the **Box** tab set **Angle** to **–40** degrees then click **OK**. The word balloon is rotated, and the sizing handles are turned to match.

4. Use the scroll bar at the right to scroll up so that you can see the highest sizing handle. Get a good look at where that sizing handle is.

5. While holding down the Windows **Ctrl** or Macintosh ⌘ key, drag the lowest sizing handle half of the way toward the highest sizing handle.

 Holding down this key means that the text will be resized in proportion to the resized shape.

6. Notice that the text of the second balloon from the top has moved down to avoid being overlapped by the top balloon. The program does this to make sure that text isn't hidden by overlapping items; however, you actually want this text to be 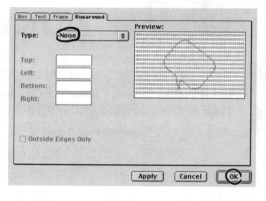 overlapped. With the top balloon still selected, go to the **Item** menu and choose **Runaround**. The modify dialog box opens.

7. Set the **Type** drop menu to **None**.

8. Click the **Box** tab, set **Color** to **White**, and click **OK**.

 When you remove the runaround, the program assumes that you want the item to have no fill. Computers make silly assumptions at times, and humans must correct them.

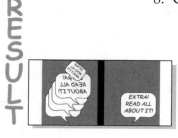

PROCEDURE 8: SHUFFLE MORE BALLOONS

1. Using the techniques from Procedure 7, take the second balloon from the top, rotate it **–30** degrees, shrink it to slightly larger than the top balloon, and set the runaround type to **None.**

2. Do the same thing to the next two balloons in the stack, setting them to **–20** degrees and **–10** degrees, respectively.

3. Select the forward balloon on the front cover and turn off its runaround, keeping the color white.

 By doing this now, you won't have to do it to every copy of this balloon once you copy it.

4. Step and repeat the balloon on the front cover, creating four copies with a **Horizontal Offset** of **–.5** inch and a **Vertical Offset** of **–1** inch.

5. Rotate the top balloon **40** degrees and resize it to match the size of the top balloon on the back cover. Similarly, rotate the lower balloons **30, 20,** and **10** degrees, resizing them to match the size of the balloons on the back cover.

6. With the fourth balloon from the top still selected, go to the **Item** menu and choose **Send to Back**. The balloon disappears.

 This command changes what item overlaps what other item. Because you sent this balloon to the back of the stack, it's now overlapped by the big red background.

7. Select and send to the back the third balloon from the top, then the second, and finally the top balloon.

8. Select the red background rectangle and send it to the back. The hidden balloons reappear.

A DEEPER UNDERSTANDING: STACKING COMMANDS

There are four stacking commands. On the item menu are the *send to back* command you just used and the *bring to front* command, which brings the selected item to the top of the stack. If you right-click an item on your Windows machine or hold down the **ctrl** key and click the item on your Macintosh, a pop-up menu appears with a *send & bring* submenu. There you will find *bring forward* to swap the item's stacking position with the item directly on top of it, and *send backward* to swap position with the item immediately below it.

R
E
S
U
L
T

PROCEDURE 9: STRAIGHTEN UP YOUR SPINE

1. Create a rectangular text box covering the spine.

2. Open up the modify dialog box.

 You can do this by going to the **Item** menu and choosing **Modify** as you have been doing, or by holding down the Windows **Ctrl** or Macintosh ⌘ key while double-clicking on the item you want to modify.

3. On the **Text** tab, set **Angle** to –90 degrees and **All Edges** to **0 pt.** then click **OK**.

 Angle measurements are counterclockwise. Rotating the angle of the text by –90 degrees tilts it so that it runs from the top of the spine toward the bottom.

4. Set the **Font** to **Comics Sans,** the **Size** to **36 pt.,** and **Color** to **Red**.

5. Type the title again in all capital letters.

6. Drag the lower-left corner of the text box up and to the right, making the box fit as closely as possible to the text without the text disappearing.

 You'll need to leave a little space to the left of the text. The program wants you to leave enough space for *descenders*, the dangly bits at the bottom of lowercase Y's, G's, and the like. It expects this space even if you don't have any lowercase letters.

7. While holding down the Windows **Ctrl** or Macintosh ⌘ key, drag the lower-left corner of the text box back down to the lower-left corner of the spine.

8. While holding down the **Ctrl** or ⌘ key again, drag the sizing handle on the center of the left edge of the text box toward the left. Drag it about the same distance as the blank space at the left of the text box. This will get the bottom of the text close to the edge of the spine.

9. On the color palette, click **None** to get rid of the text box background.

RESULT

PROCEDURE 10: FLAP THE ENDS

1. Add a text box on the end flap on the right. Enter text describing the book.

2. On the end flap on the left, add a text box with a made-up description of the author.

3. Save the file, naming it **Cover**.

4. From the **File** menu choose **Page Setup**. A dialog box opens.

5. On the **Document** tab, set **Tiling** to **Automatic** and **Overlap** to **2** inches.

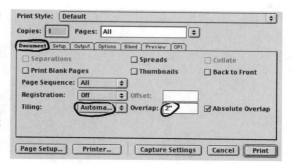

 This cover is too large for most small computer printers to handle. The tiling feature breaks the image up onto several sheets of paper, which you could then trim and paste together to make the cover.

6. On the **Setup** tab, choose the **Portrait** orientation option.

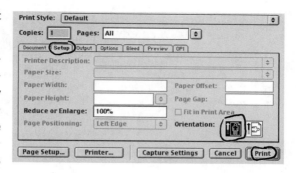

 You can build the cover from pages printed in either orientation. The portrait orientation will let the image cover one row of four pages, as opposed to the landscape orientation which will print the same cover on two rows of three sideways pages each. Fewer pages means less cutting, less pasting, and less waste.

7. Click **Print** and wait for the pages to come spilling out of the printer.

8. Get your scissors and your tape and build yourself a cover!

 You're going to have to trim the edges off of pages because most computer printers can't print all the way to the edge.

PROJECT 8
A CAR CARD

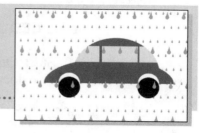

CONCEPTS COVERED

- ❏ Spot colors
- ❏ Building shapes
- ❏ Layers
- ❏ Measurement palette

REQUIREMENTS

- ❏ None

RESULT

- ❏ A postcard with a drawing of a car in the rain

PROCEDURES

1. Create permanent spot colors
2. Make a precise oval
3. A bumpy body with a flat bottom
4. Add some wheels
5. Cut some windows
6. Cut the glass
7. Start a new layer
8. Throw in a little rain
9. Throw in a big rain
10. Rearrange the rain

PROCEDURE 1: CREATE PERMANENT SPOT COLORS

1. Start QuarkXPress. If the program is already running, close any documents you have open.

 If you designate colors with a document open, they get stored as part of the document. If you designate colors while no documents are open, they get stored as part of the default list of colors that can be used in any new document.

2. From the **Edit** menu choose **Colors**. A dialog box opens up.

3. Click **New**. Another dialog box opens.

4. From the **Model** drop list choose **PANTONE Solid Uncoated.**

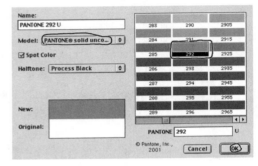

5. A scrollable list of colors appears on the right. Click the scroll arrow in the lower-right of the color list to move through the list of colors. When you find one that looks like the color of raindrops, click that color entry.

6. Click **OK.** The color is added to your list of colors with a name that begins with *PANTONE*, ends with *U*, and has a number in between.

7. Repeat steps 3 through 6, selecting a good color for a new car, then do it again and select the **Black** that is near the left end of the list.

8. Click **Save**. The default color dialog box closes.

A DEEPER UNDERSTANDING: SPOT COLORS

Until now you've worked with *process color*, colors that will be printed by mixing several set colors together, which is how full-color printing works. If you're mass printing something with just a couple of colors, however, full-color printing is imprecise and wasteful.

Spot colors are colors that will be printed using an actual ink of that color. The screen can't re-create a specific color exactly, but a serious graphic artist will buy Pantone Color Books, which show you thousands of printed colors with a number assigned to each. That way you can specify that your raindrops should be Pantone 292U and be confident that the color your print shop uses will match the color you found in the book.

PROCEDURE 2: MAKE A PRECISE OVAL

1. Start a new document, **6** inches wide and **4** inches high, with no margins and no automatic text box.

2. Get the **Oval Picture Box** tool and draw an oval on the image.

3. From the **View** menu choose **Show Measurements**. A measurement palette opens, displaying information about the size and placement of your oval.

> If you don't see the *show measurements* command on the list but you do see *hide measurements*, then this palette is already open.

4. On the palette, double-click the value next to **X** and type **2** to set the horizontal position to 2 inches from the left.

5. Hit the **Tab** key to move to the **Y** field and type **1** to set the vertical position to 1 inch from the top.

6. Press **Tab** again and enter **3** into the **W** field to set the width, then hit **Tab** one last time and set the **H** field to **2.5** to set the oval's height.

7. Press the **Return** or **Enter** key. The oval changes to match the settings you just entered.

8. Go to the color palette and click the new car color you chose.

A DEEPER UNDERSTANDING: THE MEASUREMENT PALETTE

The modify dialog box you used in the past has all the settings in the measurement palette and more, but if you leave the measurement palette open you can access the key size settings much more quickly.

The settings that you see on the right side of the palette are for the placement of a picture in this picture box. The palette always shows settings appropriate to the currently selected item.

RESULT

PROCEDURE 3: A BUMPY BODY WITH A FLAT BOTTOM

1. From the **Item** menu choose **Duplicate**. A second oval of the same size and color appears.

 Because you already had the oval selected, this is quicker than getting the tool again and drawing another oval. If you learn the keyboard shortcut, then the new oval would be just a key click away!

2. Using the method from Procedure 2, go to the measurement palette and set the dimensions for this copied oval. Set **X** to **1, Y** to **1.75**, **W** to **4.5**, and **H** to **1.75**.

3. While holding down the **Shift** key, click on the original oval. This selects the original oval without deselecting the copied oval, so now both are selected.

4. From the **Item** menu choose **Merge, Union**. The two selected items are combined into a single shape that covers anything that was in either of the two ovals.

5. Get the **Rectangular Picture Box** tool.

6. Point to the leftmost point of the shape and drag to above and to the right of the shape.

 You don't have to size this rectangle precisely as long as it covers everything above the shape's widest point.

7. Hold down **Shift** and click on the visible portion of the bumpy shape so that both the rectangle and the shape are selected.

8. From the **Item** menu choose **Merge, Intersection**. The rectangle disappears and the bottom is cut off the bumpy shape, leaving a flat bottom.

 The *intersection* command takes the selected item that's lowest in the stack and removes any portion that isn't covered by another selected object.

PROCEDURE 4: ADD SOME WHEELS

1. Using the technique from Procedure 2, create a **PANTONE Black U** colored circle **.75** inch high and wide, **1.5** inches from the left and **2.25** inches from the top. This is your front wheel.

2. Using the technique of Procedure 3, make a copy of the front wheel **4.25** inches from the left and **2.25** inches from the top. This is the rear version of the front wheel, which automotive enthusiasts call *the rear wheel.*

3. Select both wheels, then go to the **Item** menu and choose **Merge, Union**. The two wheels combine into a single object. They may look like two separate shapes to you, but the program just thinks it's one shape with a big gap in the middle.

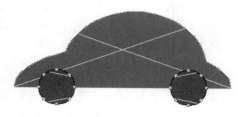

4. Get the **Item** tool from the tool palette, then go to the **Edit** menu and choose **Copy**. A copy of the wheels is stored in the clipboard.

5. Select the car body without deselecting the wheels.

6. From the **Item** menu choose **Merge, Difference**. The wheels disappear, and two wheel cutouts are left in the car body.

7. From the **Edit** menu choose **Paste**. The wheels reappear, but they're in the middle of the page, not where you want wheels to be.

8. On the measurement palette, set **X** to **1.5** and **Y** to **2.4**, then hit **Return** or **Enter**.

9. From the Item menu choose Content, None, so that the program doesn't keep thinking that the wheels will have pictures put in them.

10. Select the auto body, then go to the **Item** menu and choose **Content, None** again for the same reason.

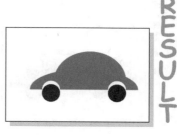

RESULT

PROCEDURE 5: CUT SOME WINDOWS

1. Use the **Rectangular Picture Box** tool to draw a small rectangle, then use the measurement palette to place it **0** inches from the top and left edge.

2. Create another rectangle, covering much of the upper bump of the body where the windows would be.

3. Draw two thin vertical rectangles cutting across the height of the previous rectangle.

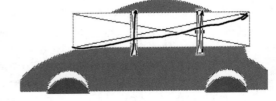

4. Select these last three rectangles then go to the **Item** menu and choose **Merge, Difference**. The two thin rectangles are cut away, leaving window supports. The window looks like three rectangles, but it's just one object.

5. On the color palette, select the color you choose for rain and set the **Shade** drop menu to **20%**. This creates a lightly tinted window.

6. With the window still selected, select the car body as well.

7. Go to the **Item** menu and choose **Merge, Difference** again. The car remains with the windows cut out.

8. With the car body still selected, select the small rectangle in the upper-left as well.

 This rectangle is there to serve as an *anchor*. If you were to move the selected items, you could easily put them back in the right place because you know the right location for that rectangle.

9. Make sure the **Item** tool is selected in the toolbox, then go to the **Edit** menu and choose **Copy**. The car body and the rectangle are copied onto the clipboard.

10. From the **Edit** menu choose **Undo Merge**. The window rectangles reappear.

 The undo command undoes the most recent command that changed your document. The copy command changed the clipboard, not the document, so it can't be undone.

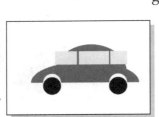

RESULT

PROCEDURE 6: CUT THE GLASS

1. Select just the window.

 When you start this procedure, the window and the body are probably both selected. If you try just clicking on the window, everything remains selected. You can deselect everything then click the window, but it's quicker to just hold down the **Shift** key and click the body of the car. Clicking with the shift key down toggles an item between being selected and deselected.

2. From the **Item** menu choose **Send to Back**. The window shape goes below the body shape.

3. From the **Item** menu choose **Content, None** to de-picturize the box.

4. Select the body again in addition to the window shape.

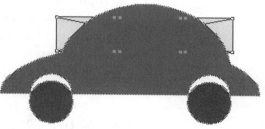

5. Go to the **Item** menu and choose **Merge, Intersection**. The body disappears, and the glass is trimmed to match the curved shape of the body, rather than having corners sticking out at each end.

6. From the **Edit** menu choose **Paste**. The body with the windows cut out and the anchor rectangle reappear on the document, although the car and the windows don't line up.

7. On the measurement palette set **X** and **Y** to **0**. This moves the copied anchor rectangle back to the upper right, dragging the car body back into place as well.

8. Use the **Item** tool to drag a rectangle around the upper-left corner of the document to select both the original and the copied anchor rectangle, then press the **Delete** key to delete them.

..

A DEEPER UNDERSTANDING: OTHER MERGING COMMANDS

In addition to the merge commands already demonstrated, there is also *reverse difference*, which creates an object with the attributes of the lowest object but the shape of the upper objects except where they cover the lower one. The *exclusive or* and *combine* commands leave only the areas covered by an odd number of the selected objects. With *combine*, only one shape is left, but *exclusive or* may leave several shapes.

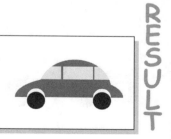

RESULT

PROCEDURE 7: START A NEW LAYER

1. From the **View** menu choose **Show Layers**.

 If this command is not on the menu then the palette is already open.

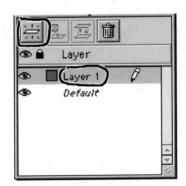

2. On the layers palette click the **New Layer** button. An entry marked *Layer 1* appears on the list.

3. Double-click the **Layer 1** entry.

4. A new dialog box opens. Type **little rain** into the **Name** field.

5. Click the **OK** button. The dialog box closes.

. .

A DEEPER UNDERSTANDING: LAYERS

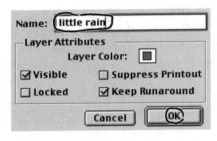

The use of layers makes it easier to deal with complex documents, particularly when it comes to restacking items. Think of a layer as a clear plastic sheet that you place items on. If you draw a building on one layer and Supergiraffe and the All Giraffe Squadron on another, the heroic flying giraffes will appear to fly behind the building if you put the building layer on top. Move the building layer below the giraffe layer and the giraffes fly in front of the building.

You can also *lock* the giraffe layer by clicking on the lock column on the layer palette. When locked, the layer is protected from accidental changes. You can also click the column with the eye icon to make the giraffe layer invisible, making it easier to work on the building without distraction. Clicking the eye column again restores the visibility.

PROCEDURE 8: THROW IN A LITTLE RAIN

1. Get the **Oval Picture Box** tool and draw a small circle, about one-sixteenth of an inch across near the upper left of the image.

 Watch the measurement palette as you drag. The height and width of the oval are updated as you drag. One-sixteenth is .0625 in decimal, but you don't need to be that precise. Anything between .05 and .07 should be fine.

2. Use the **Zoom** tool to get a close-up look at the oval.

 Don't worry about trying to make the oval too big. You can't enlarge your view to more than eight times the actual size.

3. Set the oval to have no content then go to the color palette and click the rain color.

 If a square-with-a-diamond design shows up on the oval, it is there to tell you what layer this is on. The color of the square can be matched with the color guide on the layer palette.

4. Use the method from Project 7, Procedure 3 to make this shape editable.

5. Use the **Content** tool or the **Item** tool to drag the top point of the oval upward, doubling the height of the shape.

6. Two curve handles appear around the top point. Take one of them and drag it to directly above the top point.

7. From the **View** menu choose **Fit in Window.**

8. From the **Item** menu choose **Step and Repeat**. Use the dialog box to duplicate this item **23** times, with a **Horizontal Offset** of .25 inch and a **Vertical Offset** of **0.**

9. On the layer palette, click the eye icon on the **Default** entry. The car becomes invisible.

10. From the **Edit** menu choose **Select All**. All the raindrops become selected.

11. Do another **Step and Repeat** command, duplicating this **7** times with a **Horizontal Offset** of .03 and a **Vertical Offset** of .5.

 You can hide all those square layer indicators by going to the **View** menu and choosing **Hide Visual Indicators.**

PROCEDURE 9: THROW IN A BIG RAIN

1. If you're using Windows, right-click the **little rain** entry on the layers palette. If you're using a Macintosh, hold down the **ctrl** key and click on the **little rain** entry. Whatever kind of computer or Etch-a-Sketch™ you're using, choose **Duplicate little rain** from the menu that appears.

2. Pull up the same menu again, this time clicking on the **little rain copy** entry that has appeared on the palette. Choose **Hide Other Layers.** Now only the copied layer is visible, although it's hard to tell the difference because it has the exact same contents as the layer that had just turned invisible.

3. Using the same technique from Procedure 7, rename the **little rain copy** layer to **big rain.**

4. Use the **Item** tool to drag a rectangle that covers the right half of the rain field. All of the raindrops on that side become selected.

5. Press the **Delete** key. All of the raindrops on the right side disappear.

6. Using the same technique, delete all of the raindrops on the lower-half of the image.

7. From the **Edit** menu choose **Select All**. All of the remaining visible raindrops are selected.

8. From the **Item** menu choose **Modify**. A dialog box opens.

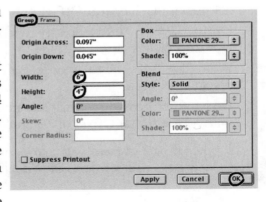

9. On the **Group** tab, set the **Width** to **6** inches and the **Height** to **4** inches then click **OK**. The raindrops are enlarged and the spaces between them expand until they are scattered all over the card.

PROCEDURE 10: REARRANGE THE RAIN

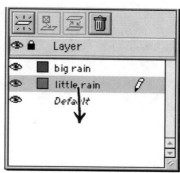

1. Bring up the layers palette menu again and choose **Show All Layers.** The car and the little raindrops reappear.

2. While holding down the Windows **Alt** or Macintosh **option** key, drag the **little rain** entry on the layer palette down below the **Default** entry. This restacking puts the small raindrops behind the car so that the car covers up some of them. This way, the large raindrops look like they're in front of the car and the smaller drops look further away.

3. Go to the **View** menu and choose **Hide Guides** if that option is available. Any black outlines that were appearing around objects now disappear.

> Even if you didn't turn off this display, the black outlines would not show up on the printout.

4. Save the file, naming it **CarCard.**

A DEEPER UNDERSTANDING: QUARKXPRESS AS A DRAWING TOOL

QuarkXPress is a great page layout program. It's not a great drawing program. The drawing features that are included are nice and handy, and you will likely find little ways to tweak your page layouts using these features. However, if your real goal is to make drawings like the one in this project (or, I would hope, drawings that look much better than this one), you would be better off using a drawing-oriented program like Illustrator or Freehand. You can take the output from those programs and bring it in as a picture in your QuarkXPress document.

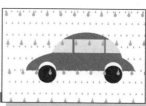

RESULT

PROJECT 9

THE TRICKY 4-10 SPLIT

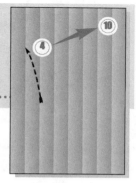

CONCEPTS COVERED

- ❏ Creating groups
- ❏ Spacing and alignment
- ❏ Line design
- ❏ Arrows
- ❏ Moving items between layers

REQUIREMENTS

- ❏ None

RESULT

- ❏ A diagram of how to make a tricky bowling shot

PROCEDURES

1. Draw a lane
2. Pieces of a pin
3. Put the pieces together
4. Nine more pins
5. Point the points
6. Properly place the pins
7. Design a line
8. Set up a shot
9. Draw the ball's path
10. Draw the pin path

PROCEDURE 1: DRAW A LANE

1. Start a new document, **4** inches wide and **6** inches high, with no margins, no automatic text box, and only one column.

2. Using the technique from Project 2, Procedure 2, create two new shades of woody brown, naming them **Wood 1** and **Wood 2**.

 Be sure to clear the **Spot Color** check box when designing your color. Otherwise, the program thinks that you're designating a single-color ink rather than a color that will be mixed using CMYK component colors.

3. Use the **Rectangular Picture Box** tool to create a rectangle running the full height of the document. Make it one-half inch wide starting from the left edge.

4. From the **Item** menu choose **Content, None.**

5. Using the technique from Project 2, Procedure 3, fill the rectangle with a **Linear Blend** from **Wood 1** to **Wood 2.**

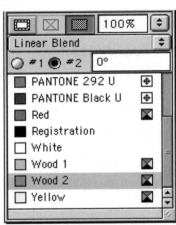

6. Using the technique from Project 4, Procedure 3 make 7 more copies of this plank with a **Horizontal Offset** of .5 inch.

7. Using the technique from Project 8, Procedure 7, create a new layer named **Pins**.

RESULT

SCREEN LAYOUT

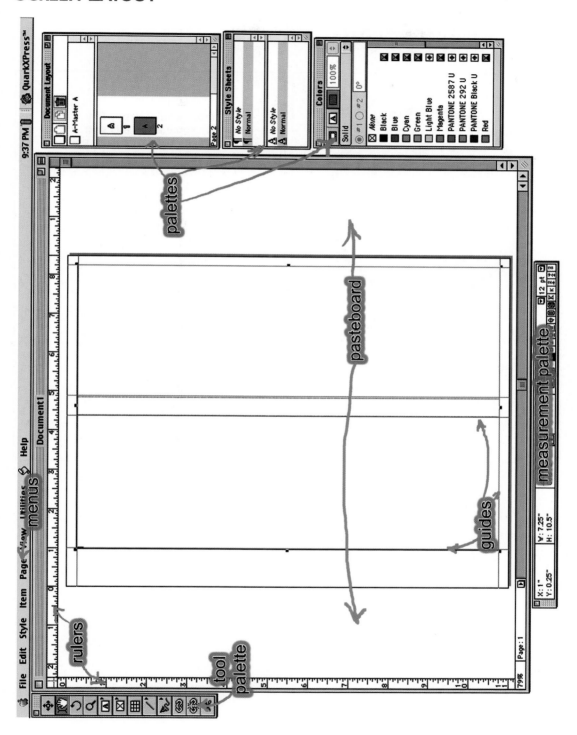

PROJECT 1: HAPPY HAPPY DAY

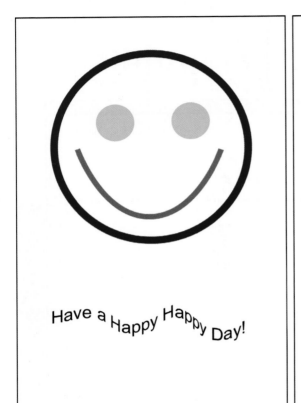

Have a Happy Happy Day!

International Happy Day
has come again this year.
You mustn't sob or sulk or pout
but just grin ear to ear.

PROJECT 2: YOUR OWN BASEBALL CARD

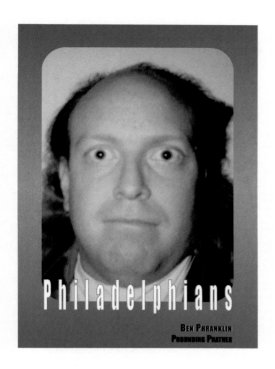

PROJECT 3: BACK OF YOUR BASEBALL CARD

Ben Phranklin

YEAR	Donuts	Cats	Mellow
2000	17	1	7
2001	13	1	3
2002	2	0	5

PROJECT 4: A STORY BOOKLET

Nat Gertler, Movie Star (well, Extra)

A while back, I signed on with an extras casting agency. In Hollywood terms, an "extra" is an actor who doesn't have any lines (except as part of crowd noise) or a significant part in the piece. The other guys on the escalator, the lady walking down the street in the background, the audience at the movies: those are extras. Sometimes called "background" or "atmosphere", the extra is more a prop than he is an actor. There are both union and non-union extra jobs (and a movie can be a union film while still using non-union extras). The work is piecemeal.

There are a number of extras casting agencies in Hollywood. Most are scams, taking money from the would-be actor to represent him, but with little actual work to offer. There's one or two large, serious extra agencies which do charge a small fee for taking your photo and information, and that's a cost-offsetter and not how they make their money. I signed with one of those.

Why did I sign on? Well, earning a little extra money wouldn't hurt, but that's not why I did it. (The money's pretty bad; $40 for any shoot lasting under 8 hours, with $7.50 an hour after that.) However, I wanted to see what the film word was like from the inside. I wanted to add appearing in a film or on TV to my list of experiences. And I wanted to have some Degree of Kevin Bacon. (For those unfamiliar with the concept: there is a movie trivia game where you have to see how many links it takes to connect any actor to actor Kevin Bacon through films. For example, Elizabeth McGovern was in She's Having A Baby with Kevin, which makes her One Degree of Kevin Bacon. Mary Tyler Moore was in the movie Ordinary People with Elizabeth McGovern, so she's Two Degrees of Kevin Bacon. Someone who was in a film with Mary Tyler Moore would be Three Degrees, at most. Using this system, the vast majority of actors in the history of Hollywood are Six Degrees or less.)

Once they have your photo and information on file, you can call in each day to hear a recording of jobs they have open for the next day. I have the bad luck of not being much of a type; there is no shortage of 30-something white guys, and I'm not menacing, not attractive, and I don't look military. The few times that I've found something on the recording that I fit, when I call in I learn that the part was already taken.

A couple weeks back, a message started cropping up warning that they had a big shoot coming up, requiring thousands of extras. The film would be Primary Colors, which I knew was based on the Joe "Anonymous" Klein political satire of the Clinton presidency. A little net research told me that Mike Nichols and Elaine May (the old Nichols&May comedy team) would be directing and writing, respectively. John Travolta would play the governor running for president (renamed from Clinton to something else), Emma Thompson his wife, with Jack Nicholson, Billy Bob Thornton, Maura Tierney, John Malkovich, Adrian Lester, Diane Ladd, and Kathy Bates in various other roles. All in all, a major picture. (It will make me Two Degrees of Kevin Bacon; I leave it as an exercise to the reader to determine how.) (Added later: The reports of Nicholson and Malkovich being in the film proved false, so that removes all of the Two Degrees links from the listed actors, However, there is

a more obscure actor in the film who gives me a Bacon Rating of 2.)

When they opened up the lines for calls on Monday, I called in and gave my social secutiry number (which they use to index the information). I was immediately told "you're in", and transfered to a recording of information about the shoot. It was going to be Friday, starting at 6 PM. The recording gave me the location I would have to go to. It also told me that the scene would be outside during winter in Connecticut, so I'd be required to dress with a heavy coat and other appropriate clothing. Plus, all clothing would have to be either black, grey, red, white, or blue. Obviously, this was to be a political rally of some sort, and they wanted to create a real red, white, and blue impression.

Problem was that the only jacket that I had that met that description was a black leather jacket with a big radio station emblem on the back, and I knew that ad clothes were generally discouraged on sets. However, $5 at a local thrift shop bought me a nice and appropriate piece (winter clothing being fairly cheap around here, as demand is low.)

(We did end up lucking out with a cool night, so the heavy clothes weren't too bad. Still, the idea of using summer in L.A. for winter in the northeast seems a bit much.)

there is no shortage of 30-something white guys

PROJECT 5: BUILD A BOOK

Table of Contents

PROJECT 6: BOOKENDS FOR YOUR BOOK

EXTRA:
Read All About It

Index

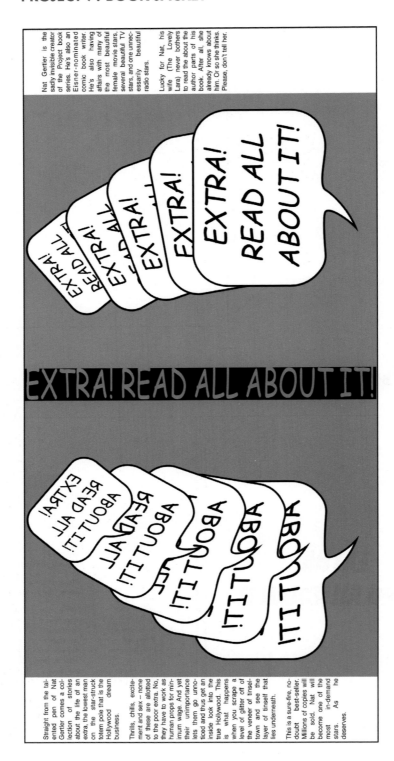

PROJECT 8: A CAR CARD

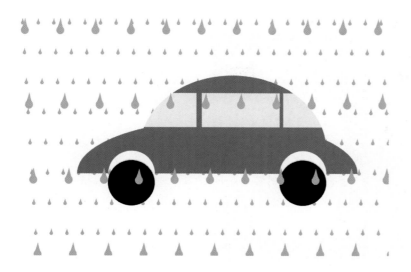

PROJECT 9: THE TRICKY 4-10 SPLIT

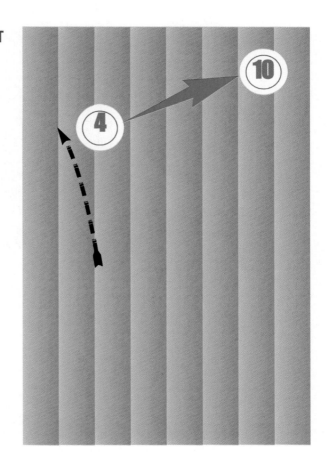

PROJECT 10: A ONE-PERSON GROUP

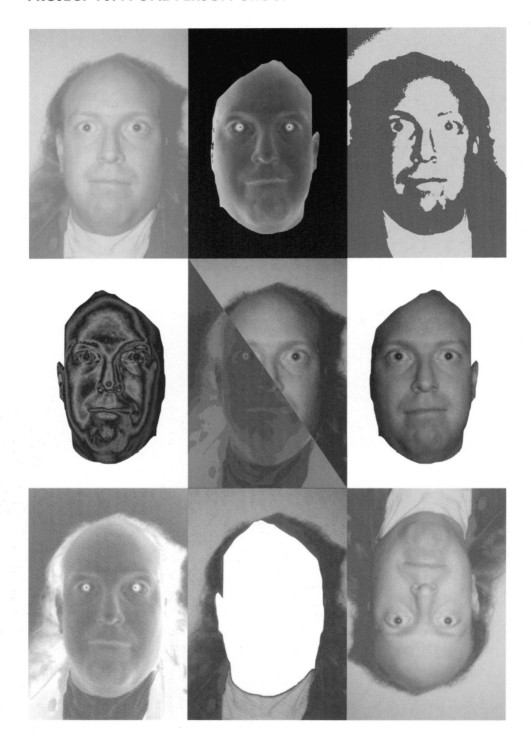

PROJECT 11: A CIRCULAR CIRCULAR

A while back, I signed on with an extras casting agency. In Hollywood terms, an "extra" is an actor who doesn't have any lines (except as part of crowd noise) or a significant part in the piece. The other guys on the escalator, the lady walking down the street in the background, the audience at the movies: those are extras. Sometimes called "background" or "atmosphere", the extra is more a prop than he is an actor. There are both union and non-union extra jobs (and a movie can be a union film while still using non-union extras). The work is piece-meal.

There are a number of extras casting agencies in Hollywood. Most are scams, taking money from the would-be actor to represent him, but with little actual work to offer. There's one or two large, serious extra agencies which do charge a small fee for taking your photo and information, but that's a cost-offsetter and not how they make their money. I signed with one of those.

Why did I sign on? Well, earning a little extra money wouldn't hurt, but that's not why I did it. (The money's pretty bad; $40 for any shoot lasting under 8 hours, with $7.50 an hour after that.) However, I wanted to see what the film word was like from the inside. I wanted to add appearing in a film or on TV to my list of experiences. And I wanted to have some Degree of Kevin Bacon. (For those unfamiliar with the concept: there is a movie trivia game where you have to see how many links it takes to connect any actor to actor Kevin Bacon through films. For example, Elizabeth McGovern was in She's Having A Baby with Kevin, which makes her One Degree of Kevin Bacon. Mary Tyler Moore was in the movie Ordinary People with Elizabeth McGovern, so she's Two Degrees of Kevin Bacon. Someone who was in a film with Mary Tyler Moore would be Three Degrees, at most. Using this system, the vast majority of actors in the history of Hollywood are Six Degrees or less.)

Once they have your photo and information on file, you can call in each day to hear a recording of jobs they have open for the next day. I have the bad luck of not being much of a type, there is no shortage of 30-something white guys, and I'm not menacing, not attractive, and I don't look mili-tary. The few times that I've found something on the recording that I fit, when I call in I learn that the part was already taken.

A couple weeks back, a message started cropping up, warning that they had a big shoot coming up, requiring thousands of extras. The film would be Primary Colors, which I knew was based on the Joe "Anonymous" Klein political satire of the Clinton presidency. A little net research told me that Mike Nichols and Elaine May (the old Nichols&May comedy team) would be directing and writing, respectively. John Travolta would play the governor running for president (renamed from Clinton to something else), Emma Thompson his wife, with Jack Nicholson, Billy Bob Thornton, Maura Tierney, John Malkovich, Adrian Lester, Diane Ladd, and Kathy Bates in various other roles. All in all, a

CONTINUED ON PAGE 2

CONTINUED FROM PAGE 1

major picture. (It will make me Two Degrees of Kevin Bacon; I leave it as an exercise to the reader to determine how.) (Added later: The reports of Nicholson and Malkovich being in the film proved false, so that removes all of the Two Degrees links from the listed actors. However, there is a more obscure actor in the film who gives me a Bacon Rating of 2.)

When they opened up the lines for calls on Monday, I called in and gave my social security number (which they use to index the information.) I was immediately told "you're in", and transferred to a recording of information about the shoot. It was going to be Friday, starting at 6 PM. The recording gave me the location I would have to go to. It also told me that the scene would be outside during winter in Connecticut, so I'd be required to dress with a heavy coat and other appropriate clothing. Plus, all clothing would have to be either black, grey, red, white, or blue. Obviously, this was to be a political rally of some sort, and they wanted to create a real red, white, and blue impression.

Problem was that the only jacket that I had that met that description was a black leather jacket with a big radio station emblem on the back, and I knew that ad clothes were generally discouraged on sets. However, $5 at a local thrift shop bought me a nice and appropriate piece (winter clothing and appropriate piece fairly cheap around here, as demand is low.)

(We did end up lucking out with a cool night, so the heavy clothes weren't too bad. Still, the idea of using summer in L.A. for winter in the northeast seems a bit much.)

The recording made one other point: No cameras were to be brought to the set. Anyone bringing a camera to the set would be immediately thrown off the set, and they would be dropped from the ranks of the agency. This is a fairly common statement. First off, having a camera on set can be distracting, and using a flash can ruin a shot. Additionally, many movies are considered "closed shoots", in order to keep aspects of the filming out of the press. However, in this particular case, this restriction would prove interesting.

Eventually, inevitably, Friday comes. I get my clothes together and head out to the location, leaving hours early so that I can find it, be sure I know where I'm going, and then head into downtown LA for a quick bite (I know they'll be feeding us, but I'm not sure when) and perhaps a bit of shopping. Between traffic getting to the shoot and traffic getting around LA, I only have time for a quick bite from a drive-thru-only McDonalds. (I can hear those who know I should be watching my fat intake quivering in horror.)

I'm directed to a parking lot somewhere in a large Veteran's Administration complex. After parking my car, a school bus takes me not to the shoot, but to another parking lot, which has been turned into a waiting area. I am told that since I was asked to be there at 6 PM, I was part of Group H. In the waiting area are rows and rows of tables, separated by group (A through H and Red, oddly enough). And I quickly learn that the earliest groups, who were told to be there at 2:30 or 3:00, were still in the waiting area. It looks like I have a wait ahead of me.

I notice a line for food at the back. Now, I'd eaten maybe half an hour before, but people who know me know that food is one of my favorite things to eat, and free food is a particularly attractive subcategory. I get in line, grab some fruit, a half a sandwich, an apple fritter, a donut, some tortilla chips, and some iced tea. Grabbing a seat, I start talking with fellow extras, while chomp-

CONTINUED ON PAGE 3

PROJECT 12: PREPRESS FOR A CAR CARD

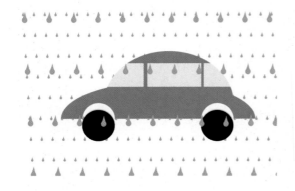

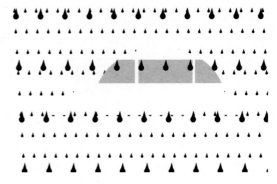

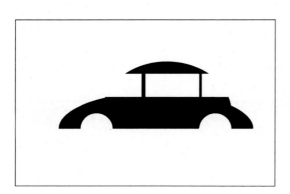

PROJECT 13: MINI MOVIE POSTER

PROJECT 14: SOUNDTRACK CD COVER

PROJECT 15: A CATALOG OF PROJECTS

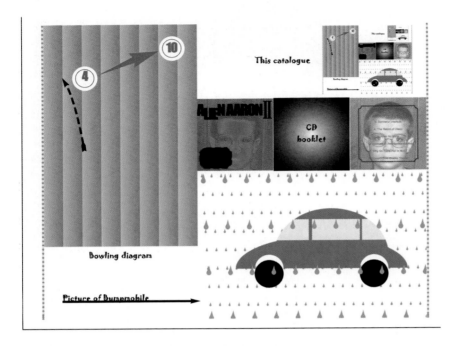

PROJECT 16: DECEMBER CALENDAR

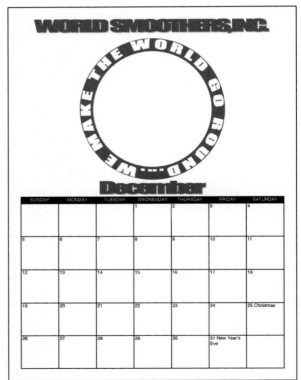

PROJECT 17: CORPORATE ANNOUNCEMENT

We are going to retire our ◯ motto design in favor of a minor revision of the design which looks like: ◯. Henceforth, whenever you would formerly use ◯ you should instead use ◯. Thank you for your assistance.

Pat Patterson
President

PROJECT 18: A LIMERICK FOR THE WORLD WIDE WEB

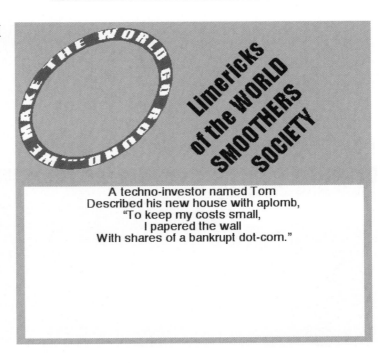

A techno-investor named Tom
Described his new house with aplomb,
"To keep my costs small,
I papered the wall
With shares of a bankrupt dot-com."

PROJECT 19: LET US RHYME ONE MORE TIME

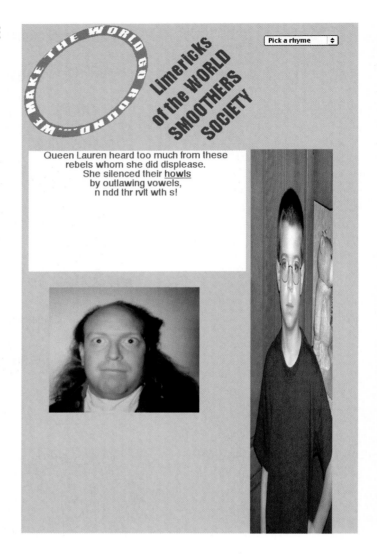

Queen Lauren heard too much from these
rebels whom she did displease.
She silenced their <u>howls</u>
by outlawing vowels,
n ndd thr rvlt wth s!

PROJECT 20: FORMING A FORM

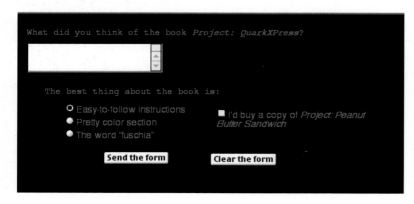

Color mixing

CMYK COLOR

Standard full-color printing uses a color mixing system called *CMYK*. The CMYK color specification system uses four component colors, cyan (C), magenta (M), yellow (Y), and black (K), with the amount of each color measured from 0 (no color) to 100 (full strength). The more color you add, the darker the result.

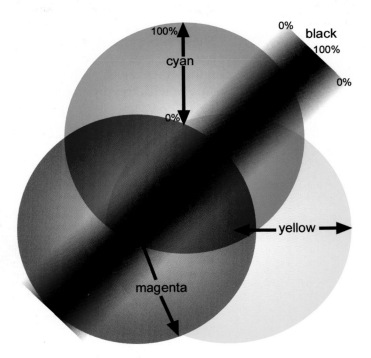

RGB COLOR

When designing for the Web you use the RGB color mixing system, in which you specify how much red (R), green (G), and blue (B) mix together to make the color. This diagram shows how the colors mix together at full strength. The more color you add, the brighter the result.

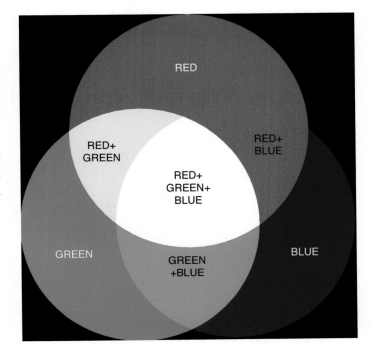

TOOL PALETTE GUIDE

These show the pop-out button bars in their default state. As you use the tool palettes, the buttons on the button bars keep rearranging themselves. Whenever you select a button, it switches positions with the previously visible button.

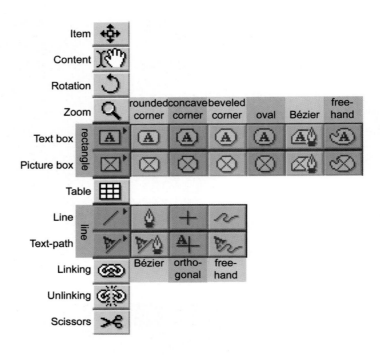

WEB TOOL PALETTE GUIDE

PROCEDURE 2: PIECES OF A PIN

1. Use the **Oval Text Box** tool to create a circular text box, two-thirds of an inch (that's **.667** in decimal) across toward the upper-left corner of the document.

2. From the **Item** menu choose **Duplicate** to create a second circular text box.

3. Go back to the **Item** menu and choose **Modify**. A dialog box opens up.

4. On the **Box** tab, set **Height** and **Width** to **.5**.

5. On the **Frame** tab, set **Width** to **1 pt.**, **Style** to **Solid**, **Color** to **Black**, and **Shade** to **50%** then click **OK**.

> By setting the shade to 50%, you create a lighter shade that will print using half the ink of the full strength color. A half black will give you a gray.

6. Click the **Content** tool on the smaller circle and type **10,** then drag across the **10** to select it.

> It will be easier to see what you're doing if you turn off the layer indicator on the items by going to the **View** menu and choosing **Hide Visual Indicators.**

7. On the **Measurement** palette, click the **Centered** button, the **B** (for Bold) button, and set the **Font** to **Impact**. Try different sizes of font until you find the largest value you can use without the text disappearing.

8. On the color palette click **Red**.

9. Right-click (Windows) or hold down **ctrl** and click (Macintosh) on the **Red** entry on the color palette and choose **Edit Red** from the menu that appears. A dialog box appears.

10. Set **Model** to **CMYK** then click **OK**.

> The red, green, and blue colors in the color palette aren't really designed for printing. They use the RGB color model, meant for specifying on-screen color. Although files including these colors will print fine on your computer printer, they will cause problems if you use them for commercial printing.

Procedure 3: Put the Pieces Together

1. Get the **Item** tool, hold down the **Shift** key, and click on the bigger circle so that both circles are selected.

2. From the **Item** menu choose **Space/Align**. A dialog box opens up.

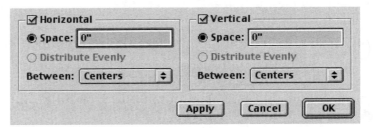

3. Put checks in the **Horizontal** and **Vertical** check boxes, set both **Space** values to **0**, and set both **Between** drop menus to **Centers**.

4. Click **OK**. The two circles now overlap, sharing a center the same way the rings of an archery target do.

 Your settings arranged the items so that there was zero space between the centers horizontally and vertically, putting the centers at the same spot. Notice that the larger circle stood still and the other circle moved to meet it. When spacing items, the program doesn't move the item whose top edge is closest to the top of the document. Everything else moves relative to that item.

5. From the **Item** menu choose **Group**.

 This tells the program to track these two items as a single group, making it easy to move or replicate these two items together.

. .

A DEEPER UNDERSTANDING: GROUPING VERSUS MERGING

Grouping may sound very similar to merging, because both take multiple items and treat them as a single item. They are, however, very different. Merging takes the items and actually turns them into a single item, changing the shape to combine them. Once you do this, the original items are gone and cannot be restored. A group, on the other hand, still contains the individual items. It's like a rock group that can be made up of several musicians. If needed, you can eventually break the group up into the individual solo performers by using the *ungroup* command on the *item* menu. And when their careers fade, the group can be recombined for the big reunion tour.

PROCEDURE 4: NINE MORE PINS

1. Use the **Step and Repeat** command to make **9** more copies of the pin, spaced **.2** inch both horizontally and vertically.

2. On the layer palette, point to the **Default** entry. Put your pointer so that the little picture of a lock is directly above it then click.

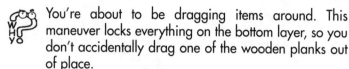

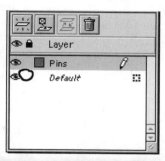

You're about to be dragging items around. This maneuver locks everything on the bottom layer, so you don't accidentally drag one of the wooden planks out of place.

3. Use the **Item** tool to drag the pins into a rough bowling pin arrangement: a line of four pins at the top, a row of three pins below it, then a row of two, and finally a row of one (which actually doesn't count as a row, I suppose).

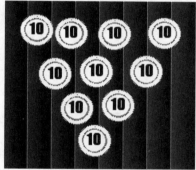

4. Drag the **Content** tool across the **10** in the upper-left pin to select it, then press **7** to make this pin number 7.

5. Using the same method, turn the next two pins in the row into pins **8** and **9.**

6. Turn the second row into pins **4, 5,** and **6,** the third row into pins **2** and **3,** and the head pin into pin **1.**

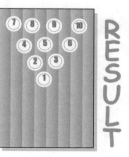

RESULT

PROCEDURE 5: POINT THE POINTS

1. Use the **Item** tool to move pins **8, 9,** and **10** down a little bit. You just have to make sure that pin 7 is closer to the top of the document than any of those pins.

 You'll be using the space and align function to arrange these pins. You want the 7 pin to be the anchor when arranging the pins.

2. Select pins **7, 8, 9,** and **10.**
3. From the **Item** menu choose **Space/Align**. A dialog box opens up.

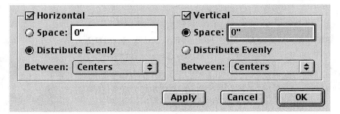

4. Put a check in the **Vertical** check box and set the **Space** value to **0.**

 This lines up all the pins smoothly.

5. Put a check in the **Horizontal** check box and choose the **Distribute Evenly** option.

 The *distribute evenly* option keeps the leftmost and rightmost selected items where they are horizontally, and spaces the remaining selected objects evenly between the two.

6. Click **OK**. The top row of pins turns nice and smooth.

 It doesn't matter what you set the *between* drop menus to. All of the objects are the same size, so it doesn't matter if you try to line them up by their top edges or their centers. If you space the centers of the pins or the left edge of the pins evenly, they still line up the same. It would be different if you were working with items of differing sizes.

7. Select pins **1, 7,** and **10.**
8. From the **Item** menu choose **Space/Align** again.
9. Clear the **Vertical** check box, set the horizontal **Distribute Evenly** option, and click **OK**.

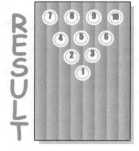

RESULT

PROCEDURE 6: PROPERLY PLACE THE PINS

1. Select pins **1, 2, 4,** and **7.**

2. From the **Item** menu choose **Space/Align** yet again. By now, this command is becoming your closest friend.

3. Put checks in both the **Horizontal** and **Vertical** check boxes, and select both **Distribute Evenly** options then click **OK**.

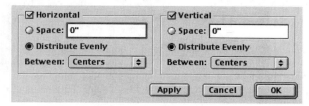

 Distributing evenly vertically keeps the top and bottom items where they are and move the in-between items up and down to space them evenly between the two. By distributing evenly both horizontally and vertically, you end up with a nice evenly spaced diagonal line.

4. Select pins **1, 3, 6,** and **10** and line them up using the same method.

If the pin arrangement changes radically and unexpectedly, you probably had an extra pin selected. Go to the **Edit** menu, choose **Undo Item Change,** and then reselect the pins and try again.

5. Select pins **3, 5,** and **8** and line them up using the same method.

A DEEPER UNDERSTANDING: WHY USE SPACE AND ALIGN

You could put the pins in strict horizontal lines by creating a guide and placing the pins along it, but that's something that would be problematic if you were trying to line up the centers of objects with differing sizes.

You could also space things evenly and place everything precisely if you used the measurement palette or modify dialog to place the items precisely. However, figuring out the positions for in-between items requires math, and modern life is designed to let us avoid math.

Procedure 7: Design a line

1. From the **Edit** menu choose **Dashes & Stripes**. A dialog box appears.

2. Click the **New** button and choose **Dash** from the menu that appears.

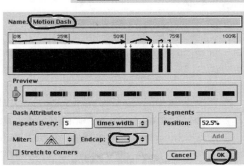

3. Another dialog box appears.

4. Set the **Name** to **Motion Dash.**

5. Click the **Endcap** button and choose **Square** from the drop menu that appears.

 The *square* options generate dash segments with flat ends, as opposed to the *round* options, which generate dash segments with rounded edges so you can make dotted lines.

6. On the percentage ruler, drag from the **0%** mark to the **50%** mark. A black rectangle appears in the design display area below.

7. Drag three more times on the ruler. The first drag should go from about **53%** to **63%,** the second should go from **65%** to **67%,** and the third from **69%** to **70%.**

 If you mess up in dragging any of these, you can go to the design display area and drag the rectangle off the bottom of the display. When you do this, the rectangle disappears and you can try dragging it again.

8. Click **OK**. The design dialog box closes.

9. Close the dialog box that lists the types of dashes and stripes by clicking **Save**.

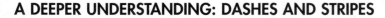

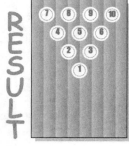

A DEEPER UNDERSTANDING: DASHES AND STRIPES

If you want something other than a solid line, you can either use a dash or a stripe. A *dash* interrupts the line at regular intervals along its path. A *stripe* is made up of several parallel lines that all follow the path.

PROCEDURE 8: SET UP A SHOT

1. Using the technique from Project 8, Procedure 7, create a new layer named **Unused pins.**

2. Save the file under the name **bowling**.

 This file has the basic pin layout and line design in it, so you can use it as a base for modeling any bowling shot you want.

3. Select pins **1, 2, 3, 5, 6, 7, 8,** and **9.**

 You're trying to diagram a *4-10 split,* which is a tricky bowling shot for the second frame when just the 4 and 10 pins remain standing.

4. On the layer palette click the **Move Item to Layer** button.

5. Another dialog box opens up. Set the **Choose Destination Layer** drop list to **Unused pins** then click **OK.** Although the image does not appear to have changed, the selected pins are now on the unused pins layer.

6. Click the little eye icon on the left of the **Unused pins** entry on the layer palette. The icon disappears and so do the pins. The pins are still there, as you can see if your reclick the same spot; they just aren't seen on the screen or on the printout.

 You can make a layer visible on screen but invisible in the printout, which is handy if you want to keep some reference notes on your document. To do this, just double-click the layer entry on the palette and put a check in the **Supress Printout** check box in the dialog box that appears.

PROCEDURE 9: DRAW THE BALL'S PATH

1. On the layers palette, click **Pins** to make it the current layer so that you're drawing on a visible layer.
2. Get the **Bézier Line** tool.
3. Click about 2 inches below the **4** pin, then go to about one-quarter inch to the left of the pin and drag up and to the left.

 The drag sets the angle of curve through the point, making it look like the path of a well-hooked bowling ball.

4. Click the **Item** tool button.

 The program keeps you in Bézier drawing mode until you either select another tool or double-click a point into place. However, because the last point you need is a curve point, that has to be dragged rather than clicked into place.

5. On the measurement palette are two **W** values. The one on the right is the **Weight**; set this to **4 pt**.

6. From the drop list to the right of the width choose **Motion Dash.**
7. From the drop list at the far right of the measurement palette choose a leftward-pointing arrow.

 If you've used drawing programs to draw arrows, this might be confusing. With most programs, picking a left-pointing arrow means to put the arrowhead at the first point you created in your line and to put the arrowtail at the last point. In QuarkXPress, picking a left-pointing arrow means the arrowhead goes on whichever end of the line is more to the left.

PROCEDURE 10: DRAW THE PIN PATH

1. Use the **Line** tool to drag a line from pin **4** to pin **10**.
2. On the measurement palette, set the weight **W** value to **12 pt.**
3. From the arrow drop list choose a right-aimed arrow with no arrowtail.
4. On the color palette click **Magenta.**
5. From the **Item** menu choose the **Shape** submenu and pick the editable shape (the dented oval).
6. While holding down the Windows **Alt** or Macintosh **option** key, point to one of the points at the base of the arrow. When the pointer turns into a box with an X through it, you're aimed at the right spot. Click to delete that point.

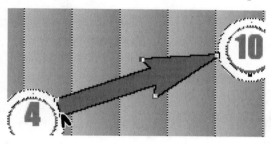

7. Save the file, giving it the name **410split.**

CONCEPTS COVERED

❏ Clipping images
❏ Contrast
❏ Coloring

REQUIREMENTS

❏ A digital close-up photo, preferably one downloaded from:

http://www.delmarlearning.com/companions/projectseries

RESULT

❏ A Warholesque grid of images

PROCEDURES

1. A grid of clones
2. Trim away some excess
3. Recolor some clones
4. A stark contrast
5. Clone of chrome
6. A split-level clone
7. Flip some clones

PROCEDURE 1: A GRID OF CLONES

1. Go to http://www.delmarlearning.com/companions/projectseries and follow the directions there to download the grayscale image.

 If you can't access this image, then any grayscale facial image will do. If you know how to use Photoshop or a similar graphics program, select the face in the image, turn that selection into an alpha channel, and save the file in the TIFF format.

2. Start a new document, **6** inches wide and **9** inches high, with no margins, no automatic text box, and only one column.

3. Using the technique from Project 2, Procedure 1, add guides running across the image at **3** inches and **6** inches from the top. Add vertical guides running **2** and **4** inches from the left. The page is now divided into a tic-tac-toe grid.

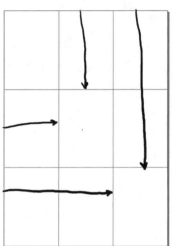

 The measurement palette will show you the exact placement of the guide as you drag it.

4. Use the **Rectangular Picture Box** tool to drag a rectangle, filling the upper-left tic-tac-toe space.

5. Using the technique from Project 2, Procedure 4, place the picture you downloaded into the picture box.

6. From the **Style** menu choose **Fit Picture To Box.** The picture is stretched and squashed to fit the height and width of the picture box. This may distort the image somewhat, because the picture may need to be stretched more in one direction than the other.

 The measurement palette shows exactly how much the image is stretched or squashed in each direction. The X% value shows the ratio between the original and current width, whereas the Y% value is the same information for the height.

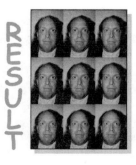

7. By using the **Item, Duplicate** command to copy the picture box and the **Item** tool to drag the copy, place a copy of this picture in every cell of the tic-tac-toe grid.

PROCEDURE 2: TRIM AWAY SOME EXCESS

1. Select the second picture on the top tier of pictures by clicking on it.

 If you're using your own grayscale picture and you haven't added an alpha channel to it, skip this page and move on to the next.

2. From the **Item** menu choose **Clipping**. The modify dialog box opens with the clipping tab already selected.

3. Set **Type** to **Alpha Channel**.

 An *alpha channel* is a hidden grayscale image that is stored as part of a picture file. This image is often used to store the outline of some relevant portion of the image with the area inside the outline stored as white and the area outside the outline stored as black.

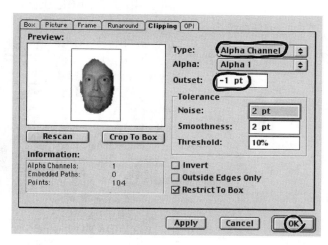

4. Set **Outset** to **–1 pt.**

 This trims away the edge of the shape indicated by the alpha channel. A positive value in this field would expand the shape.

5. Click **OK.** The trimmed version of the image appears in the grid. Only the face appears

6. Repeat this same process to trim the first and third pictures on the second tier.

7. Repeat the process again for the second picture on the third tier. This time, also select the **Invert** option in the dialog box. The head appears with a blank face.

 The invert option displays the area where the alpha channel is black and hides the white areas, rather than the other way around.

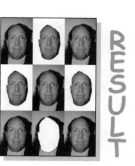

PROCEDURE 3: RECOLOR SOME CLONES

1. Select the upper-left picture.

2. From the **Style** menu choose **Color, Cyan**. The picture changes color; instead of being shades of gray, it's now shades of cyan.

3. Using the same technique, turn the second picture on the first tier **Yellow** and the third picture **Magenta**.

4. Select the first picture on the second tier then go to the **Style** menu and choose **Color, Other**. A dialog box opens up.

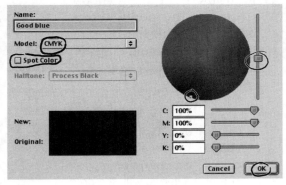

5. Set the **Mode** to **CMYK**, clear the **Spot Color** check box, mix yourself a good blue color, and click **OK**. The selected image turns blue, and the new color is added to your color palette.

6. Use this same method to make the remaining two pictures on the row red and purple, and to make the first two images on the next row green and brown.

7. Select the second image on the first row then go to the color palette, click the **Background Color** button, and click the color entry for the blue color you mixed. Now instead of the image fading from white to yellow, it fades from blue to yellow with a blue background.

8. Select the lower-left image then go to the **Style** menu and choose **Negative**. The light parts of the picture turn dark and the dark parts turn light.

9. Select the lower-right picture then go to the **Style** menu and choose **Shade, 50%.** The picture becomes half as dark as before.

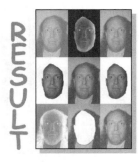

PROCEDURE 4: A STARK CONTRAST

1. Select the upper-right picture.
2. Go to the **Style** menu and choose **Contrast**. A dialog box opens.

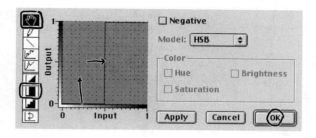

3. On the left side is a column of different tools you can use to adjust the contrast. Click the **High Contrast** tool button. The shape of the line across the graph changes.
4. Click the **Hand** tool.

 This tool is used to drag the whole graph line across the graph.

5. On the graph is a vertical line. Drag that line to halfway across the graph.
6. Click **Apply** and see what the picture looks like on the document. It will be part white, part solid magenta, with no shades in between. If there's too much of either color for the image to be clear, drag the line again. Drag it left for more magenta, right for more white.
7. A line runs across the bottom left corner of the graph over to the vertical line. Drag that one-third of the way toward the top of the graph.
8. Click **OK**. The image is now made up of two colors: solid magenta and light magenta.

...

A DEEPER UNDERSTANDING: THE CONTRAST GRAPH

The contrast settings alter the darkness of each shade of the image. For each *pixel* (the individual dots that make up the image) of the source picture, the program finds the darkness along the fading stripe at the bottom of the graph. When it finds the pixel's darkness, it goes straight up until it runs into the line drawn across the graph, then goes to the left and checks the darkness on the fading stripe on the left edge of the graph. The darkness of that spot is the darkness that the pixel will be displayed with.

The tools on the left of this dialog box are all used to change the graph line shape in different ways, and thus change the way the contrast of each pixel is adjusted.

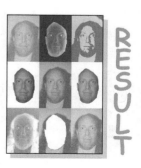

RESULT

PROCEDURE 5: CLONE OF CHROME

1. Select the first picture on the second tier.
2. Go to the **Style** menu and choose **Contrast**. The contrast dialog box opens again.

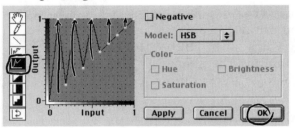

3. Click the **Spike** tool on the left side of the dialog box. A series of points appears along the graph line.
4. Drag the second, fourth, sixth, eighth, and tenth points to the top of the graph. The graph line bounces between the points you dragged and the points you left alone.

 For shinier chrome, drag all the other points down to the bottom of the graph.

5. Click **OK**. The picture now shines like chrome.

. .

A DEEPER UNDERSTANDING: THE CONTRAST TOOLS

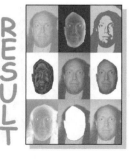

The top five tools on the left edge of the contrast dialog box are used to make adjustments to the line. The *hand* tool doesn't change the shape of the line but moves the placement of the line on the graph. The *pencil* tool lets you directly doodle the line. You use the *line* tool to drag perfectly straight lines. The *posterizer* tool and the *spike* tool each put movable points every 10 percent of the way across the line. When you move a point with the spike tool, lines go straight from the previous point and the next point to the point you moved. Move that same point with the posterizer tool and 5% of the line to either side of the point moves to the same level, creating a little step. This little step means that all the colors in that range of darkness in the source picture will turn a single shade.

The next three tools simply set the line to a preset shape. The *normal contrast* tool sets the input color to match the output color. Unless you do further editing, the resulting image will be the same color as what you started with. The *high contrast* tool translates the entire picture into just two different shades, and the *posterized* tool makes it six different shades.

Click the last tool, the *inversion* tool, to turn the line upside down.

PROCEDURE 6: A SPLIT-LEVEL CLONE

1. Select the center picture.

2. Go to the **Item** menu and use the **Step and Repeat** command to duplicate the picture, with the **Horizontal Offset** and **Vertical Offset** both set to **0.** The copy of the picture completely covers the original.

3. On the color palette, click the **Background Color** button then click the **Cyan** entry on the color list.

4. From the **Style** menu choose **Contrast** to open the contrast dialog box.

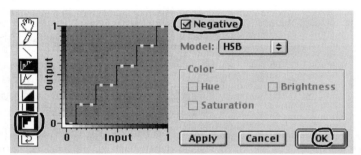

5. Click the **Posterized** tool, put a check in the **Negative** check box, and click **OK.**

6. Go to the **Item** menu, choose the **Shape** submenu, and select the editable shape from the list.

7. Hold down the Windows **Alt** or the Macintosh **Option** key while clicking on the upper-right corner point of the center picture's box. The point is deleted, leaving three points and thus turning the rectangular picture box into a triangular one. The upper-right half of the original image you copied is now revealed.

· ·

A DEEPER UNDERSTANDING: THE RIGHT TOOL

As you've seen, the contrast and color changing tools in QuarkXPress are simple. This is good, because it makes them easy to use, but it's also bad because there's only so much one can do with simple tools.

If you're serious about adjusting the appearance of pictures, you'll find that professional picture editing software such as Photoshop gives you a richer set of tools to work with, allowing you more options with better results.

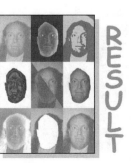

PROCEDURE 7: FLIP SOME CLONES

1. Select the middle picture on the top tier.
2. On the measurement palette, click the **Flip Horizontal** button, the sideways-pointing arrow in the center of the palette. The picture becomes a mirror image.

3. Using the same method, flip all three images on the right side of the document.
4. With the bottom right image still selected, click the **Flip Vertical** button, the upward-pointing arrow in the middle of the measurement palette. The picture turns upside down.
5. Save the file, using the name **Clones**. Now you can make your own multichromatic and occasionally chrome clones anytime you want.

RESULT

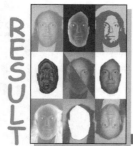

PROJECT 11
A CIRCULAR CIRCULAR

CONCEPTS COVERED

- ❏ Linking
- ❏ Creating columns
- ❏ Flowing text around images
- ❏ Continuation cross-references

REQUIREMENTS

- ❏ A reasonably long text file, such as the ones you used in Projects 4 and 5, and the image file you downloaded for Project 10.

RESULT

- ❏ A multipage document with decorations

PROCEDURES

1. Disk o' text
2. Frame the page
3. A master with a mister
4. Link the text boxes
5. Link *all* the text boxes
6. Tell the readers where to go
7. Tell the readers where they've been
8. Fix the last page
9. Your circular is collectible

PROCEDURE 1: DISK O' TEXT

1. Start a new document, **8** inches in each direction, with no margins, one column, and no automatic text box.

2. Use the **Oval Text Box** tool to drag a text box going all the way from the upper-left corner to the lower right of the document.

 You may need to go to the **View** menu and choose **Fit in Window** to be able to see the whole document.

3. On the measurement palette, set **Cols** to **3** then press **Enter** or **Return**. Three text columns appear in the circle.

| X: -0.899" | W: 8" | △ 15° | |
| Y: 1.172" | H: 8" | Cols: ③ | |

The measurement palette can be used to set the number of columns, but if you want to set the space between columns you need to go to the **Item** menu and choose **Modify**. The column settings are on the **Text** tab.

4. Set the angle field above the cols field to **15** degrees. The circle rotates counterclockwise, tilting the columns at a jaunty angle.

5. Get the **Content** tool.

6. From the **File** menu choose **Get Text,** and use the file browser that opens up to select and open a long text file, such as the ones you used in Projects 5 and 6.

. .

A DEEPER UNDERSTANDING:
TEXT COLUMNS AND TEXT BOXES

Even though the circle you made here has three columns, those columns aren't all separate text boxes. QuarkXPress considers this one text box, which is why the text box automatically flowed from one column to the next.

When you set up a new document with columns and the automatic text box option selected, the program treats the entire area between the margins as one text box broken into columns.

PROCEDURE 2: FRAME THE PAGE

1. Use the **Rectangular Picture Box** tool to drag a rectangle fitting the entire document.

 If you're using your own grayscale picture and you haven't added an alpha channel to it, skip this page and move on to the next.

2. From the **Item** menu choose **Frame**. The modify dialog box opens with the frame tab already selected.

3. Set **Width** to **60 pt., Style** to **Deco Plain, Color** to **Black**, and **Shade** to **40%** then click **OK**.

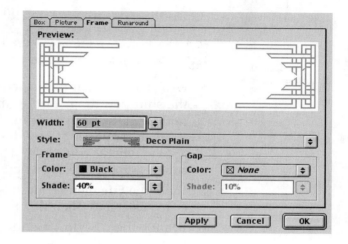

4. On the colors palette, click the **Background Color** button. Set the **Style** drop menu to **Circular Blend**, set color **1** to **White** and color **2** to **Black** with **Shade** set to **30%**. A faint gray appears in the center, fading out to nothing.

5. From the **Item** menu choose **Send to Back**. This decorated rectangle goes behind the circular text box.

6. Click on the circular text box to select it.

7. Use the colors palette to set the **Background Color** to **None**.

 This replaces the white that had filled the background of the text box, letting the background pattern show through.

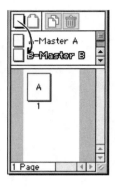

PROCEDURE 3: A MASTER WITH A MISTER

1. On the document layout palette, drag the **Blank Single Page** icon onto the master area. A new master page is created. Double-click its icon to display the master in the document area.

2. Use the **Rectangular Text Box** tool to place a text box over the entire page.

3. On the measurement palette, set **Col** to **3**.

 Remember, you always have to press **Enter** or **Return** after changing values on the measurement palette.

4. Using the **Rectangular Picture Box** tool while holding down the shift key, drag starting from the middle of the page to the middle of the right column. Because the shift key is held down, a square appears. If you drag slightly up, the square appears above where you drag. Drag slightly downward and the square appears below where you drag. You want it below.

5. From the **File** menu choose **Get Picture**, and use the file browser to select and open the picture you used in Project 10.

6. From the **Style** menu choose **Fit Picture To Box (Proportionally).** The picture becomes centered in the box.

 This command fits the picture to the box as best as it can without distorting the image. The picture either becomes as tall as the box with equal amounts of blank space on either side, or it becomes as wide as the box with equal blank space above and below.

7. From the **Item** menu choose **Clipping**, setting **Type** to **Alpha Channel** on the dialog box.

8. Click the **Runaround** tab, set **Type** to **Alpha Channel** and **Outset** to **20 pt.,** then click **OK**.

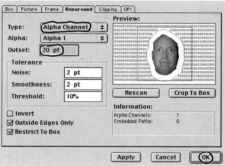

 This lets text run as close as 20 points to the visible edge of the shape. It has this specific effect only because you set both the clipping type and runaround type to the same alpha channel. You could have not used the clipping but still set the runaround type, which would let text run over parts of the picture without touching the face.

PROCEDURE 4: LINK THE TEXT BOXES

1. On the document layout palette, drag **B—Master B** down to the right of page 1 to add a second page. When you do this, the first page is displayed again.

 When you added a new page, the program assumed that you wanted to stop working on your master page. It automatically returned to the last page you were editing, the only page that had previously existed.

2. Get the **Linking** tool from the tool palette.
3. Click the tool on the first page's text box.

 Your first click with the linking tool indicates which text box you want to link *from*.

4. Double-click page **2** on the document palette to display it.
5. Click on the text box of the second page. The text of the story flows across the second page, picking up from where it left off on the first page.

 The second click indicates which text box you want to link *to*.

A DEEPER UNDERSTANDING: LINKING

Linking is used to create a *story*. Now to you or me, a story may be *Little Red Riding Hood* or *The Decline and Fall of the Roman Empire* or that explanation you told mom years ago about why the kitchen floor was covered with macaroni and Ping-Pong balls. To QuarkXPress, however, a story is nothing more than a series of text boxes that a single string of text runs through, with no Ping-Pong balls involved whatsoever.

You can add another text box to a story simply by using the linking tool as you do here. To link more than two text boxes into a story, hold down the Windows **Alt** or Macintosh **option** key while clicking each box in turn. To remove a text box from a story, get the **Unlinking** tool (right below the linking tool on the palette) and hold down **Shift** while clicking the box you want to remove.

PROCEDURE 5: LINK *ALL* THE TEXT BOXES

1. On the document palette, double-click the icon to the left of **B—Master B** to open up this master page for editing.

2. From the **View** menu choose **50%** The page is shown at half size, so it can easily fit on the screen.

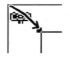

3. Click the **Item** tool on the text box to select it, then drag the upper-left sizing handle down and to the right, so that the text box no longer covers the little broken link icon in the upper-left corner.

 You'll need to interact with this icon, which you can't do while the text box is covering it up.

4. Get the **Linking** tool again, clicking it first on the broken link icon on the upper left of the page and then on the text box. The icon changes to an unbroken link, and an arrow runs from that icon to the text box.

 The unbroken link icon indicates that this page has an *automatic text box*, and the arrow points to that text box. This works just like the text boxes that are generated when you select the automatic text box option when starting a new document, automatically linking these text boxes on every page into a single story.

5. Drag the upper-left corner of the text box back to the upper-left corner of the page.

6. On the document layout palette, drag **B—Master B** down below page **1.** A third page is added. You can now see all three pages of your document in the display window at the same time.

7. Click the **Linking** tool on the second page's text box and then on the third page's text box. The text flows onto the third page. If you have more text, further pages are automatically generated using master B, with the text automatically flowing onto the pages' automatic text boxes.

 You might have to scroll down to see these pages. Unless you're using a facing pages master, QuarkXPress automatically puts only one page on each row.

PROCEDURE 6: TELL THE READERS WHERE TO GO

1. From the **View** menu choose **Fit in Window**, then go to page **1.**

 You can scroll to any page or double-click the page on the document layout palette to pull it up. If you have a large document, however, the quickest way to a specific page may be to go to the **Page** menu, choose **Go to,** and enter the page number in the dialog box that appears.

2. Use the **Rectangular Text Box** tool to drag a small text box in the lower left of the page.

3. On the measurement palette set **H** to **1.2** inches and set the angle to **15** degrees so that the rectangle tilts to match the text column.

4. Use the **Item** tool to move the text box so that the lower-left corner of the text box is where the left edge of the right column meets at the lower-left corner of the right text column.

 If the text box seems to jump around when you get it close to the right location, it's because the lower-right corner is so close to the guide at the right edge of the page that the program assumes you want it on that guide. Go to the **View** menu and choose **Snap to Guide** to turn that feature off.

5. Drag the right-side sizing handle, placing it so that the upper-right corner of the box touches the edge of the text circle.

6. On the color palette, click the **Background Color** button then click **None** so that the edge design is not covered up.

7. Get the **Content** tool then type **CONTINUED ON PAGE** followed by a space.

8. Hold down the Windows **Ctrl** or Macintosh ⌘ key and press **4.** The number 2 appears.

 This key combination tells QuarkXPress to store a special *next page* code. Whenever a text box with that code is displayed or printed, the program finds what text box is overlapped by this text box, then shows the page number of the next text box in that story.

PROCEDURE 7: TELL THE READERS WHERE THEY'VE BEEN

1. On the document layout palette, double-click the icon to the left of **B—Master B.** The master displays for editing.

 If you turned off the *snap to guide* feature, return to the **View** menu and turn it back on. This will make the upcoming steps easier.

2. Using the technique from Procedure 6, add a text box with **CONTINUED ON PAGE,** followed by the page number over the bottom of the right column.

 Instead of the page number, *<None>* appears on the master. This is because the master text box isn't linked to any others. Wherever the text box is used in the document, the next page number appears because the boxes on the actual pages are linked.

3. Add a text box over the top of the left column. In this text box, type **CONTINUED FROM PAGE** followed by a space.

4. Hold down the Windows **Ctrl** or Macintosh ⌘ key, then press **2** to put a pointer to the previous page in the chain.

 Remember, Ctrl or ⌘ plus 3 shows the current page number, and you add one for the next page in the chain or subtract one for the previous.

5. Select the main text box then go to the **Item** menu and choose **Modify**. A dialog box opens.

6. On the **Text** tab set **Text Angle** to **15** degrees.

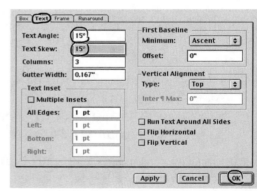

 Click **Apply** to see the effect. The columns tilt within the shape, which doesn't tilt.

7. Set **Text Skew** to **15** degrees.

 This pushes the column back up but leaves the text at the angle it was in the tilted columns. You won't see this on the master because the master has no text.

8. Click **OK.**

PROCEDURE 8: FIX THE LAST PAGE

1. On the document layout palette, click the icon to the left of **B— Master B.** The master is selected.
2. Click the **Duplicate** button. A new master appears on the list.
3. Double-click the icon to the left of **C—Master C.** The master opens for editing, although you won't notice anything because it's an exact duplicate of the master that had been open.
4. Select the **CONTINUED ON PAGE <None>** box in the lower-right corner of the page.
5. From the **Item** menu choose **Delete**. The text box disappears.
6. Go the document layout palette and drag the scroll bar on the page list down to the bottom. The last page is displayed.
7. Drag the icon for **C—Master C** down onto the last page. Now the last page will look like the previous pages, except that it won't have a *CONTINUED ON* message when obviously there is no story left to continue.

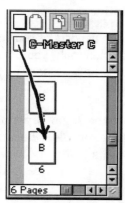

PROCEDURE 9: YOUR CIRCULAR IS COLLECTIBLE

1. Save the file under the name **Circular**.

2. From the **File** menu choose **Collect for Output**. A file browser opens up.

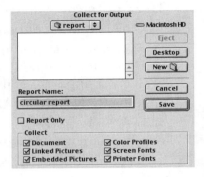

 This command copies all of the files related to your document, including the document file itself, into a single folder. It also changes that copy of the document so that it points to the new related files instead of the original files.

3. Create a new folder by clicking the **New Folder** button and entering a name for that folder. If this folder doesn't automatically become current, double click it.

4. Put checks in all the check boxes in the **Collect** area.

 This includes all of the types of files that might be needed for someone else to open this document. If you're using common fonts, you probably won't need to copy the fonts, but it's better to be safe than sorry.

5. Click **Save**.

6. A dialog box appears warning you about the legal repercussions of sharing some font files with someone else. Because you're not actually sharing these files at this point, however, this is not a concern. Click **OK**, and you'll have a nice folder full o' files!

A DEEPER UNDERSTANDING: COLLECTING

Collecting is an important step for preparing your project for commercial printing. After all, you're going to need to send your files to the print shop. By putting all relevant files into a single folder, you can easily burn them onto a CD-ROM or copy them onto another type of disk. Then all of the files will be in the proper place, and the print shop's copy of QuarkXPress will be able to open when the time comes.

PROJECT 12

PREPRESS FOR A CAR CARD

CONCEPTS COVERED

- ❏ Replacing colors
- ❏ Trapping by color
- ❏ Overprinting
- ❏ Separation

REQUIREMENTS

- ❏ The CarCard file that you created in Project 8

RESULT

- ❏ A recolored document ready to go to press

PROCEDURES

1. Give your car a paint job
2. Throw out the extra paint
3. Rain on everything
4. Set your window traps
5. Knock out your tires
6. Encapsulate your document
7. Separation without anxiety

PROCEDURE 1: GIVE YOUR CAR A PAINT JOB

1. Reopen the **CarCard** file you created in Project 8.

2. Use the **Item** tool to select one of the raindrops. The colors palette, which was grayed out while nothing was selected, is now visible.

3. If you're using a Windows machine, right-click on the palette entry for your car's body color. If you're using a Macintosh, hold down the **ctrl** key while clicking on that entry. A menu appears.

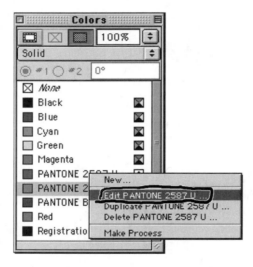

4. Select the **Edit Pantone Whatevercoloryouchose** command from the menu. A color editor appears, automatically opening to the same Pantone model you used for selecting the car color in the first place.

5. Select another cool car color from the color area.

6. Click **OK.** The car changes to the selected color.

 You replaced the original color in your color set with this new color. The new color now appears everywhere in the document where the original color was specified. Because the color is named after its Pantone value, the color may change its position on the colors palette, which is organized alphabetically.

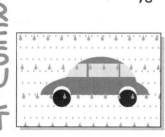

PROCEDURE 2: THROW OUT THE EXTRA PAINT

1. There are plenty of colors on the color palette that you aren't using, and getting rid of some of them will keep your palette simpler. Go to the **Edit** menu and choose **Colors**. A dialog box opens up.

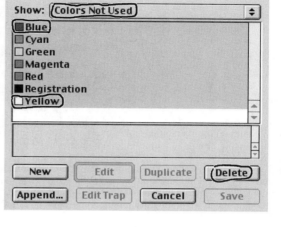

2. From the **Show** drop menu choose **Colors Not Used**. The colors you selected for the car, the tire, and the rain disappear from the list.

3. Click on the first color on the list. It becomes selected.

4. While holding down the **Shift** key click on the bottom color on the list. The entire list becomes selected.

5. Click the **Delete** button. Some of the colors disappear from the list.

 The colors that remain, **Cyan, Magenta, Registration,** and **Yellow,** are permanent and can't be deleted.

6. Click **Save**. The changes to the palette are saved.

 There are some other colors that remain on the colors palette. *White* and *None* aren't actual printing colors.

· ·

A DEEPER UNDERSTANDING: DELETING COLORS

If you just want to delete one or two colors, you don't have to go through all the rigmarole you see here. Merely right-click or ctrl-click on the color name on the colors palette and choose **Delete Whateverthecolorname** from the menu that appears.

When you delete unused colors, you're just simplifying your color list. If you were to delete a color that is actually in use a dialog box would appear asking you which of the remaining colors you want to replace it with. That way, deleting a color doesn't delete any objects from your design; it merely changes them to another color.

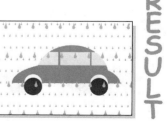

RESULT

PROCEDURE 3: RAIN ON EVERYTHING

1. From the **Edit** menu choose **Colors**. The same dialog box you opened in Procedure 2 opens again.

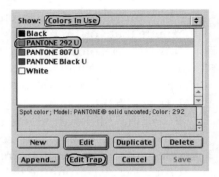

 You didn't have to save your color changes in Procedure 2 and then reopen it here. You could have just left the dialog box open and continued working.

2. Set the **Show** drop menu to **Colors In Use**. Only the colors that are in your image are displayed.

3. Click on your rain color to select it.

4. Click **Edit Trap**. A dialog box opens.

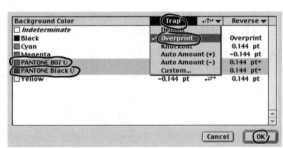

 Trapping is the control of what is printed when one color overlaps or touches another in your design.

5. Click on the auto body color.

6. Hold down the Windows **Ctrl** key or Macintosh ⌘ key and click on the tire color.

 This selects the color in addition to the previously selected color. It's different from using the *shift* key because this does not select any colors listed between the two clicked colors.

7. The **Trap** column header is actually a drop menu. Click it and choose **Overprint**.

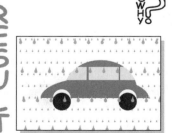

This sets what happens when the rain color is on a higher layer or when it is on the same layer but higher in the stack of items than the auto body or tire color. *Overprint* means that both the rain color and the color it overlaps are printed there. This means that the car will appear to be tinted through the rain, rather than completely blocked by it. The *reverse* column sets what happens if the other color overlaps the rain color.

8. Click **OK** to close this dialog box, leaving the colors dialog box open.

PROCEDURE 4: SET YOUR WINDOW TRAPS

1. On the colors dialog box, select the auto body color.
2. Click **Edit Trap**. The trap dialog box reopens, this time listing what happens when the auto body color overlaps the other colors in your document.
3. Click the rain color to select it.

 Remember, the windows are actually a light shade of the rain color.

4. Click the **?** column header that appears between the *trap* and *reverse* column header. A drop menu opens.
5. Choose **Independent Traps** from the menu that appears.

 Without this option, changing the trapping value for when the body is higher on the stack than the rain color will also change the value when the rain color is higher in the stack than the body. That would change, for example, where the big raindrops touch the car body.

6. Click the **Trap** drop menu and choose **Custom**. A dialog box opens.
7. Enter **.3** point as the trapping value then click **OK**.

 This tells the program to spread the auto body color out by three tenths of a point wherever the auto body color touches the window color and the auto body is on a higher level.

8. Click **OK** to close the trapping dialog box.

..

A DEEPER UNDERSTANDING: TRAPPING

Setting a trapping value like this spreads the color so that it slightly overlaps the lower color. The practical reality of commercial printing is that the paper often shifts slightly when going from one printing press to the next. Without trapping, this could leave a miniscule yet highly visible gap between the two color areas. The small overlap, a fraction of a point, protects against this.

The good news is that you usually don't have to worry about this. It's not that printers are perfect, it's that QuarkXPress automatically sets a little trapping by default.

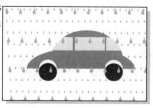

RESULT

PROCEDURE 5: KNOCK OUT YOUR TIRES

1. On the color list, select the Pantone black that you chose as the tire color.
2. Click **Edit Trap**. The trap settings dialog open.

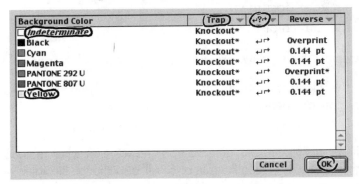

Background Color	Trap ▼	(?▼)	Reverse ▼
Indeterminate	Knockout*		
■ Black	Knockout*	↵↱	Overprint
■ Cyan	Knockout*	↵↱	0.144 pt
■ Magenta	Knockout*	↵↱	0.144 pt
■ PANTONE 292 U	Knockout*	↵↱	Overprint*
■ PANTONE 807 U	Knockout*	↵↱	0.144 pt
Yellow	Knockout*	↵↱	0.144 pt

Cancel OK

3. Click the first color on the list, and then hold down **Shift** and click the last color on the list. The entire list becomes selected.

> **TIP** The *Indeterminate* entry on the list is used to set the trapping when the main color overlaps a multicolored background, such as an inserted photo.

4. Using the same technique as you used in Procedure 4, set the **Independent Traps** option.
5. Open the **Traps** drop menu and choose **Knockout**.

> **WHY** *Knockout* means that there is absolutely no overprint. Wherever the tire color is there is no color for any item lower on the stack. Knockout doesn't always take effect if you're using the color at a shade of less than 100%.

6. Click **OK** to close the trap setting dialog box.
7. Click **Save** to close the color list.

> **TIP** Notice that the document still looks the same onscreen as it did at the end of Procedure 1. The trap settings do not change how the image looks on the screen. The change is only obvious in printed versions, and even then, only if it is commercial-style printing or on color separations.

RESULT

A DEEPER UNDERSTANDING: TRAPPING DEFAULTS

Go to the **Edit** menu and choose **Preferences, Preferences**. On the dialog box that opens up, click **Trapping** to get a screen of trapping settings. There you can set the default spread, as well as the limit of shade density for a knockout to take effect.

PROCEDURE 6: ENCAPSULATE YOUR DOCUMENT

1. From the **File** menu choose **Save Page as EPS**. A file browser opens up.

 EPS stands for Encapsulated PostScript, a standard graphics format. By storing a copy of your file in this format, you can open a copy of a page of your document in Photoshop or other graphic programs.

2. Set the **Name** to **CarCard.eps**, **Format** to **Color**, and **Space** to **RGB**.

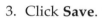 Saving this as an RGB image is the first step to making this an image for the Web, because all Web images are in RGB. If you were saving a process color document, you might want to save this in CMYK space and then use your image-editing program to convert that to RGB, as that program would likely give you more color space conversion options. Because you're working with spot colors in this image, however, you're going to have to convert it to something, either CMYK or RGB, as EPS is not designed for spot color.

3. Click **Save**.

4. If a dialog box opens warning you that saving in RGB space may cause problems with separations, click **OK**. If you're saving in RGB, you're probably aiming for on-screen presentation, and separations are only needed if you're planning for printed presentation.

 Your CarCard.eps file is now ready to be opened by Photoshop or similar graphic editing programs. When you open it, you'll be asked what size and resolution you want the image. This is because the EPS file stores the image as a series of lines and shapes, without any inherent resolution.

RESULT

Procedure 7: Separation without anxiety

1. From the **File** menu choose **Save As** and save the file as **CarCard2**.

 The EPS version only stores an image of the page without layers, trap settings, and so on. To edit this document later you'll need a QuarkXPress format file.

2. From the **File** menu choose **Print**. A dialog box opens.

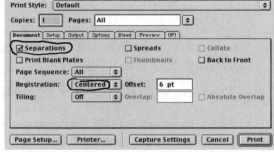

3. Put a check in the **Separations** check box.

 If this check box is grayed out then your printer doesn't understand the PostScript page description language and can't print separations.

4. Set **Registration** to **Centered**.

 This prints marks around the side of the image to show where the edges go.

5. On the **Setup** tab, set **Page Positioning** to **Centered**.

6. On the **Output** tab, set **Plates** to **Used Process & Spot** to print only the plates for the three colors actually used in the image.

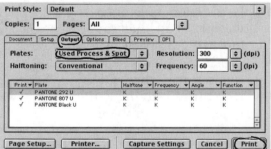

7. Click **Print** and three pages print, each showing where one color appears in the image. These are how the printing plates will look.

A DEEPER UNDERSTANDING: OUTPUT SETTINGS

On the output tab you'll see a number of other settings. The *resolution* and *frequency* settings control the sharpness of the image. On the grid, you can set what color your plates print out in (the default is black), and how the separation will depict the *halftones*, the areas where that color has a shade of less than 100%.

PROJECT 13
MINI MOVIE POSTER

CONCEPTS COVERED

- ❏ Color image adjustment
- ❏ Rich black
- ❏ Kerning
- ❏ Tracking
- ❏ Customizing justification

REQUIREMENTS

- ❏ A color digital picture file

RESULT

- ❏ A small poster for a nonexistent movie

PROCEDURES

1. Bring in a picture
2. Make the picture eerie
3. Enrich your black
4. Entitle your movie
5. Condense your title
6. Make it a sequel
7. Give credit where credit is due
8. Set your H&Js
9. Justify yourself

PROCEDURE 1: BRING IN A PICTURE

1. Start a document, **8** inches wide and **10** inches high, with zero margins and no automatic text box.

2. From the **Edit** menu choose **Preferences, Preferences**. A dialog box opens up.

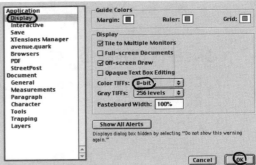

3. In the left column, click **Display**. A list of options for how you view your document appears.

4. From the **Color TIFFs** drop menu choose **8-bit**.

 This sets how precisely your computer displays the color of each pixel of a color image. Although the other settings will show the color more precisely, they will also slow down your operations, making it hard to deal with large documents that have lots of color images. More important for this project is that the program allows you to do certain image processing commands only when you have 8-bit selected.

5. Click **OK**.

6. Use the **Rectangular Picture Box** tool to create a square picture box that covers the whole width and the top **8** inches of the document.

7. Use the techniques from Project 2, Procedures 4 and 5 to put your digital photo into the picture box, with the most interesting portion of the image filling the area.

A DEEPER UNDERSTANDING: DIGITAL IMAGE FORMATS

Most digital photos are stored in the *Joint Photographic Experts Group (JPEG)* format. This is a handy format because it stores a high-quality version of your photo in a reasonable amount of disk space, or a poor version in a very small amount of space. Your computer-created files might be in a *compressed Tagged Image File Format (TIFF)* format, which efficiently stores images with large areas of solid color.

Standard commercial printing systems have problems with both JPEG and compressed TIFF files. If you're actually planning to send something out to be printed, use a graphics program to convert all your files to *uncompressed TIFF* format before adding them to your document. It will eat up a lot of disk space, but it will save your project.

PROCEDURE 2: MAKE THE PICTURE EERIE

1. From the **Style** menu choose **Contrast**. A dialog box opens.

2. Set the **Model** drop menu to **RGB**.

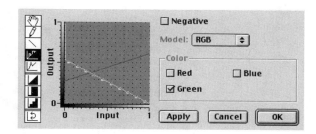

 Although your image may have been stored using any of the listed models to describe the color of each pixel, you can edit the contrast using whatever model you like. By selecting this model, you can easily mess with the color of each pixel by setting how much red, how much green, and how much blue you would mix to make that color.

3. Clear the **Red** check box, leaving checks in the **Green** and **Blue** check boxes.

 You're going to leave the same amount of red in each pixel as when you started. You're just going to change the green and the blue.

4. Use the **Line** tool to drag a line across the contrast box. It should be at an angle, but it should come close to the very center of the box.

5. Clear the **Green** check box and drag a different line across the contrast box, again passing close to the center.

 You should now see three lines across the contrast box: one red, one green, and one blue. Each shows how that color from the original image is changed to create the color of the contrast-altered image. Each line works the same as the contrast line explained in Project 10, Procedure 4.

6. Click **Apply** to see how this change of contrast settings alters the image.

7. If you like the eerie look of the recolored image, click **OK**. Otherwise, use the tools to keep messing with the green and blue color lines, and click **Apply** again. Keep doing this until you make an interesting image, then click **OK**.

RESULT

PROCEDURE 3: ENRICH YOUR BLACK

1. Go to the colors palette, point to **Black**, and either right-click (Windows) or hold down **ctrl** and click (Macintosh). A pop-up menu appears.

2. Choose **Duplicate Black**. A dialog box opens.

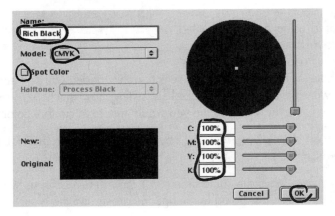

3. Set the **Name** to **Rich Black.**

4. Set the **C, M, Y,** and **K** values to **100%**.

 Don't worry that the *New* and *Original* colors in the dialog box look the same. Your RGB monitor has only one way to display black, and that is by turning off all the color in a pixel. What you're specifying here is an ink mixture, and the black that's created by printing with all four inks looks different from the original black, which just uses the black ink.

5. Click **OK**. An entry marked *Rich Black* now appears on the color palette.

A DEEPER UNDERSTANDING: RICH BLACK

The black that's created by printing all four CMYK inks as solidly as possible on the same spot is actually a blacker black than what you get when you just use black ink. The more ink you pile on a spot, the better it is at blocking light from bouncing off the paper.

Rich black looks better on a color background than does *pure black*. This is not only because the extra darkness gives it a lively contrast, but also because there are fewer trapping problems with rich black. Even if there is a slight *registration* problem with the printed colors not quite lining up, there is still color right up to the edge of the black.

PROCEDURE 4: ENTITLE YOUR MOVIE

1. Using the **Line Text-Path** tool, drag a line straight across your photo, about one-third of the way from the top.

 Remember, holding down **Shift** as you drag will keep this line perfectly horizontal.

2. Get the **Content** tool.

 The font-related settings don't appear on your measurement palette when the item tool is selected.

3. On the measurement palette, set the **Font** to **Impact**.

4. Type the word **ALIEN** followed by a word describing the picture in all capital letters.

5. Drag across the text to select it.

6. On the measurement palette, adjust the **Font Size** so that the text is as big as possible while still fitting on the image.

7. On the colors palette, click the **Text Color** button then click the **Rich Black** entry.

8. Drag across the middle three letters of the word **ALIEN** to select your lie.

9. From the **Style** menu choose **Baseline Shift**. A dialog box opens up.

 Yes, many of the things on the style menu actually open up the same dialog box. The individual commands remain there from earlier versions of Quark, where each command had its own dialog box. You can set the baseline shift in this dialog box no matter what command you used to open it up.

10. Set the **Baseline Shift** value to **–30** then click **OK**. The selected text is now 30 points lower than the rest of the text.

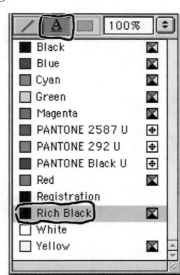

PROCEDURE 5: CONDENSE YOUR TITLE

1. From the **Edit** menu choose **Select All** to select all the text.
2. From the **Style** menu choose **Track**. That same old dialog box opens up.
3. Set the **Track** value to **–10** points.

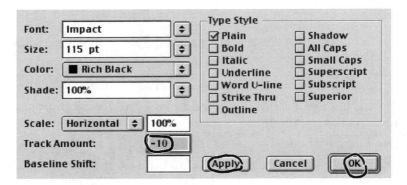

 The tracking value alters the spacing between the letters in a line of text. A positive value increases the spacing, and a negative value brings the letters together.

4. Press **Apply**, and see how the letters come together.
5. If most of the letters are touching the next letter but all are still readable, click **OK**. Otherwise, adjust the **Track** value and try again.

 You want to leave a little space between the *I* and *E* of *ALIEN*. Otherwise, the *I* kind of disappears, just making the spine of the *E* look thicker.

Procedure 6: Make it a sequel

1. Because you squeezed your text together with the tracking, there should now be a gap between the end of the text and the right edge of the poster. Use the **Line Text-Path** tool to drag a horizontal line a smidgen (or a smidgen-and-a-half) under the gap.

2. Set the **Font** to **Times New Roman,** the **Font Size** to **100** point, turn on the **Bold** type style, and type the uppercase letter *i*, twice.

 If both I's won't fit at 100 point, pick a smaller font size.

3. Select both letters.

4. From the **Style** menu choose **Horizontal/Vertical Scale** (or any other command that opens up that same dialog box), set the **Scale** drop menu to **Vertical**, and adjust the value so that the top of the selected letters are now higher than the rest of the logo.

5. Use the **Apply** button to test the value you selected, and click **OK** once you're happy with the height of the letters.

6. Click the **Content** tool right between the **I's**.

7. On the measurement palette, click the **Decrease Kerning** button until the tops and bottoms of the two I's meet.

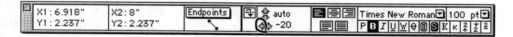

 The same measurement palette buttons used to change kerning can also change tracking.

A DEEPER UNDERSTANDING: KERNING VERSUS TRACKING

Kerning and *tracking* are similar concepts, both addressing the spacing between letters. Tracking sets the general spacing for the text. Kerning adjusts the spacing between just two letters. Kerning adjustment is particularly needed for larger text, such as logos, because specific combinations of letters may leave odd-looking spacing.

QuarkXPress uses the same field to address both kerning and tracking. When you have multiple letters selected, the field is *Track Amount*. When the cursor is between letters, it's *Kern Amount*.

PROCEDURE 7: GIVE CREDIT WHERE CREDIT IS DUE

1. Use the **Rectangular Text Box** tool to create a text box covering the bottom 2 inches of the poster.

2. Use the colors palette to set the **Text Color** to **White** and the **Background Color** to **Rich Black**.

 It's easy to worry when you're putting white text on a rich black background. What if one of the color plates misregisters? You would end up with color blurring the edge of the text, right? The Quark programmers have worried about this, too, so they automatically set the cyan, magenta, and yellow portions of rich black to *choke* (pull back by a certain amount) around the edges of white text. This is an automatic trapping feature.

3. Open that same old text settings box and set the text **Font** to **Helvetica** or **Arial, Font Size** to **14 pt.**, and **Scale** to **Vertical 200%**. Put a check in the **Small Caps** check box then click **OK**.

 Most of this can be set on the measurement palette, but the palette doesn't have scaling control. You want the sort of tall, skinny lettering that appears on movie posters. Of course, you could just get a tall, skinny font, but this is a way to make a tall font out of a font I know you have.

4. Type a set of credits for your movie, including *produced by, written by,* and *starring* credits. Put all the names in **Bold** type style. Type enough to almost fill up four lines of text, but don't press **Enter** or **Return** at the end of each line.

 If you use word processors a lot, you're probably accustomed to holding down the Windows **Ctrl** or Macintosh ⌘ key and pressing **B** to turn on the bold type style. Alas, in QuarkXPress this opens up the frame modify dialog box. To get bold while typing, hold down the **Shift** key while hitting the **Ctrl** or ⌘ + B combination.

Procedure 8: Set your H&Js

1. From the **Edit** menu choose **H&Js**. A dialog box opens.

2. Select **Standard** from the list at the top then click **Edit**.

3. Another dialog box opens listing the *Hyphenation* and *Justification* settings (the H&Js). Clear the **Auto Hyphenation** check box.

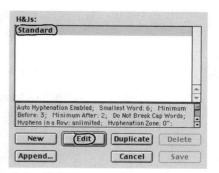

 With this cleared, QuarkXPress won't break any words in the middle when they wrap to a new line.

4. In the **Space** row, set the **Min** or **Minimum** value to **100%**, the **Opt** or **Optimum** value to **110%**, and the **Max** or **Maximum** value to **120%**.

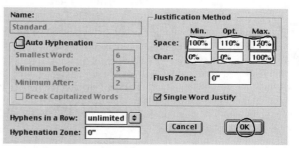

 These fields are used when justified or forced alignment are turned on, which means that shorter lines of text have to be stretched to touch both edges of the column. Normally, most of the stretching is done by stretching out the space between words, but you just indicated that you want those spaces stretched out to no more than 120% of their normal size.

5. In the **Char** row, set the **Min** or **Minimum** value to **0%**, the **Opt** or **Optimum** value to **0%**, and the **Max** or **Maximum** value to **100%**.

 This limits how much the spaces between letters can be stretched to justify the short line. You've set the maximum space between letters to 100% of the normal width of a character, which is a huge gap.

6. Click **OK** to close this dialog box.

7. Click **Save** to close the list of H&J formats.

A DEEPER UNDERSTANDING: H&J SETTINGS

H&J settings are like style sheets. You can create different sets of settings with different names. When creating a paragraph style sheet, you can then select which H&J setting set you want to use.

PROCEDURE 9: JUSTIFY YOURSELF

1. Click the **Content** tool after the last character in the text box to place the cursor there.
2. Go to the **Style** menu and choose **Alignment, Forced**. All lines but the last become justified.

> The *forced* alignment aligns every line in a story or selection except the last one. It even aligns the last lines of paragraphs, which makes it different from the *justified* alignment setting.

3. Press the **Return** or **Enter** key. The last line of your text becomes justified.

> By hitting this key, you've actually added a new blank line, so the last visible line of text is no longer actually the last line, and thus becomes justified.

4. From the **Edit** menu choose **Select All** to select all of the text.
5. From the **Item** menu choose **Modify**.

6. On the **Text** tab, go to the **Vertical Alignment** area and set **Type** to **Justified,** then click **OK**. The spacing between the lines is expanded so that the first line is at the top of the text box, the last line is at the bottom, and the other lines are evenly spaced in-between.
7. Save the file under the name **Movie**.

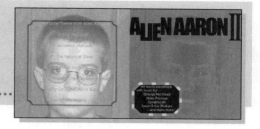

PROJECT 14
SOUNDTRACK CD COVER

CONCEPTS COVERED

- ❏ Appending
- ❏ Trapping by item
- ❏ Decolorizing
- ❏ Vertical justification

REQUIREMENTS

- ❏ The mini movie poster you created in Project 13 and the bowling diagram you made in Project 9

RESULT

- ❏ The booklet cover for the soundtrack CD for your movie

PROCEDURES

1. Shrink the poster
2. Get that bowling line
3. Announce your artists
4. Trap your blurb
5. The back of the booklet
6. Eliminate color
7. List your songs

PROCEDURE 1: SHRINK THE POSTER

1. Open the **Movie** file that you saved in Project 13.

2. Go to the **File** menu and choose **Save As,** then save the file under the name **CDCover**.

 It can be very easy to instinctively save your file while you're working on it, and generally it's a good idea. You don't want to wipe out your movie poster when you save it.

3. Click the **Item** tool on the credits text box to select it.

4. Go to the **Item** menu and choose **Delete** to eliminate the credit box.

5. From the **Edit** menu choose **Select All** to select all the remaining elements of the poster.

6. From the **Item** menu choose **Group** to treat everything as a single item for resizing.

7. While holding down the **Shift** key and the Windows **Ctrl** or Macintosh ⌘ key, drag the lower-right corner of the selection up and to the left until it's about 4 inches wide and high.

 The *shift* key keeps it square, while the other key reduces the font size to keep the text fitting in the space.

8. From the **File** menu choose **Document Setup**. A dialog box opens.

9. In the **Width** field, enter **4+3/4**. In the **Height** field, enter **4+11/16** then click **OK**.

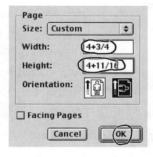

 This is how you enter the new document size of 4 3/4 inches by 4 11/16 inches without worrying about dividing out the decimal value. No math!

10. While holding down the Windows **Ctrl** or Macintosh ⌘ key, drag the lower-right corner of the group down to the new lower-right corner of the document. Because the document is not quite square, this will distort your picture somewhat, but the distortion will be so small that it won't be detectable.

PROCEDURE 2: GET THAT BOWLING LINE

1. From the **File** menu choose **Append**. A file browser opens.
2. Locate and select the **410Split** file you saved in Project 9 then click **Open**. Another dialog box opens.

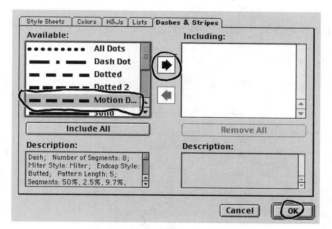

3. Click the **Dashes & Stripes** tab.
4. Select the **Motion Dash** in the left pane, and click the **Append Item** arrow button to move that entry into the right pane.
5. Click **OK**. The motion dash design is copied from the 410Split document into the current document.

A DEEPER UNDERSTANDING: APPENDING

Using the same command that you just used to copy a dash design from another file into your current file, you can also copy style sheets, colors, lists, and H&J settings that you created in another file. That way, you don't have to keep reinventing the wheel. If you need a feature from a previous file, you can just steal it.

Appending is similar to the synchronizing that you did to transfer masters between documents when making the book in earlier projects. Use synchronizing when you want the documents to remain related, such as the chapters in a book. When you want to borrow elements from a totally unrelated document like the bowling diagram, use the append command.

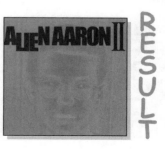

RESULT

PROCEDURE 3: ANNOUNCE YOUR ARTISTS

1. Get the **Beveled-corner Text Box** tool.
2. Drag a text box onto your image. The size and placement are up to you. You don't want to cover too much on your picture, but you want room for clear text.
3. From the **Item** menu choose **Frame**. A dialog box opens up.

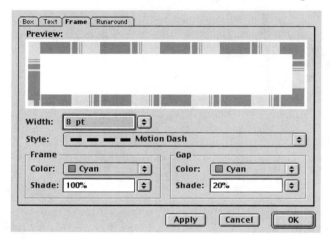

4. Set **Width** to **8 pt.** and **Style** to **Motion Dash**.
5. In the **Frame** area, set **Color** to **Cyan** and **Shade** to **100%.**
6. In the **Gap** area, set **Color** to **Cyan** and **Shade** to **20%.**

 The gap color fills the area of the outline not covered by the dash design.

7. Click **OK**.
8. Get the **Content** tool, then use the colors palette to set the **Background Color** to **Rich Black** and the **Text Color** to **Cyan** with a **Shade** of **20%.**
9. Put a description of the soundtrack and the bands on it in the text box. Style it however you wish. By now, you should know the basic text tools well enough to do this.

 If you haven't already done so, you'll probably want to go to the **View** menu and adjust your view of the document, so you're not trying to write in a space so small that you can't see what you're writing.

PROCEDURE 4: TRAP YOUR BLURB

1. From the **View** menu choose **Show Trap Information**. A new palette opens up.

2. Set the **Gap Outside** drop menu to **Overprint**.

 This sets the trap for how the gap in the frame relates to the photo. *Gap Inside* sets the trap information for how the gap relates to the rich black background of the text box.

Background:	Default		
Frame Inside:	Default	0.144 pt	i
Frame Middle:	Default	Overprint	i
Frame Outside:	Custom	0.2 pt	
Gap Inside:	Default	0.144 pt	i
Gap Outside:	Overprint		
Text:	Default	0.144 pt	i

3. Set the **Frame Outside** drop menu to **Custom**, and type **.2** into the value field to set it to a fifth of a point.

 This sets the trap for how the darker part of the frame relates to the photo. *Frame Middle* sets how the frame color relates to the gaps in the frame design. *Frame Inside* sets the trap information for how the frame color relates to the background of the text box.

4. From the **View** menu choose **Hide Trap Information** to get rid of this palette, so it's not in the way while you're working on other things.

A DEEPER UNDERSTANDING: TRAP INFORMATION PALETTE

As you see here, the trap information palette can be used to set the trap information for specific portions of the currently selected object. These settings override the settings by color like the ones you set in Procedure 12, and those settings override the ones you set in the Preferences.

The palette also gives you information about just what is setting the trap for a given element. For any element where the drop menu is set to *Default*, a button with an i on it appears at the right. Click that **i** and a display appears listing the color of the element and the color it's being trapped against. Below that is a list of the two sources for default trapping, with the active one highlighted. Below *that* is a list of special properties that QuarkXPress has special rules for, and the ones that apply to the current element are highlighted.

RESULT

PROCEDURE 5: THE BACK OF THE BOOKLET

1. On the document layout palette, drag the **Blank Single Page** icon onto the left edge of the page that's already in the layout. Release your mouse button when the pointer turns into a leftward-pointing arrow.

 Even though what you're adding is the last page, by adding it next to the front page you're creating a *zpread*. You could print this right out of your printer and fold it in half.

2. Go to the front page and click the **Item** tool on the photo.

3. From the **Item** menu choose **Ungroup**.

 The program still thinks of the picture box and the logo as a single item because you turned it into a group in Procedure 1. You want to copy just the picture box.

4. Click the **Item** tool on a blank area to deselect everything.

 After you ungroup the group, all of the elements of the group are still selected. Because you only want one item selected, it's quicker to deselect everything and then to reselect that item.

5. Click on the photo.

6. From the **Edit** menu choose **Copy**.

7. Go to the back cover.

8. From the **Edit** menu choose **Paste**.

9. Drag the picture into place, covering the back cover.

RESULT

PROCEDURE 6: ELIMINATE COLOR

1. With the back cover photo still selected, go to the **Style** menu and choose **Contrast**. A dialog box opens up.

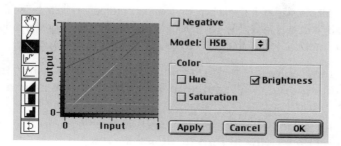

2. Set the **Model** drop menu to **HSB**. Three check boxes appear below: one each for hue, saturation, and brightness.

3. Clear the check marks from the **Hue** and **Brightness**, leaving **Saturation** checked.

4. Use the line tool to draw a horizontal line low across the contrast box.

 Click the **Apply** button to see how this drains the color from the image. By putting the saturation low but not all the way at zero, you leave the picture with a tint of color, although not very much.

5. Clear the **Saturation** check box and put a check in the **Brightness** check box.

6. Drag a line starting midway up the left side of the contrast box and ending in the upper-right corner.

 This lightens the entire image while still keeping the darker parts darker than the lighter part.

7. Click **OK**.

 Before you do this, try experimenting with the hue line. By drawing a straight line across the contrast box, you can tint the entire photo a single color. If you draw wild squiggles, you can turn all the reds into purples, all the purples into yellows, and other psychedelic effects. Then click the **Normal Contrast** tool button on the left (the one with the clean diagonal slice) to return the hue settings to normal.

RESULT

PROCEDURE 7: LIST YOUR SONGS

1. Use the **Concave-corner Text Box** tool to create a text box going one-half inch from all the edges of the back cover.

 You can set the size of the text box on the measurement palette by setting **W** to **3+3/4** and **H** to **3+11/16**. If you do this, make sure that you delete the quote marks (") from the fields so as not to confuse the program.

2. Create a new color, a dark purple named **Purple**, using the **CMYK** color model. Make sure the **Spot Color** option is turned off when you do so.

3. From the **Item** menu choose **Frame**, and set the frame to an **8 pt.** wide **Thin-Thick** stripe in **Purple**, then click **OK**.

4. Set the **Background Color** to **None** and the **Text Color** to **Purple**.

5. In the text box, type the names of the songs on your soundtrack, using your choice of font and size but setting the **Type Style** to **Outline** and **Alignment** to **Centered**.

6. From the **Edit** menu choose **Select All** to select all of the text in the text box.

7. On the measurement palette click the **Increase Leading** up arrow repeatedly. This changes the *leading*, the space between lines of text. Keep clicking it until the last line of text disappears from the text box, then click the **Decrease Leading** down arrow below it once. The line of text reappears, and the text is spaced as far apart as possible while still fitting in the box.

| X: 0.5" | W: 3.75" | ◿ 0° | 34 pt | Helvetica | 12 pt |
| Y: 0.5" | H: 3.687" | Cols: 1 | 0 | PBKUWⒶⓄⓈK k 2 2 | |

 You can't use the vertical justification technique you used in Project 13, Procedure 9, because that technique only works on rectangular text boxes.

8. Go to the **File** menu and choose **Save** to save the file. Now you have everything you need for a soundtrack CD—except for a movie, a bunch of recorded songs, and a CD manufacturing plant.

RESULT

PROJECT 15

A CATALOG OF PROJECTS

CONCEPTS COVERED

❏ Advanced table techniques
❏ Transferring elements between documents
❏ Style sheet palette

REQUIREMENTS

❏ The bowling diagram you made in Project 9, the CarCard2 file and CarCard EPS file you made in Project 12, and the CD booklet you created in Project 14

RESULT

❏ A catalog of some of the projects you've completed

PROCEDURES

1. Set the table
2. Merge some cells
3. Decorate the edges
4. Show off your car
5. Recover the CD cover
6. Bring in a split
7. Label an image
8. Label another image
9. Label more images, fun fun fun
10. Catalog the catalog

PROCEDURE 1: SET THE TABLE

1. Start a new document, **11** inches wide, **8.5** inches high, with **1/2** inch margins on the side and **1/4** inch margins on the top and bottom and no automatic text box.

2. Use the **Tables** tool to drag a table into place, covering the entire area within the margins. A dialog box opens up.

3. Set **Rows** to **8**, **Columns** to **10**.

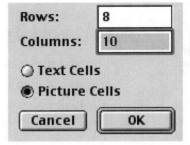

 This creates a table where each cell is one square inch.

4. Choose the **Picture Cells** option.

 Most of the *cells*, the individual squares of the table, will be used to store pictures. Some of the cells will be used to store text, but you'll be able to convert those cells into text cells when the time comes.

5. Click **OK**. The table appears.

 The X's in the cells of the table won't appear in the printout. They're just there to indicate that these are empty picture cells

PROCEDURE 2: MERGE SOME CELLS

1. Click the **Content** tool.

2. While holding down the **Shift** key, click on the lower-right-hand corner cell to select it.

3. With the **Shift** key still down, click the cell to the left of the currently selected one. It becomes selected as well, turning into the reverse color.

 If the color doesn't reverse, you may be running into an odd problem that crops up sometimes where you cannot select cells near the bottom margin of the page. Drag the bottom sizing handle upwards until the table is about half of its original size then try again.

4. Continue to hold down the **Shift** key, and click. Select a block 6 cells wide and 4 cells high in the lower-right corner.

 You may need to reselect the first cell you selected.

5. If you're using Windows, right-click on the selected area. If you're using a Macintosh, hold down **ctrl** while clicking on it. A pop-up menu appears.

 Most items and most palettes have this type of pop-up menu, filled with commands that are specific to the item. Often, you can get to a command much quicker via this pop-up menu than by going to the menu bar.

6. Choose **Table, Combine Cells** from the menu that appears. The selected group of cells turns into one huge cell.

 If you resized the table, drag the sizing handle back down to the bottom margin now.

. .

A DEEPER UNDERSTANDING: SELECTING CELLS

You can select an entire horizontal row of cells by pointing just outside the edge of a selected table. When the arrow turns into a horizontal arrow, click and the row is selected, or drag up or down to select several rows. The same technique works for selecting vertical columns of cells, pointing above or below the column then clicking or dragging horizontally.

RESULT

PROCEDURE 3: DECORATE THE EDGES

1. Bring up the table's pop-up menu and choose **Gridlines, Select Vertical**.

 The pop-up menu's *table* and *gridlines* submenus can also be found on the *item* menu.

2. From the **Style** menu choose **Shade, 0%** to hide the vertical lines.

 Some of the vertical lines may still be visible because they're currently selected and thus are highlighted.

3. From the pop-up menu choose **Gridlines, Select All**.

4. From the **Item** menu choose **Modify**. A dialog box opens up.

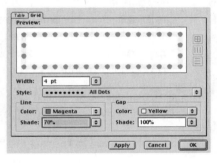

5. On the **Grid** tab, set **Width** to **4 pt.**, and **Style** to **All Dots**. In the **Line** area, set **Color** to **Magenta** and **Shade** to **70%**. In the **Gap** area, set **Color** to **Yellow** and **Shade** to **100%**. Click **OK**. A yellow line with pink dots outlines the table.

6. Go to the pop-up menu yet again and choose **Gridlines, Select Horizontal**.

7. From the **Style** menu choose **Width, 1 pt**. The top and bottom yellow and pink lines become really thin.

8. Return to the **Style** menu and choose **Shade, 0%.** Most horizontal lines disappear altogether, although the yellow parts of the top and bottom lines remain.

 The shade setting sets the line shade, not the gap shade.

9. On the **Style** menu, again set the **Line Style** to **Solid**. The yellow top and bottom disappear.

This may seem like a lot of work to get these results. Theoretically, you could have selected all the gridlines, turned them invisible, then selected the two vertical borders by clicking on them and setting the style for those two lines. Although the interior guidelines are easily selected individually by clicking on them, it's hard to do that with the border lines, particularly when they're sitting right on the margins. With all of the item controls and the margins right there, QuarkXPress can get confused easily about what you're trying to click on.

PROCEDURE 4: SHOW OFF YOUR CAR

1. Point the **Content** tool at the big cell in the lower right, bring up the pop-up menu, and choose **Get Picture.**

2. A file browser opens. Select the **CarCard.EPS** file you made in Project 12, then click **Open**. The picture appears.

3. From the **Style** menu choose **Fit Picture to Box (Proportionally).**

This image was 4 inches by 6 inches. Because you selected a 4 × 6 grid of squares, shouldn't it be the right size already? The table's 10 inch width actually includes not only the size of the cells but also the size of the thin lines between the cells. This makes the big cell area just a point thinner in each dimension than you would expect.

4. From the **File** menu choose **Open** and open the **CarCard2** file from Project 12. This window is in front of the other window.

5. Use the technique from Project 12, Procedure 6, to save this as an EPS file, but set **Space** to **CMYK** instead of RGB. Name it **CarCard.eps** and save it in the directory you saved it in before.

When you're preparing something for print, you want all your images to be grayscale or CMYK. RGB files are only for screen display.

6. A dialog box appears. Click **Replace** or **Yes.**

7. From the **File** menu **Close** to close the CarCard2 file.

8. If you're using Windows, select the car image, repeat steps 1 to 3 to update it, then move on to Procedure 5. If you're using a Macintosh, double-click the car image in the table. A dialog box opens.

9. Click the **Get Edition Now** button to update the image.

The program will always include the current version of the picture file when you collect the document for publishing.

PROCEDURE 5: RECOVER THE CD COVER

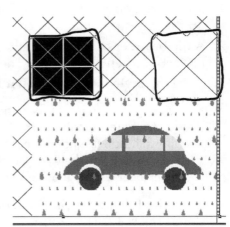

1. Using the same technique you used in Procedure 2, select a grid 2 cells wide and 2 cells high just above the car picture over at the right edge of the table, and combine them into a single cell.

2. Create another square combined cell the same size, just over the upper-left corner of the car picture.

3. Open the **CDCover** file you created in Project 14 and display the back cover.

4. Save an **EPS** version of it like you just did with the CarCard, naming it **CDBack.eps**.

5. Select the front cover page and save an **EPS** version, naming it **CDFront.eps**.

Remember, each EPS file can only store one page of a multipage document, so you can't have both the front and back in a single file.

6. Close the **CDCover** file.

7. Using the same technique you used in Procedure 4, import the **CDFront.eps** picture into the left large cell and the **CDBack.eps** picture into the right one, fitting each picture proportionally into the space.

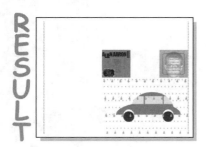

PROCEDURE 6: BRING IN A SPLIT

1. Open the **410split** file you created in Project 9.
2. With the **Item** tool selected, go to the **Edit** menu and choose **Select All**. All of the contents of the document become selected.
3. From the **Item** menu choose **Group** to turn all of the contents into a single item.
4. From the **Edit** menu choose **Copy** to copy the entire diagram onto the clipboard.
5. If you're using Windows, go to the **Windows** menu. If you're using a Macintosh, go to the **View** menu and open the **Windows** submenu. At the bottom of the menu is a list of all the documents you have open at the moment, which should be just the 410split document and the table document. Select the table document name, which is likely **Document1** unless you've saved it under another name, and the table document comes to the front.
6. From the **Edit** menu choose **Paste**. The bowling diagram appears in front of the table.

 Doing this adds to the new document any style sheets, dash designs, colors, and other attributes that you used in the copied material.

7. On the measurement palette, set **X** to **1/2+4/72** and **Y** to **1/4** then hit **Enter** or **Return**.

 This will put the diagram in the upper left of the table. The *1/2* and *1/4* measurements are for the margins. The *4/72* makes up for the 4 point wide left border, each point being 1/72 of an inch.

8. Use the method from step 5 to make **410split** the current document.
9. From the **File** menu choose **Close**. When you're asked if you want to save the changes, click **No**.

PROCEDURE 7: LABEL AN IMAGE

1. Select the four cells immediately below the bowling diagram and turn them into a single cell.

2. Point to the wide cell you just made, bring up the pop-up menu, and choose **Content, Text**. The cell converts into a text cell.

3. From the **Item** menu choose **Modify**. A dialog box opens.

4. On the Text tab put a check in the **Multiple Insets** check box and set **Top** to **10 pt** and **Left** and **Right** to **5 pt.**

 This keeps the text away from the edges of the box. You want a bit more distance from the top because the bowling diagram actually overlaps the cell slightly.

5. Click **OK.**

6. Type the words **Bowling diagram** into the cell, using your own choice of type, size, and color, with **Alignment** set to **Centered.**

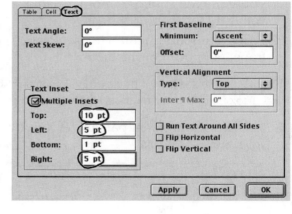

7. From the **Edit** menu choose **Style Sheets.**

8. On the dialog box that appears, click **New** and choose **Character** from the menu that appears. Another dialog box appears.

9. In the **Name** field, enter **labels**, click **OK** to close this dialog box, then click **Save** to close the other dialog box. Now the current text settings are saved as a style sheet.

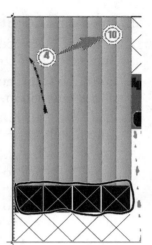

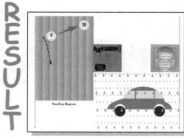

PROCEDURE 8: LABEL ANOTHER IMAGE

1. Drag the **Line Text-path** tool across the row of picture cells in the lower-left corner to create a line that ends at the car image.

2. From the **View** menu choose **Show Style Sheets**. The style sheet palette appears.

 If the command *Hide Style Sheets* is there instead, this means the style sheets palette is already open, although it may be buried under other palettes. If you don't see it, choose the **Hide Style Sheets** command, then return to the **View** menu and choose **Show Style Sheets** again to bring the palette to the front.

3. With the **Content** tool selected, click on the **labels** entry on the style sheets palette.

4. Type the words **Picture of Bumpmobile**.

5. On the colors palette, set the **Line Color** to **Black**.

6. Select the **Item** tool.

 This way, the measurement palette will display information about the line rather than the text.

7. On the measurement palette, set **W** (for *width*) to **4 pt.** and choose a rightward-pointing arrow from the arrow menu.

A DEEPER UNDERSTANDING: STYLE SHEETS PALETTE

The style sheets palette lets you select character or paragraph style sheets quickly for currently selected text or for the text you're about to type. You can also edit or delete a style sheet quickly by pointing to it and bringing up its pop-up menu.

RESULT

PROCEDURE 9: LABEL MORE IMAGES, FUN FUN FUN

1. Select the four picture cells between the CD booklet's front and back covers and turn them into one text cell.
2. From the **Item** menu choose **Modify**. A dialog box opens.
3. On the **Text** tab set **Vertical Alignment** to **Centered** then click **OK**.

4. Select the **labels** style sheet and set **Alignment** to **Centered**.
5. Type **CD**, press **Return** or **Enter**, then type **booklet**. The words end up centered in the cell.
6. On the colors palette, press the **Background Color** button, set the **Style** to **Full Circular Blend**, and set color **#1** to **Black** and color **#2** to **White**.
7. Above the CD covers are two rows of six cells remaining. Combine the left three cells from both rows into a single cell and put the words **This catalog** in it, right-justified, vertically centered, and using the **labels** style sheet.
8. Six individual cells remain in the upper-right corner. Combine them into one picture cell.

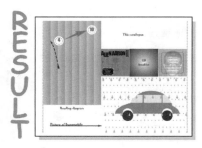

PROCEDURE 10: CATALOG THE CATALOG

1. Save the page in EPS format, naming it **catalog.eps**.

2. Use the **Content** tool to select the upper-right cell, bring up the pop-up menu, choose **Get Picture**, and select and open **catalog.eps** as the picture. Now you have a picture of the catalog in the catalog.

3. From the **Style** menu choose **Fit Picture to Box (Proportionally)**.

4. Save the page again in EPS format, again naming it **catalog.eps**. When asked if you want to replace the existing file, click **Replace** or **Yes**. Another dialog box appears, warning you that pictures are either missing or have been modified.

> ⚠ **Some disk files for pictures in this document are missing or have been modified. Continue?**
>
> [List Pictures] [Cancel] [OK]

5. Click **OK**.

6. Use the technique from Procedure 4 to update the catalog picture. Now the picture includes the picture of the catalog in it.

7. Repeat steps 4 through 6 to place a picture of the catalog in the picture of the catalog in the picture of the catalog. You can repeat this process to get smaller and smaller details in there if you wish, but I'm not going to rework that last sentence again and again.

8. Save the file as **Catalog**.

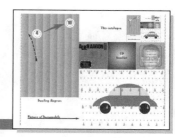

RESULT

PROJECT 16

DECEMBER CALENDAR

CONCEPTS COVERED

- ❏ Converting text to tables
- ❏ Libraries
- ❏ Print styles

REQUIREMENTS

- ❏ None

RESULT

- ❏ A one-month calendar

PROCEDURES

1. Make some dates
2. Adjust the grid
3. Make your logo
4. Motto-go-round
5. Be a librarian
6. Organize your library
7. Style your printing
8. Print in style

PROCEDURE 1: MAKE SOME DATES

1. Start a new document, **6** inches wide, **8** inches high, with **1/4** inch margins all around and the **Automatic Text Box** option turned on with **Columns** set to **1.**

2. Click the **Content** tool in the text box.

3. Set the **Font** to **Helvetica** or **Arial** and **Font Size** to **6** pt.

4. Type:

 SUNDAY,MONDAY,TUESDAY,WEDNESDAY,THURSDAY, FRIDAY,SATURDAY then press **Return** or **Enter** to start a new line.

 These will become the entries in the first row of a table. The commas mark where one cell ends and the next begins.

5. Type **,,,1,2,3,4** then start a new line; type **5,6,7,8,9,10,11** and start another new line; then type **12,13,14,15,16,17,18** and start another new line; then type **19,20,21,22,23,24,25** *Christmas* and then type **26,27,28,29,30,31** *New Year's Eve* and you're done.

 To quickly turn on or turn off the italics just hold down the Windows **ctrl** or Macintosh ⌘ key and the **Shift** key and press **I.**

6. From the **Edit** menu choose **Select All** to select all the text.

7. From the **Item** menu choose **Convert Text to Table**. A dialog box opens.

 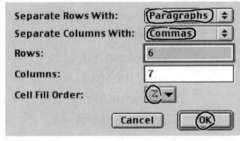

8. Set **Separate Rows With** to **Paragraphs** and **Separate Columns With** to **Commas.**

9. Click the **Cell Fill Order** drop menu button and choose **Left to Right, Top Down.**

 You don't have to set the number of columns or rows. The right values are calculated automatically based on the number of lines, paragraphs, and commas you have.

10. Click **OK.** A new table appears displaying a calendar for December 2005.

RESULT

PROCEDURE 2: ADJUST THE GRID

1. Use the **Item** tool to select text box, which is still visible above and to the left of the table.

2. From the **Item** menu choose **Delete** to get rid of the text box.

3. Drag the table, placing it so that it's right between the margins.

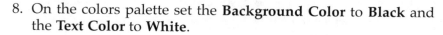 Tables generated by the text to table feature are the same size as the text box the text was in.

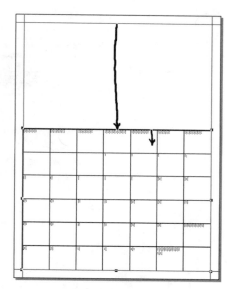

4. Point to the sizing handle in the middle of the top edge and drag it down to about the 3 1/2 inch mark.

5. Get the **Content** tool and point it to top edge of the table but not on a sizing handle. When the pointer becomes a horizontal line with up-and-down arrows coming out of it, start dragging the top edge downward. The rest of the lines stay in place, so this drag just makes the top row shorter. Make the row just a little taller than the text it holds.

6. Move the pointer so it's next to the table, right next to the first row. When the pointer turns into a sideways arrow, click. The first row becomes selected.

7. From the **Style** menu choose **Alignment, Center**.

8. On the colors palette set the **Background Color** to **Black** and the **Text Color** to **White**.

A DEEPER UNDERSTANDING: TEXT TO TABLE

The *convert text to table* function is handiest when you import text where you might have a comma-separated or tab-separated list. Typing a table like this is also handy because you can correct what goes in which cell by just moving a comma, rather than having to copy from one cell and paste to another. The text box remains when you make the conversion so that if the table doesn't come out right, you can delete the table and correct the text.

RESULT

PROCEDURE 3: MAKE YOUR LOGO

1. On the upper half of the page drag the **Line Text-Path** tool from the left margin to the right, holding down the **Shift** key to keep the line strictly horizontal.

2. On the line, type **WORLD SMOOTHERS, INC.**, with two spaces between the first two words. Use the **Impact** font at **24 pt.** size, the **Bold** and **Shadow** type styles, with the **Type Color** set to one of the Pantone colors, **Horizontal Scaling** set to **200%**, **Track Amount** set to **–30**, and **Alignment** set to **Centered**.

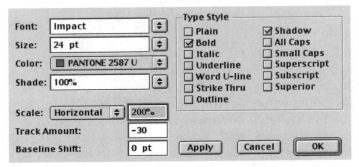

 The negative alignment value will cause the letters to overlap each other. Putting two spaces between the two words helps keep the letters from overlapping.

3. Use the **Item** tool to drag the item up so that the tops of the letters are near the top margin.

When you get the item close, you can use the up-and-down cursor keys to fine-tune the placement.

4. From the **Item** menu choose **Duplicate**. A second logo appears.

5. Drag the copied logo down until it's just above the calendar grid, with the end points touching the left and right margins.

6. Select the text on the copied logo by switching to the **Content** tool then going to the **Edit** menu and choosing **Select All**.

 You can also select by dragging across the text.

7. Type **December**.

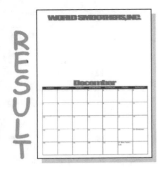

PROCEDURE 4: MOTTO-GO-ROUND

1. Use the **Oval Text Box** tool to draw a circle **2.75** inches across between the logo and the December text.

2. Go to the **Item** tool and, from the **Shape** submenu, pick the squiggly line.

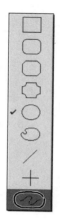

This doesn't actually change the shape. Instead, it tells the program to think of the circle as if it was drawn with the freehand text path tool. This means that the text will appear along the edge of the shape rather than inside it.

3. With the **Item** tool selected, set the line's **Weight** to **20 pt.** and the **Line Color** to the same Pantone color you picked for the logo.

4. From the **Item** menu choose **Modify**. A dialog box opens.

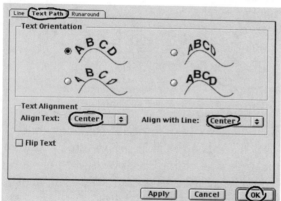

5. On the **Text Path** tab, set **Align Text** to **Center** and **Align with Line** to **Center,** then click **OK**.

By default, the text is placed so that the *baseline*, the bottom of the non-dangly letters, sits on the line. You've just changed it so that the center of the text is on the center of the line.

6. Click the **Content** tool.

7. Set the **Font** to **Impact**, the **Font Size** to **18 pt.**, the **Text Color** to **White**, the **Type Style** to **Bold, Horizontal Scaling** to **200%,** and Alignment to Forced.

8. Type **..WE MAKE THE WORLD GO ROUND..** and then press **Return** or **Enter**.

Hitting Return or Enter makes the forced justification apply, which causes the text to spread across the full circumference of the circle.

PROCEDURE 5: BE A LIBRARIAN

1. From the **File** menu choose **New, Library**. A file browser opens up.

2. In the **File Name** or **Library Name** field, type **Corporate** then click **Create**. A new palette opens up.

3. Drag the **World Smoothers, Inc.** logo onto the corporate library palette. A small version of the logo appears on the palette.

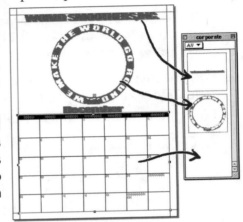

 Remember, the actual object you're dragging is the line that the logo rests on. You'll have to point to that line to grab the item with your drag.

4. Drag the circular motto onto the library palette.

 Be very careful doing this. It's easy to accidentally drag one of the points and thus alter the shape of the circle. Try dragging from the inner rim of the circle. Be sure to drag it to a blank area of the library palette, because if you release it over an item already in the library, the program thinks you want to replace that item.

5. Drag the calendar grid onto the library palette.

A DEEPER UNDERSTANDING: LIBRARIES

Libraries are simply files in which you can store QuarkXPress items. By keeping files in relevant libraries, you can easily get at an element to reuse it. If you're working on a document and you want to get a cool version of your logo, you don't want to have to dive back into all of your documents to figure out which one you used it in. Whenever you create an element that you might want to reuse, just store it in a library. To reuse the element, use the **File** menu's **Open** command to reopen the library, then just drag the item out of the library and onto your document!

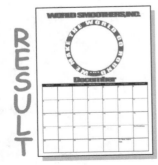

R
E
S
U
L
T

PROCEDURE 6: ORGANIZE YOUR LIBRARY

1. On the library palette, double-click your logo. A dialog box opens up.

2. In the **Label** field type **Branding** then click **OK**.

 This is used to sort your library entries into categories. You just created a category named *Branding*.

3. Using the same technique from steps 1 and 2, give the calendar grid the label **Calendar**.

4. On the library palette, double-clickthe motto. The dialog box opens up again.

5. Click the drop menu button at the right of the **Label** field and choose **Branding** from the list that appears, then click **OK**.

6. Choose **Branding** from the drop list at the top of the library palette. Now the logo and the motto are shown, because those are the two items in the branding category.

RESULT

PROCEDURE 7: STYLE YOUR PRINTING

1. From the **Edit** menu choose **Print Styles**. A dialog box opens up.

2. Click **New**.

3. Another dialog box opens up. In the **Name** field type **Registered output**.

4. On the **Document** tab, set **Registration** to **Centered** and **Offset** to **10 pt.**

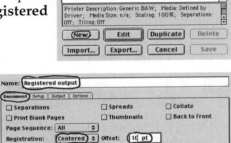

 Because you're printing a document on paper that's larger than the document, it will be hard to see where the edges are on the printout. Registration places tic marks to show the edges and corners of the document. The offset is how far the tic marks are from the edge of the document.

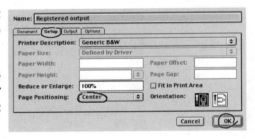

5. On the **Setup** tab, set **Page Positioning** to **Centered**.

 If page positioning is grayed out, set **Printer Description** to Generic Imagesetter.

6. Click **OK** to close the second dialog box.

7. Click **Save** to close the first dialog box.

A DEEPER UNDERSTANDING: PRINT STYLES

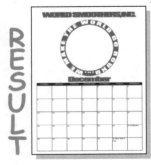

As you've just seen, a print style simply stores a set of options for printing. Even though the dialog box for creating print styles looks like the ones for creating H&Js or style sheets, there is one major difference: print styles aren't stored in the document. Instead, every print style you create is stored in a master file. That way, if you have a group of settings that you like to use for separations and another group that you use for printing *thumbnails* (pages full of miniature versions of the pages of your document), you can store them as print styles and quickly access them from any document you're working on.

PROCEDURE 8: PRINT IN STYLE

1. On the document layout palette, click page **2** then click the **Delete** icon.

 Where the heck did page 2 come from? When you first created the table, it overlapped the automatic text box, so there wasn't enough room in the text box for the text. Because it was an automatic text box, the excess text flowed onto page 2. Then you deleted the text box on the first page, so the whole story moved into the text box on the second page.

2. When a dialog box asks you if you really want to delete that page, click **OK.**
3. Save the file, naming it **Calendar**.
4. From the **File** menu choose **Print**. The print dialog opens.
5. From the **Print Style** drop menu choose **Registered output**. The options you set for the print style now appear in the dialog box.
6. Click **Print**, and the calendar page pours out of your printer. Now you're ready for December 2005!

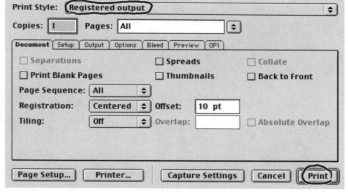

 Even though you used a spot color, the program will translate it into a CMYK process color for printing on your color printer or turn it into a gray on your black-and-white printer.

7. Click the **Close** button on the title bar of the library palette to close it.

A DEEPER UNDERSTANDING: CHANGING PRINT SETTINGS

If you want to use most but not all of the settings of a print style just select that print style then alter the options. To permanently change the options, go to the **Edit** menu, choose **Print Styles**, select the print style in dialog box, and then click **Edit**.

You can also save one set of print settings for a specific document. From the **File** menu choose **Print**. In the print dialog box, set the options you want then click **Capture Settings**.

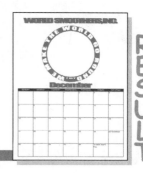

PROJECT 17

CORPORATE ANNOUNCEMENT

We are going to retire our ◯ motto design in favor of a minor revision of the design which looks like: ◯. Henceforth, whenever you would formerly use ◯ you should instead use ◯. Thank you for your assistance.

Pat Patterson
President

CONCEPTS COVERED

❏ Reusing library material
❏ Anchoring images in text
❏ Resizing Bézier items

REQUIREMENTS

❏ The corporate library you created in Project 16 and any digital photo of a person

RESULT

❏ An announcement of a new corporate logo

PROCEDURES

1. Retrieve the motto
2. Resize the motto
3. Rework the motto
4. Plan your hyphens
5. Write the text
6. Add the updated design
7. Paste a picture
8. Fix *some* problems
9. Fix *all* the problems

PROCEDURE 1: RETRIEVE THE MOTTO

1. Start a new document with the **Size** set to **US Letter**. Give it **1/4** inch margins all around and the **Automatic Text Box** option turned on, with **Columns** set to **1.**
2. From the **File** menu choose **Open**.
3. Use the file browser that opens to locate and select the **Corporate** library you created in Project 16.
4. Click the **Open** button. The library palette reopens, displaying the items that you added to it.

 You never actually saved the library, so it may seem odd to see the items in there. The truth is that you never have to issue a save command for a library. Whenever you add something to the library, that item is instantly written to the disk.

5. Drag the circular motto design out of the library and onto the document. It doesn't matter where you put it, as this is only a temporary placement.

 If you don't see the motto in the library, select **Branded** from the drop menu at the top of the library.

A DEEPER UNDERSTANDING: LIMITS OF THE LIBRARY

A library can hold up to 2,000 items, which is more than you're likely to ever put in it. Feel free to use it not only for complex graphic elements like the motto, but even for simple text items that you're likely to use again and again, such as a corporate address or a standard disclaimer. You can't just paste raw text into the library; the text has to be in a text box. Similarly, any picture you put in the library has to be in a picture box.

You're not even limited to just one library. You can create as many libraries as you want, and even have multiple libraries open at the same time.

PROCEDURE 2: RESIZE THE MOTTO

1. Get the **Item** tool from the tools palette.

2. From the **Item** menu choose **Edit, Shape**. A square bounding box with sizing handles appears around the motto.

 Remember that although this shape looks like a circle, the program is thinking of it as a Bézier line item. By default, when you use the item tool on such items, the program thinks that you're trying to change the path of the line rather than trying to resize it. That's what the check next to the *shape* command means. When you select the command, the check disappears. If you want to edit the shape later, just select this command again.

3. On the **Style** menu choose **Width, 1 pt.**

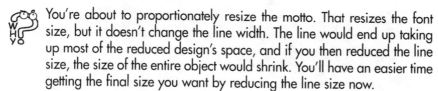 You're about to proportionately resize the motto. That resizes the font size, but it doesn't change the line width. The line would end up taking up most of the reduced design's space, and if you then reduced the line size, the size of the entire object would shrink. You'll have an easier time getting the final size you want by reducing the line size now.

4. While holding down the **Shift** key (to keep the height and width equal) and the Windows **Ctrl** or Macintosh ⌘ key (to resize the font proportionately), drag one of the corner sizing handles, resizing the item to be about **.5** inch in each dimension.

5. Get the **Content** tool. The font information displays on the measurement palette.

6. Drag across the **Font Size** field on the measurement palette, then hold down the Windows **Ctrl** or Macintosh ⌘ key and press **c**.

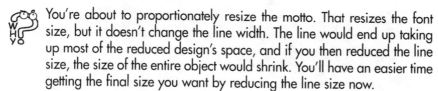

 This is the copy command. You've copied the font size onto the clipboard.

7. Click the **Item** tool on the tool palette. The measurement palette displays the line settings.

8. Drag across the **W** field on the right half, then hold down the Windows **Ctrl** or Macintosh ⌘ key and press **v** to paste the font size into this field, then press **Return**.

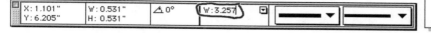

R
E
S
U
L
T

PROCEDURE 3: REWORK THE MOTTO

1. With the motto design still selected, go to the **Item** menu and choose **Duplicate**. A second copy of the motto design appears.

2. Go to the **Item** menu and choose **Modify**. A dialog box appears.

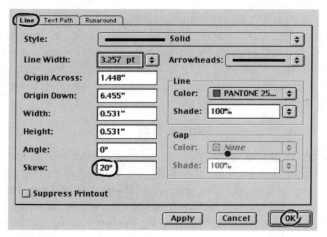

3. On the **Line** tab, set the **Skew** to **20** degrees then click **OK**. The logo tilts like a badly built outhouse in a stiff wind.

4. Using the method from Project 16, Procedures 5 and 6, add the tilted motto design to the library and give it the **Branding** label.

5. Go to the colors palette, point to the Pantone color used for motto, and bring up its pop-up menu by either right-clicking it (Windows) or holding down **ctrl** and clicking it (Macintosh).

6. From the pop-up menu that appears, choose **Make Process**.

 This motto design was created for the previous project, which was intended for two-color printing, using just a black plate and a spot-color plate. This project, on the other hand, is designed for four-color process printing, and it would be wasteful to treat the motto color as a fifth color. The command you just did replaced the spot color with the closest possible process color. This process color will be used everywhere that the original color was specified.

7. From the **Item** menu choose **Delete** to delete the tilted motto design from the page.

PROCEDURE 4: PLAN YOUR HYPHENS

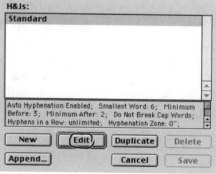

1. From the **Edit** menu choose **H&Js**. A dialog box opens up.

2. Click **Edit**.

 You don't have to worry about selecting which H&J settings you want to edit because there is only one set, *Standard*, and so it's automatically selected.

3. Another dialog box opens. Set **Smallest Word** to **5, Minimum Before** to 2, and **Minimum After** to **2**.

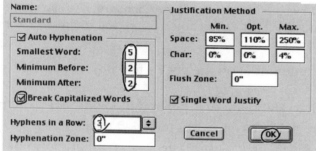

 You're about to use a large font to create big type. To avoid leaving large gaps at the margins, you want the program to avoid wrapping a word to start a new line. You've told the program that even if it has a word as short as five letters, it can break the word into two parts on two lines, as long as both the first part and the second part are at least two letters long.

4. Put a check in the **Break Capitalized Words** check box.

 Without a check in this check box, the program avoids breaking any word that starts with a capital letter. That keeps it from awkwardly breaking the first word in a sentence, from impolitely breaking someone's name, and from confusingly breaking acronyms like CD-ROM.

5. In the **Hyphens in a row** field, type **3**.

 This prevents you from having four or more consecutive lines ending in a hyphen, which would make the whole document look like a mere string of hyphens.

6. Click **OK** to close this dialog box.

7. Click **Save** to close the list of H&J setting sets.

RESULT

PROCEDURE 5: WRITE THE TEXT

1. Use the **Item** tool to select the original motto design.

2. From the **Edit** menu choose **Cut**. The motto design is removed from the page and stored on the clipboard.

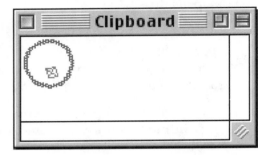

 You can view the contents of the clipboard at any time by going to the **Edit** menu and choosing **Show Clipboard**. The clipboard window you open will have to be closed before you can resume working on your document.

3. Click the **Content** tool on the page's text box to place the cursor there.

4. Set the **Font** to **Helvetica** or **Arial** and the **Font Size** to **40 pt.**

5. Type **We are going to retire our** followed by a space.

6. From the **Edit** menu choose **Paste**. The original motto design appears.

 The cut, copy, and paste commands are good ones to learn the keyboard shortcuts. Each of them involves holding down the Windows **Ctrl** or Macintosh ⌘ key and pressing a letter. The letter for cut is **x**, copy is **c**, and paste is **v**.

7. Type **motto design in favor of a minor revision of the design which looks like: . Henceforth, whenever you would formerly use** then type a space; paste another copy of the motto design in. Continue typing **you should instead use . Thank you for your assistance.**

. .

A DEEPER UNDERSTANDING: ANCHORING IMAGES

RESULT

We are going to retire our ◯ motto design in favor of a minor revision of the design which looks like: . Henceforth, whenever you would formerly use ◯ you should instead use . Thank you for your assistance.

Pasting a graphic element into a text box like this actually makes it part of the text flow. You could have the same effect by putting the graphic as a separate item over the text box. The difference is that when you have pasted the graphic into a text box (called *anchoring*), if you do something to change the flow of the text, the anchored item moves to keep its place within the text.

PROCEDURE 6: ADD THE UPDATED DESIGN

1. On the library palette, click the entry for the tilted motto design.

2. From the **Edit** menu choose **Copy**.

 Use the keyboard shortcut! The same keyboard shortcuts used for cut, copy, and paste in QuarkXPress are also used in every other program you use. You can even use them to copy an image out of another program and paste it as an anchored item in your text box.

3. Click the **Content** tool before the period at the end of the first sentence.

4. From the **Edit** menu choose **Paste**, or simply use the keyboard shortcut. The tilted design appears in place.

5. Repeat steps 3 and 4, placing the design at the end of the second sentence.

A DEEPER UNDERSTANDING: LIMITS TO ANCHORING

You can anchor any picture box, text box, or text path into a text box or on a text path with one exception: You cannot have an anchored item in a text box or path that itself is anchored in another text box or path. No box-in-a-box-in-a-box allowed!

We are going to retire our ○ motto design in favor of a minor revision of the design which looks like: ○. Henceforth, whenever you would formerly use ○ you should instead use ○. Thank you for your assistance.

RESULT

PROCEDURE 7: PASTE A PICTURE

1. Use the **Rectangular Picture Box** tool to draw a small picture box on the *pasteboard*, the blank areas outside the edges of the page.

 The pasteboard is a good place to do temporary work and experiments. That way, you don't mess up anything that's on the page. You can even leave your experiments and working items on the pasteboard without worrying about them showing up on the printout.

2. In the **W** field on the measurement palette type **100 pt** and in the **H** field type **40 pt** then press **Return** or **Enter**. The measurements are converted into inch measurements automatically.

 | X: −0.723" | W: 100 pt | △ 0° |
 | Y: 4.625" | H: 40 pt | 0" |

3. From the **File** menu or the picture box's pop-up menu choose **Get Picture,** and use the file browser that appears to select and open a digital photo of a person.

4. From the **Style** menu choose **Fit Picture to Box (Proportionally).** Unless you used an extremely wide image, the picture will now be as tall as the box with a blank space on the sides.

 If your picture doesn't entirely fit in the box then you used a picture that was too big. The program can only scale pictures between 10% and 1000% of their original dimensions

5. From the **Style** menu or the pop-up menu choose **Fit Box to Picture.** The box narrows so that the blank area disappears.

6. Get the **Item** tool then use the **Copy** command to copy the picture box.

 Selecting the item tool means that when you copy, you're copying the box with its contents, not just its contents. You need the box when you create an anchored item.

7. Get the **Content** tool, click at the end of the text in the text box, press **Enter** or **Return,** then press **Tab.** Type **Pat Patterson,** paste in the picture, and press **Enter** or **Return** again. Press **Tab** again and type **President**.

R
E
S
U
L
T

We are going to retire our ○ motto design in favor of a minor revision of the design which looks like: ○. Henceforth, whenever you would formerly use ○ you should instead use ○. Thank you for your assistance.

 Pat Patterson 🏳
 President

PROCEDURE 8: FIX SOME PROBLEMS

1. Notice that the lines of text are irregularly spaced. Even though the picture and the motto designs are shorter than the text size of 40 points, the text size measurement includes the descending portions of dangling y's and g's, and the bottom of the picture and motto designs are at the same spot as the bottom of the non-dangly letters (the *baseline*). The program puts extra space between lines to make up for the extra height of the graphic items. Click the **Item** tool on the first non-tilted motto design to select it, then go to the **Item** menu and choose **Modify**. A dialog box opens.

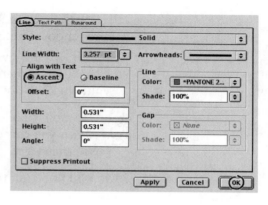

 You have to click the motto design's line and not the empty space inside. This is easier if you zoom in on the design.

2. On the **Line** tab, select the **Ascent** option and then click **OK**. The top of the motto design lines up with the top of the text characters, fitting the design better in the text.

3. Repeat steps 1 and 2 for the other untilted motto design on the page.

 If you were to do this to your tilted design, it would untilt. This is because the modify box for an anchored text path doesn't have a skew setting, and when you use the modify box the skew is automatically reset to zero.

4. Select the picture box then go to the **Item** tool and choose **Modify**. A dialog box opens.

5. On the **Box** tab, select the **Ascent** option and then click **OK**. The picture realigns with the text.

We are going to retire our ○ motto design in favor of a minor revision of the design which looks like: ○. Henceforth, whenever you would formerly use ○ you should instead use ○. Thank you for your assistance.

Pat Patterson
President

RESULT

PROCEDURE 9: FIX *ALL* THE PROBLEMS

1. Click the **Content** tool in the text box, then go to the **Edit** menu and choose **Select All.** All of the text and anchored items become selected.

2. Use the **Style** menu or the measurement palette to set the **Leading** value to **70.** Now there are huge gaps between all the lines!

 The most important practical page layout lesson I can give you is this: When you cannot get the design you want to work, decide to want something else.

3. If you look at the colors palette, you'll notice a new color at the very top of the list. Actually, it's the Pantone color you used for the motto design, only an asterisk has been added to the start of the name, and the symbol at the right indicates it's a spot color. We can't have any spot colors actually 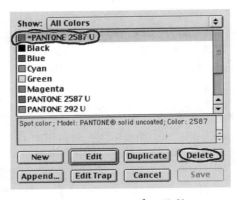 used in this document, so to get rid of it, go to the **Edit** menu and choose **Colors.** A dialog box opens.

 When you copied the tilted motto design out of the library, it still had the spot color with it. QuarkXPress saw that there was a process color with the same name in your document, so it added an asterisk to this color name and put it back in your document.

4. Select the aster-isked version of the Pantone color then click **Delete.** Another dialog box opens.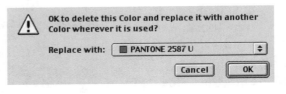

5. Select the asteriskless version of the Pantone color from the **Replace With** drop menu, then click **OK** to close this dialog box.

6. Click **Save** to close the color list dialog box.

7. Save the file, naming it **announcement**. Now you have an utterly unnecessary corporate memo!

RESULT

We are going to retire our ○ motto design in favor of a minor revision of the design which looks like: ○. Henceforth, whenever you would formerly use ○ you should instead use ○. Thank you for your assistance.

Pat Patterson
President

A LIMERICK FOR THE WORLD WIDE WEB

CONCEPTS COVERED
- Web page basics
- Converting text to art

REQUIREMENTS
- The corporate library you created in Project 16

RESULT
- A Web page with a limerick

PROCEDURES
1. Start a document
2. The master motto
3. Set image options
4. Logo-a-gogo
5. Make the page
6. Play tag
7. Give your limerick a title
8. Generate your Web site

PROCEDURE 1: START A DOCUMENT

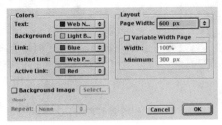

1. Go to the **File** menu and choose **New, Web Document**. A dialog box opens.

2. Set the **Text** drop menu to **Web Navy**.

 This will be the default color of your text.

3. Set **Link** to **Blue** and **Visited Link** to **Web Purple**.

 These are the colors for your *links*, portions of the text that the user can click on to be taken to another Web page or another part of this Web page. The *visited link* color will appear when the link points to a recently visited location, and the *link* color is for links to locations that were not recently visited.

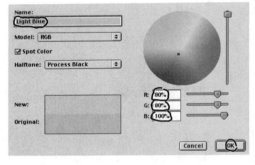

4. Click the **Background** drop menu and choose **Other** from the very top of the list. Another dialog box appears.

5. For the Name type **Light Blue**. Set **R** to 80%, **G** to 80%, and **B** to 100%, then click **OK**.

 Web pages are intended for on-screen display, and computer screens make color by mixing red, green, and blue. Because of this, you can most accurately specify colors for the Web by using the *RGB* (short for *Red, Green, Blue*) color space.

6. Set the **Page Width** to **600 px** (short for *pixels*).

 You don't want your Web page design to be wider than people's computer screens. Different people have their screens set to different resolutions, but even someone using an older computer to browse the Web will likely have his or her screen set to at least 640 pixels wide. Limiting your page to 600 pixels will make sure it fits between the Web browser's borders without facing the limitations and unpredictable page layout that the *variable width page* option can cause.

7. Click **OK**. A blank document is created, filled with the light blue background color you specified.

PROCEDURE 2: THE MASTER MOTTO

1. Go to the document layout palette and double-click the **A— Master A** icon. The master page displays in the window. Of course, it's hard to tell the difference just by looking at it, because both the master page and the document are nothing but a field of light blue at this point.

2. If the **Corporate** library is not already open, open it as you did in Project 17, Procedure 1.

3. Drag the untilted version of the logo out of the library and place it in the upper-left corner.

 The items in the library appear on the Web site at 72 pixels in size for each inch of the original. At that resolution, the small tilted image will be too small to be read. On the other hand, the untilted version is so big that it's not graceful. There actually isn't a size that will make this look good. The real answer is that this motto is a poor design for a Web page. Simple and small is what you want for the Web, and for many other things as well.

4. On the measurement palette, set **X** to **10** and **Y** to **5** to position the design.

 These measurements are in pixels. Given the varying sizes and resolutions of people's screens, inches are meaningless on the Web (and furlongs are just plain cumbersome).

5. From the **Item** menu choose **Modify**. A dialog box opens up.

6. On the **Line** tab, set **Skew** to 20 degrees to re-create the tilt.

7. Click **OK**.

 Notice that the X value on the measurement palette has changed. This is because the skew moved the top edge of the design and moved the upper-left sizing handle with it. The values on the measurement palette are the position of this sizing handle.

RESULT

PROCEDURE 3: SET IMAGE OPTIONS

1. From the **Item** menu choose **Modify**. A dialog box opens up. Yes, it's the same dialog box that opened up the last time you did this command. What did you expect, magic?

2. Click the **Export** tab and set **Export As** to **GIF**.

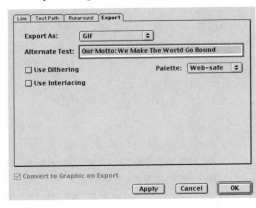

 There are three standard file formats for storing images for the Web. The Graphic Interchange Format *(GIF)* file format is the best choice for saving solid-colored items, whereas Joint Photographic Export Group *(JPEG)* is best for photos and items with color blends. The Portable Network Graphics *(PNG)* format has a lot of nice features, but too many Web browsers still don't properly support it.

3. Set the **Palette** drop menu to **Web-safe.**

 Some computers can only display 256 colors at a time. Web browser manufacturers have standardized on 216 colors, the *Web-safe palette*, that their browsers can always display. Colors outside of this set may need to be *dithered*, which means that they will be displayed as mixed dots of two different colors that average to the intended color. By selecting this option, you've told the program to translate all colors of the image into colors from that palette.

4. Clear the **Use Dithering** check box.

 If you had this option selected, colors from the Web-safe palette would have been dithered to simulate the color of the item, which is exactly what you tried to avoid in step 3! By not allowing dithering, however, your motto design may not be the exact color you picked for it, but merely the most similar color from the set of 216.

5. Type **Our Motto: We Make The World Go Round** into the **Alternate Text** field, then click **OK**.

 This descriptive text appears in browsers that have image-loading turned off. It is also used by special browsers for the visually impaired.

RESULT

PROCEDURE 4: LOGO-A-GOGO

1. Use the **Rectangular Text Box** tool to drag a text box in the area to the right of the motto design, about as high as the motto design and filling up most of the remaining width.

2. On the colors palette, set the **Background Color** to **None**.

3. With the **Content** tool selected, type **Limericks of the WORLD SMOOTHERS SOCIETY.**

4. From the **Item** menu choose **Modify**. A dialog box comes into your life.

5. Go to the **Text** tab and look at it. So many things are grayed out. Put a check in the **Convert to Graphic on Export** option and many of them become ungrayed.

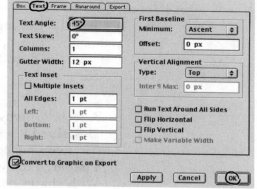

 The words in Web pages are generally stored as simple text, which the Web browser then figures out how it looks on the page. This is very efficient, making the page download quickly and making it possible to copy text from a Web page and paste it into a word processor. Alas, this only lets you do horizontal text with fairly simple formatting such as bold and italic styles. With this option selected, the program instead puts out a picture of your text design, which is slower to download but looks exactly like you want it to look.

6. Set **Text Angle** to **45** degrees then click **OK**.

 The little icon of a camera in the corner of the text box means that this text box will be converted to a graphic in the final Web page.

7. If none of the words end up hyphenated, skip to the next procedure. Otherwise, go to the **Utilities** menu and choose **Hyphenation Exceptions**. A dialog box opens.

8. Type the hyphenated word into the bottom text field, click **Add**, then click **Save**.

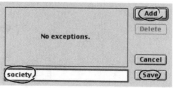

 This controls where a word gets hyphenated. If you had typed dashes into the middle of the word, those dashes would have been the breaking points when the word gets broken. No dashes means this word never gets hyphenated.

9. Click the end of the text in the box then hit the **space** key. This forces rehyphenation.

RESULT

PROCEDURE 5: MAKE THE PAGE

1. Use the **Rectangular Text Box** tool to drag a text box beneath the two items on the page, making it almost as wide as the document and about as tall as the motto design.

2. If the background color doesn't automatically become white, use the colors palette to set the background color to white.

3. Set the **Font** to **Helvetica** or **Arial**, the **Font Size** to **18 pt.,** and the **Alignment** to **Centered.**

4. Go to the document layout palette and double-click the page to display the page.

5. Click the **Content** tool in the white text box and then type a limerick, pressing **Return** or **Enter** after each line and **Tab** before the third and fourth lines. If you don't have a limerick, here's one:

> **A techno-investor named Tom**
> **Described his new house with aplomb,**
> **"To keep my costs small,**
> **I papered the wall**
> **With shares of a bankrupt dot-com."**

6. Go to the document layout palette. Point to the word **Export1** under the page then either click if you're using a Macintosh or double-click if you're using Windows. The word becomes selected.

 This is the name for the Web page file.

7. Type a one-word name for the file, such as **dotcom**, then press **Return** or **Enter**.

 To avoid future problems, use only lowercase letters, and avoid using any spaces or punctuations, except hyphens, in the name.

PROCEDURE 6: PLAY TAG

1. From the **Edit** menu choose **Meta Tags**. A dialog box opens up, looking much like the dialog box for lists of style sheets or colors.

2. Select **Set 1** at the top then click **Edit**. Another dialog box opens.

3. Click the entry with **keywords** in the **Name** column then click **Edit**.

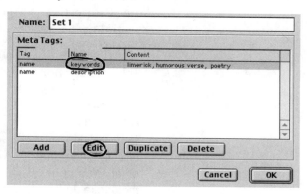

4. Another dialog box opens. In the **Content** field, type **limerick, humorous verse, poetry** then click **OK**.

 Now if someone types *humorous verse* into a Web search engine, they might get steered to your page. Well, not *now*, because your page isn't on the Web yet!

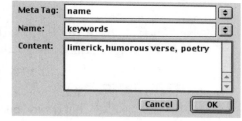

5. Click the entry with **description** in the **Name** column then click **Edit**. The dialog box opens again.

6. In the **Content** field, type a brief description of the poem, such as **A rhyme about a Web investor,** then click **OK**.

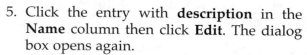 This is what some search engines will use to describe your page to people who look it up.

7. Click **OK** to close this dialog box and **Save** to close the next.

..

A DEEPER UNDERSTANDING: TAGS AND META TAGS

A *tag* is the Web term for a piece of information embedded invisibly in a Web page. There are tags that tell the Web browser what color the page is, what images to load, when to start and end italics, and basically every attribute of the page except for the text it contains.

At the beginning of many Web page files are *meta tags*, tags that don't change the way the image appears but which describe additional information to the Web browser and to other programs that examine the page. A good book on Web site design will give you a long list of meta tags and what effect they have.

RESULT

PROCEDURE 7: GIVE YOUR LIMERICK A TITLE

1. Go to the **Page** menu and choose **Page Properties**. A dialog box opens up.

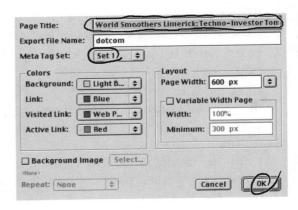

 This dialog box can be used to set this Web page's color and dimension settings differently than the other Web pages that make up this document. You can also set the file name in the field below the title, rather than using the method you used in Procedure 5.

2. In the **Page Title** field, type a nice, long name for the limerick. This is the title that appears at the top of the Web browser when the page is being displayed.

 You can use uppercase and lowercase letters as well as punctuation, but avoid "quotes" and <angle brackets>.

3. From the **Meta Tag Set** drop menu choose **Set 1.**

4. Click OK to close the dialog box.

5. Along the bottom edge of the display window is an **HTML Preview** button. Click it, and the page you designed opens up in your Web browser.

 If you point to the **HTML Preview** button and hold the mouse button down, a menu appears listing all the Web browsers installed on your system. Using that, you can select which browsers you want to use to preview your file.

6. Go to your Web browser's **File** menu and choose **Quit** or **Close** to leave your Web browser and return to QuarkXPress.

 If the QuarkXPress palettes don't reappear immediately, click the title bar of your document.

RESULT

PROCEDURE 8: GENERATE YOUR WEB SITE

1. From the **File** menu choose **Save,** and use the file browser that opens to save your document under the name **limerick**.

2. Return to the **File** menu and choose **Export, HTML**. A file browser opens.

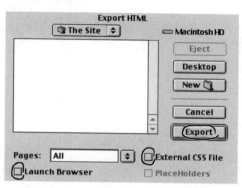

 The file you saved in step 1 is not readable by Web browsers. It has all the information needed to create your Web site, but it's only readable by QuarkXPress.

3. Clear the **Launch Browser** check box.

 This option automatically opens your browser to display your Web site once you export it. Because you just previewed the page, there's no need to do this.

4. Clear the **External CSS File** check box.

 This takes some of the description of font information that usually goes in the Web page file and stores it in a separate file. When you have a site with a number of pages, this can keep your files smaller because the same font information isn't repeated in every file. It can even speed up the site for your visitors, because the font information won't have to be re-downloaded with every page of the site they view. With a single-page Web site such as this one, however, storing the font information separately would just complicate things and slow things down.

5. Select a directory to store the files in, then click **Export**. The (HTML, the system of tags used to describe Web pages) file is stored in the directory you selected. A subdirectory named *image* is also added to the directory, and in that subdirectory are the image files for your motto design and your titled title. In other words, you have a Web site on your disk!

R
E
S
U
L
T

PROJECT 19

LET US RHYME ONE MORE TIME

CONCEPTS COVERED

❑ Links and anchors
❑ Pictures for the Web

REQUIREMENTS

❑ The limerick Web design file you created in Project 18, plus two digital photograph files, at least one of which should be in the JPEG format

RESULT

❑ A multipage Web site of limericks

PROCEDURES

1. Make another page
2. Link the text
3. Add an image
4. Link an image
5. A shortcut to the top
6. Cook up a menu
7. Install the menu
8. Finish it up

PROCEDURE 1: MAKE ANOTHER PAGE

1. Go to the **File** menu, choose **Open**, and use that file browser to locate and open the **limerick** file that you saved in Project 18.

2. On the document layout palette, drag the **A—Master A** icon to below the first page, then double-click this new page to bring it up in the display window.

> The order of the pages in this document is unimportant. The only difference it makes is that the first page on the list will be the one that opens up when you export it to the browser.

3. Type a limerick into the text field on the page. Here's one you can use:

> **Queen Lauren heard too much from these**
> **rebels whom she did displease.**
> **She silenced their howls**
> **by outlawing vowels,**
> **n ndd thr rvlt wth s!**

> You can, of course, fill text boxes by importing text, just as with a paper document.

4. Use the method from Project 18, Procedure 7 to give this page a title.

> While you have this dialog box open, you can use it to give the project a file name and then skip step 5.

5. Give the file a new file name the way you did in Project 18, Procedure 5.

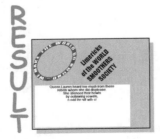

PROCEDURE 2: LINK THE TEXT

1. Double-click one word in the limerick that means something to you. That word becomes highlighted to show that it's selected.

2. From the **Style** menu choose **Hyperlink, New**. A dialog box opens.

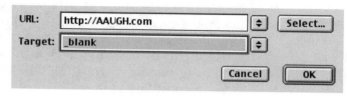

3. In the **URL** field, type the address of a Web page that relates to the word you highlighted. You need to type the full address, including the **http://** beginning.

 The easiest way to get a full proper Web address is to start up your Web browser, surf over to that page, and copy the address from your Web browser's **Address** or **URL** field, then paste it into a field here. You may need to click **Cancel** and close the dialog box before you can start your Web browser, then return to step 2 to reopen the dialog box.

4. Click the drop menu at the end of the **Target** field and choose **_blank** from the list that appears.

When this Web site is finally published, clicking this word will open up a new Web browser window with the indicated page. If you had actually left the target field empty, then the indicated page would appear in the same window, replacing the limerick page.

5. Click **OK**. The word you selected is now in your link, colored and underlined, to show that it is a link.

A DEEPER UNDERSTANDING: URL

A *URL* is a *Uniform Resource Locator,* the fancy name for an Internet address. The **http://** part tells the Web browser to use the *hypertext transfer protocol,* a system of communications for transferring a file. You may occasionally see **ftp://** for *file transfer protocol,* a system used for downloading files.

You only need to use the full URL when linking to a Web page on a different system. To link to a file on the same system, you may only need the directory name and file name *(image/pic.gif)* or even just a file name *(dotcom.htm).*

RESULT

PROCEDURE 3: ADD AN IMAGE

1. From the **View** menu choose **50%,** so that the full Web page is visible in the window.

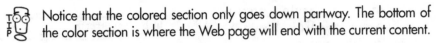 Notice that the colored section only goes down partway. The bottom of the color section is where the Web page will end with the current content.

2. Reduce the width of the text box by dragging the right side sizing handle toward the left. Make it just a bit wider than the widest line of text.

3. Use the **Rectangular Picture Box** tool to draw a picture box to the right of the text box. Make it tall, putting the bottom at about 1100 pixels from the top.

4. Go to the **File** menu, choose **Get Picture**, and use the file browser that appears to select a digital image file.

 You can use any digital image file that the program understands. It will automatically translate those files into ones that Web browsers will understand.

5. From the **Style** menu choose **Fit Picture to Box.** The picture is automatically squashed and stretched to fill the tall, skinny box.

6. From the **Item** menu choose **Rollover, Create Rollover.** A dialog box opens.

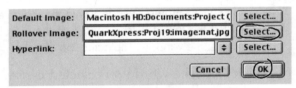

 A *rollover* is a replacement picture that appears when the visitor to your Web page moves the pointer over the original picture.

7. Click the **Select** button at the right of the **Rollover Image** field. A file browser opens.

8. Locate and select a different photo file, one in the JPEG file format, then click **Open**.

 If you don't have a JPEG file, find instructions for downloading one at http://www.delmarlearning.com/companions/projectseries.

9. Click **OK** to close the dialog box.

 You may want to click the **HTML Preview** button at the bottom of the display window and test out your rollover.

PROCEDURE 4: LINK AN IMAGE

1. Using the technique from Procedure 3, put a picture beneath the text box. Don't fill the whole space and don't give it a rollover. Reuse one of the two pictures you've used so far if you wish.

 You're about to use a Web feature called *image mapping*. This feature doesn't work with images that have rollovers, so you need a separate image to experiment on.

2. Go to the **View** menu and choose **Tools, Show Web Tools**. A second tool palette opens up.

 If you don't see this command but see one to hide the Web tools instead, that means that the palette is already showing.

3. Get the **Oval Image Map** tool.

4. Drag the tool over an interesting, round portion of your picture, such as a face.

 After you drag, sizing handles appear. Use these to adjust the placement of the oval.

5. From the **Style** menu choose **Hyperlink**. At the bottom of the submenu is a list of all the links that are already in this document. At this point, that should be just one link, the link that you made in Procedure 2. Select that link.

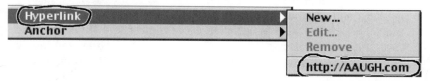

 This turned the oval into a link. Now whenever a Web visitor clicks on the area in that oval, they will be taken to the linked page.

A DEEPER UNDERSTANDING: IMAGE MAP TOOLS

Two tools share the space with the oval image map tool. The *Rectangular Image Map* tool makes square areas for linking, and the *Bézier Image Map* tool makes irregular areas. You can clear all the links on the image by going to the **Item** menu and choosing **Delete All Hot Areas.**

RESULT

PROCEDURE 5: A SHORTCUT TO THE TOP

1. Click the **Content** tool to the left of the very first letter of the limerick.

2. From the **Style** menu choose **Anchor, New**. A dialog box opens up.

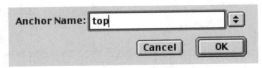

Anchor Name: top

Cancel OK

3. In the **Anchor Name** field type **top** then click **OK**.

 This creates a named spot in the text.

4. Use the **Item** tool to select the picture that has the rollover.

5. From the **Style** menu choose **Hyperlink, #top.**

 Now, if the Web visitor scrolls to the bottom of your Web page then clicks on the rollover picture, the Web browser will instantly scroll up to the start of the limerick.

A DEEPER UNDERSTANDING: ANCHORS

An anchor is simply a named location on a Web page. With anchors in place you can create links to specific locations on a Web page. This isn't that useful for short Web pages, but when you have a long article or a big reference work on a single page, anchors can be quite useful.

The anchor name itself can be any combination of letters, numbers, hyphens, and underlines. For various reasons you should avoid including spaces, periods, or other punctuation marks in the name. When referring to an anchor in a link that's on the same page as the anchor is, you simply add a # to the start of the anchor name to create the URL. When linking to an anchor on another page, you enter something like http://www.AAUGH.com/guide/lkids.htm#world with the entire URL of that other page, plus the #, plus the name of the anchor.

RESULT

PROCEDURE 6: COOK UP A MENU

1. Export your Web site as you did in Project 18, Procedure 8.

 This creates the HTML files on the disk. This is handy because it means that you can use your file browser to select the files you want to create links to.

2. When asked if you want to replace files, click **Yes to All** to automatically replace the older version of all files.

3. From the **Edit** menu choose **Menus**. A dialog box opens up.

4. Click **New**.

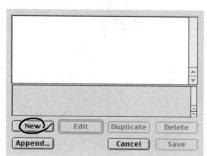

5. Another dialog box opens. In the **Name** field type **My Pages**, put a check in the **Navigation Menu** option, then click **Add**.

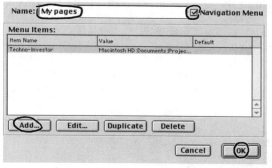

6. Yet another dialog box opens. In the **Name** field type a short name for the first limerick, then click **Select** or **Browse**.

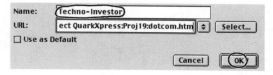

7. A file browser opens. Locate and select the file with the first limerick in it, then click **Open**.

8. Click **OK**.

9. Click **Add**, then repeat steps 6 through 8 for the second limerick. Do it a third time, setting **Name** to **Pick a rhyme**, leaving the **URL** blank, and putting a check in the **Use As Default** check box.

10. Click **OK** to close the current dialog box, then click **Save** to close the first dialog box.

RESULT

PROCEDURE 7: INSTALL THE MENU

1. Double-click the icon to the left of **A—Master A** on the document layout palette to open up the master for editing.

2. Create as much room as you can in the upper right by reducing the size of the **Limericks of the WORLD SMOOTHERS SOCIETY** text box and moving it closer to the motto design.

3. Get the **Form Box** tool from the Web tool palette and use it to drag a rectangle that covers all the space to the right of the text box you just adjusted.

> If you want to put a menu on a Web page, you first have to create a form box to put it in.

4. Go to the Web tool palette and get the **Pop-up Menu** tool and use it to drag a rectangle in the upper-left corner of the form box.

> Don't worry about the sizing of this rectangle. It will automatically be a certain fixed size.

5. From the **Item** menu choose **Modify.**

6. In the dialog box click the **Form** tab. From the **Menu** menu select **My pages** then click **OK.**

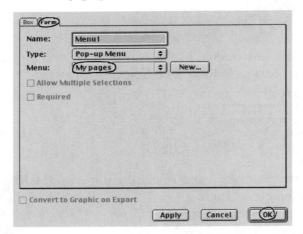

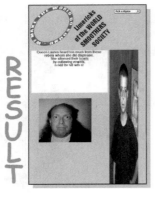

> If a warning dialog box appears to tell you that your menu names will be truncated, click **OK.**

PROCEDURE 8: FINISH IT UP

1. From the **File** menu choose **Save** to update the limerick file.

2. Select one of the pages in the document layout palette by double-clicking it. It doesn't matter which one you pick.

 The export command doesn't work when you have a master selected.

3. From the **File** menu choose **Export, HTML**. The file browser opens up.

4. Put a check in the **External CSS File** check box.

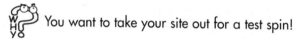 The external CSS option makes for faster-loading pages when you have multiple pages.

5. Put a check in the **Launch Browser** check box.

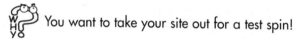 You want to take your site out for a test spin!

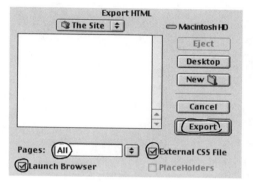

6. Set the **Pages** drop menu to **All** then click **Export**. If a dialog box asks you to replace an existing file, click **Yes to All.**

7. Your Web browser opens up. Try using the menu in the upper left and see how the pages change automatically when you make a menu selection. Your Web site works!

A DEEPER UNDERSTANDING: QUARKXPRESS FOR WEB DESIGN

QuarkXPress is a dynamite page layout tool, but truth to tell it's a lackluster Web design tool. It uses a lot of fancy, high-end features of the Web but doesn't let you make a simpler page that is more likely to be compatible with all browsers.

If you need to make Web pages that reuse a lot of elements from print documents that you designed with QuarkXPress, then you may want to use this program as a design tool. Otherwise, you're probably better off using a dedicated Web design program like Dreamweaver or Frontpage.

RESULT

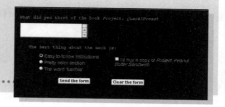

PROJECT 20

FORMING A FORM

CONCEPTS COVERED

❏ Web form design

REQUIREMENTS

❏ None

RESULT

❏ An interactive online form

PROCEDURES

1. A field for the form
2. A field in the form
3. Button up some options
4. Set your option options
5. A peanut butter check box
6. Send or clear the form
7. Set your submission policy
8. Give it a go

PROCEDURE I: A FIELD FOR THE FORM

1. Go to the **File** menu and choose **New, Web Document**. A dialog box opens.

2. Set **Text** to **Web Fuchsia** and Background to **Black**.

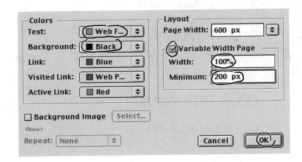

 Light colors on a dark background can look quite sharp and high tech. Some elements of a form will automatically be white, and those will show up in nice contrast to the dark background. This also gives me the chance to type the word "fuchsia," which looks like a word that doesn't quite belong in any language. Fuchsia fuchsia fuchsia.

3. Put a check in the **Variable Width Page** check box. Set **Width** to **100%** and **Minimum** to **200 px** then click **OK**.

 If you don't choose the variable width option, the content of your page won't rearrange to fit the size of the Web browser window. Choose this option and the content will be laid out to fill the width of their browser window.

4. Get the **Form Box** tool and drag a rectangle that covers most of the width of the working space, making it about **350** pixels high.

A small icon appears in the upper-right corner of the form box. This icon just means that it's a form box. There are a variety of icons that can appear in the upper-right corner of items. If you point to one, a tool tip appears telling you what it means.

- -

A DEEPER UNDERSTANDING: FORM BOXES

All of the text boxes, check boxes, and other elements that make up your form have to be placed within a single form box. That way, when the form is submitted the Web browser knows exactly which set of information it has to send to another computer.

You can have more than one form box on a single page, but they will be separate forms. Only one form will be submitted when a submission button is clicked.

PROCEDURE 2: A FIELD IN THE FORM

1. Use the **Rectangular Text Box** tool to drag a text box across the top of the form box.

2. Set the text box's **Background Color** to **Black** then type in the text box, in **Courier** font at **14 pt.** size, the question **What did you think of the book** *Project: QuarkXPress?*

3. Get the **Text Field** tool from the Web tool palette.

4. Drag a text field across most of the width of the form box, just under the text box. The text box will automatically be one line of text high.

5. Go to the **Item** menu and choose **Modify**. A dialog box opens.

6. On the **Form** tab set the **Name** to **Thoughts**.

This is a name for the field, which will be used to identify this set of information to the program that gets to process the form.

7. Set the **Type** drop menu to **Text—Multi Line,** set **Max Chars** to **1000**, and put a check in the **Wrap Text** check box.

This makes a text box that will hold up to 1,000 characters without the user having to hit the return or enter key at the end of each line.

8. Put a check in the **Required** check box.

By making the field *required*, the browser won't even submit the form if this field is left blank. Instead, the browser gives a warning and lets the user correct the form and submit it again.

9. Click **OK**.

The text field may be a different width in the Web browser than it is in QuarkXPress.

RESULT

PROCEDURE 3: BUTTON UP SOME OPTIONS

1. Under the left end of the text field, add a text box with no background with **The best thing about the book is:** in **Courier 14 pt.**

2. Get the **Radio Button** tool from the Web tool palette.

 They're called *radio buttons* because they work like the channel preset buttons on older car radios, where pushing in one button causes the others to pop out. Selecting one option from the set deselects the other ones.

3. Drag a rectangle below the text box. Make it as shallow as possible; the program won't let you make it less than one line of text high.

4. On the colors palette set the **Background Color** to **Black** and the **Text Color** to **Web Fuchsia.**

 Form elements like the text field are automatically black text on white because that's what the Web browser will make them. Other elements, such as the radio button boxes, are assumed to be black on white to match but can be changed.

5. With the **Content** tool selected type **Easy-to-follow instructions** in **14 pt. Helvetica.** The text appears next to the option button.

6. From the **Item** menu choose **Duplicate**. A copy of the radio button box appears below the first.

 Usually the new button will appear directly below the first. If it doesn't, just use the **Item** tool to drag the new button box up. It will stop just below the first.

7. Use the **Content** tool to select the text then type **Pretty color section** to replace the text.

Be careful to select just the text, not the option button itself.

8. Repeat steps 6 and 7, only use **The word "fuchsia"** as the text for this third button.

PROCEDURE 4: SET YOUR OPTION OPTIONS

1. Double-click the **Item** tool on the first radio button box. The modify dialog box opens up.

2. On the **Form** tab go to the **Group** field and type **Best**.

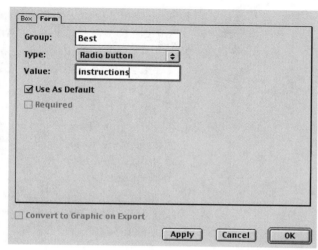

 This is the name of the variable that will be set by these option buttons.

3. In the **Value** field type **instructions**.

 If the user selects this option, the browser will send the information that the *Best* is *instructions*.

4. Put a check in the **Use As Default** check box.

This means that the *instructions* option will be the one that is initially selected when the user sees the form.

5. Click **OK**. The dialog box closes.

6. Double-click the second radio button box.

7. Set the **Group** to **Best**, the **Value** to **color**, and leave the **Use As Default** check box clear then click **OK**.

8. Double-click the third radio button box.

9. Set the **Group** to **Best**, the **Value** to **fuchsia**, and leave the **Use As Default** check box clear then click **OK**.

RESULT

PROCEDURE 5: A PEANUT BUTTER CHECK BOX

1. Use the **Check Box** tool from the Web tool palette to drag a rectangle to the right of the radio button boxes.

2. With the **Content** tool selected, use the color palette to set the **Background Color** to **Black** and the **Text Color** to **Web Fuchsia.**

3. Type **I'd buy a copy of** *Project: Peanut Butter Sandwich.*

4. From the **Item** menu choose **Modify.** A dialog box opens up.

5. On the **Form** tab set **Value** to **Yes** then click **OK.**

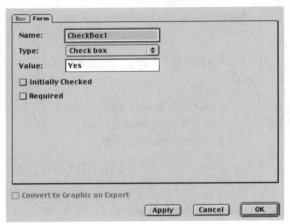

 The default variable name, **Check box1,** is as good as any.

. .

A DEEPER UNDERSTANDING: OTHER FORM ELEMENTS

Text fields, radio buttons, and check boxes aren't the only form elements that you can use. You can set up a form menu in much the same way you set up the navigation menu in Project 19, except you don't use the nagivation menu option, and you enter variable values instead of URLs.

There are also *list boxes,* which are similar to menus, except several lines are showing at once in a scrollable list. You can set up a list box so that someone can select more than one item. For example, you could have a list box listing all the stars of *The Brady Bunch,* and let the user select all the ones that should be members of Congress.

There's even a tool to set up a file selector, which users can use to select files from their hard disks. This would be handy if you were designing an E-mail application, for example, and wanted the user to be able to select a file to attach to the E-mail.

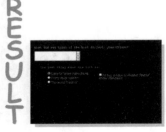

PROCEDURE 6: SEND OR CLEAR THE FORM

1. Get the **Button** tool from the Web tool palette and use it to drag a rectangle beneath the radio button boxes. You will be limited to dragging a fairly small box.

2. With the **Content** tool selected, type **Send the form.** As you do, the button expands to comfortably fit the text.

3. Repeat steps 1 and 2 to create another button next to the first one. This should say **Clear the form.**

4. With the second button still selected, go to the **Item** menu and choose **Modify**. A dialog box opens up.

5. Set the **Type** drop menu to **Reset** then click **OK**.

 By default, any button will send the content of the form. By making this a reset button, it doesn't send the form but just clears the text fields and resets all the options, check boxes, menus, and lists to their default state.

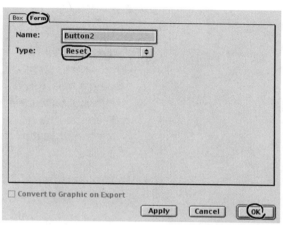

A DEEPER UNDERSTANDING: BUTTONS

You can have as many buttons as you want. At first it may seem pointless to have more than one button to submit the form and one button to reset the form. Although you never need more than one reset button, you can have several submit buttons. Part of the form information that is sent is the identity of which button was clicked. You could have a form that was nothing but two submit buttons, one that says *Yes, I'd like a peanut butter sandwich* and another one that says *No, I'd rather have two peanut butter sandwiches.*

The text for the button will be in a font and color set by the browser. It's not something you can control. To make a visually interesting button use the **Image Button** tool. This makes buttons with images you design.

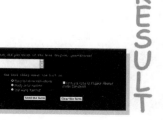

RESULT

PROCEDURE 7: SET YOUR SUBMISSION POLICY

1. Click on an empty area of the form box to select the box.

2. Go to the **Item** menu and choose **Modify**. A dialog box opens up.

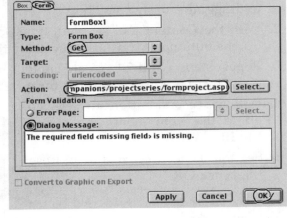

3. On the **Form** tab set **Method** to **Get**.

 This sets the method that the browser uses to send the form information to the Web site. The *get* method tacks the form information onto the end of the URL of the page it requests.

4. In the **Action** field type:

 http://www.delmarlearning.com/companions/projectseries

 to send the results of the form to a special test Web page I've set up.

5. In the **Form Validation** area choose the **Dialog Message** option then click **OK**.

 If someone doesn't fill in the required field, the indicated message will now appear, with the name of the required field instead of *(missing field)*.

6. Drag the form box's bottom sizing handle up as high as it will go, to keep the box tight around the form elements.

..

A DEEPER UNDERSTANDING: HANDLING FORMS

Designing a form is actually the easier part of setting up a form on a Web page. After all, a form is no good unless there's a program on the Web server that will do something with the form information. There is a wide range of ways of writing such programs, and which works best for you depends on what kind of Web server you have and what you're trying to do with the results. Your local bookstore should have shelf after shelf of books on how to program these things.

PROCEDURE 8: GIVE IT A GO

1. From the **File** menu choose **Save,** and save the form file under the name—oh, whattheheck, this is the last project, you can name it whatever you please!

2. Export the file, selecting the **Launch Browser** option when you do. Your browser launches, displaying your form.

3. If you need to do anything to actually connect to the Internet, do it!

4. Click the **Send the form button** without filling out the form.

5. A dialog box appears to tell you that you didn't fill in the Thoughts form. Click **OK.**

6. Fill out the form.

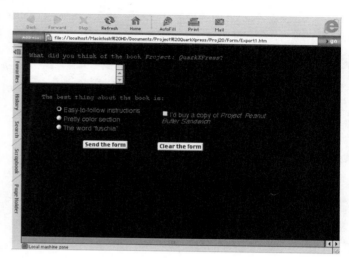

 If you write what you actually think about the book in the text field, I may actually see it. Be kind, but be truthful!

7. Click **Send the form**. The form information is sent, and a Web page appears showing you what information you filled in.

 If you don't have an Internet connection, don't worry. You'll probably get an error message telling you that the browser couldn't bring up the page. That error message will include the URL of the page you requested, and at the end of that URL is the date from the form.

8. Do a little happy dance—you've completed the last project!

RESULT

INDEX